on edge

breaking the boundaries

of graphic design

ROCKPORT

 movement

 divine orbit

 inscriptions

 Greek ideal/American reality

 anatomies

 x marks the spot

 spring fall

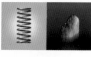 seesaw

 despair/liberation

 binary bottleneck

 verbal assault

 tension/release

Photography credits listed with projects have been provided by the designers and companies featured herein, and refer to photography hired by them for individual projects. All photography required by Rockport Publishers in the production of this title has been provided by Kevin Thomas Photography.

Many of the designations listed in *On Edge: Breaking the Boundaries of Graphic Design* are claimed as trademarks. Rockport Publishers has made every effort to supply trademark information about manufacturer's and products mentioned in this book. A list of trademarked designations and their owners appears below.

PageMaker™, Photoshop™, Photoshop Plug-Ins™, and Illustrator™, are trademarks of Adobe Systems Incorporated.
Freehand™ is a trademark of Macromedia Inc.
Hexachrome™ is a trademark of Pantone Inc.

First published in the United States of America by:
Rockport Publishers Inc.
33 Commercial Street
Gloucester, Massachusetts 01930-5089
Telephone: (978) 282-9590
Facsimile: (978) 283-2742

Distributed to the book trade and art trade in the United States by:
North Light Books, an imprint of
F & W Publications
1507 Dana Avenue
Cincinnati, Ohio 45207
Telephone: (800) 289-0963

Other Distribution by:
Rockport Publishers Inc.
Gloucester, Massachusetts 01930-5089

ISBN 1-56496-454-X

10 9 8 7 6 5 4 3 2 1

Page Design and Layout: Debra S. Ball
Cover and Opener Design: Kathleen Feerick
Cover photo and pages: 1, 3, 10, 38, 66, 94, 122, 154, 178
 Minelli Design, Self-promotion card box
 This project is featured on page 134.

Manufactured in Hong Kong.

on edge

breaking the boundaries

ROCKPORT PUBLISHERS

of graphic design

GLOUCESTER MASSACHUSETTS

Karen D. Fishler

Acknowledgments

*To my parents
Alvin and Martha Taub
for all they have given me*

Many designers and creative directors shared their thoughts with me in person, on the phone, by e-mail, by fax, or by letter as I researched this book and collected projects for it. If the book has merit, it is largely due to their generosity, and where it falls short, the fault is mine. I wish to thank the following: Primo Angeli, Kerstin Baarmann, Lois Bender, John Berry, Klaus Bjerager, Michael Bierut, Eric and Jackson Boelts, Howard Brown, Iain Cadby, André Bombonatti de Castro, Michael Connell, Michael Cronan, Bill Current, Robert Dietz, Bob Dinetz, Bill Doucette, Ursula Drees, William Drenttel, Joseph Essex, Thom Feild, Dieter Feseke, David Freeman, Chris Froeter, Ken Godat, Frank Grubich, Tim Hartford, Aryeh Hecht, Jessica Helfand, Joyce Hesselberth, Will Hyde, Michael Jager, Amy Johnson, Rich Kaalaas, Grace Kao, Ray Kristof, Eli Kuslansky, David Lemley, Heidi Libera, Dana Lytle, Kristine Matthews, Chaz Maviyane-Davies, João Machado, Corey Macourek, Richard McGuire, Mark Meadows, Peter Minelli, Clement Mok, Colette Motl, Tim Nihoff, Siegrun Nuber, Jane Osborn, Christopher Ozubko, Carlo Pagoda, Laura Perry, Kathleen Phelps, Dave Plunkert, Chris Pullman, Wayne Rankin, Kevin Roberson, James Robie, Lies Ros, Steven Rosenberg, Yves Rouselle, Amy Satran, Carlos Segura, Enrico Sempi, Jilly Simons, Steve Simula, Leslie Smolan, Peter Spreenberg, Kerry Stratford, Ron Sullivan, Lucille Tenazas, Kevin Wade, Steve Wedeen, Louis Weitzman, Alison Woods, Dan Woychick, Anthony Yell, and Lori Yi.

The book has also benefited from the assistance of thoughtful and knowledgeable design marketers, assistant vice presidents, media relations people, and others who help writers like me. Thanks to Christina M. Arbini, Jason Baranowski, Florence Bottollier, Sheree Clark, Brenda Foreman, Rebecca Hartranft, Deirdre McMennamin, Bonnie Powers, Shirley Rogers, Leslie Sherr, and Andrea Yoch.

In many instances, I would not have been able to write about projects without helpful information and materials from the designers and assistants who get packages out and track down facts. Much appreciation is due to Tina Besa, Amie Champagne, Natasha Gordon, Jocelyne Henri, Kristen Hewitt, Ben Hirby, Christine Hsiao, Jane Hyland, Shannon Kemper, Kurt Koepfle, Lesley Kunikis, Tuan Lam, Gyles Lingwood, Nancy Loose, Chris Lowery, John Odo, Leslie Parker, Jennifer Raskoff, Lance Rusoff, Kelly Simpson, Dan Stachurski, Terry Stone, Kathleen Stueck, Marla Supnick, Barbara Templeton, Christina Torri, Zahava Tzur, Michelle Wallace, and Rob Wilson.

András Fürész found me reference books and gave me valuable perspective, for which I am grateful.

If there is anybody who should be in this catalog of names and isn't, I hope he or she will forgive me and know that I appreciate the help I received, whatever form it took.

I am also grateful to have had the opportunity to launch an online magazine at Adobe Systems Incorporated. I learned much about both design and technology in the process, and in many ways this book is a continuation of my thinking about issues I became interested in while I was at Adobe. I wish especially to thank Nick Allison, a wonderful editor who made a very valuable experience possible for me. I would also like to thank Jenna Ashley, Kathy Koeneman, Carla Noble, Tamis Nordling, and Wendy Katz, along with Kimberly Chilcutt, Jeff Lalier, Leslie Nakagawa, Retsu Takahashi, and Linda Taylor. A particular, and very fond, thank you is due to Jennifer Loflin, for helping make technology fun for me. Robert Dietz and Kathy Thompson of Dietz Design, and David Newsom, did exceptional design and production work, often under very difficult circumstances. Sigrid Asmus, Jeff Carlson, Joy Cordell, Linnea Dayton, Glenn Fleishman, Rob French, Addy Hatch, Ole Kvern, Anistatia Miller and Jared Brown, Pat Riedman, and Audrey Thompson were key participants. The many others who contributed so well to *adobe.mag*—and taught me so much—are too numerous to mention.

I also wish to thank Shawna Mullen and Jeanine Caunt at Rockport Publishers for their unfailing patience, support, and expertise, to say nothing of their jokes. Editors rule! Special thanks to Anistatia Miller and Jared Brown for the act of generosity that made this book possible. Equally special thanks to Linda Miller, for her uncanny ability to say (and ask) the right things at the right time. Finally, this book would not have made it to print had not my husband, Barry Fishler, provided the unique support and understanding that only another writer can provide. He's the best editor I have, and only he knows how much that means.

Table of Contents

Introduction

If there is one thing this book ought to demonstrate, it is that designers are amazingly adaptable people. Over the past two decades, they have seen the implementation of the Apple Macintosh computer; the development of Adobe PostScript; the invention of Aldus (now Adobe) PageMaker, QuarkXPress, and other layout applications; the appearance of Adobe Photoshop and other image-editing programs; and the rise of multimedia and the Web.

During this period, the computerization of layout and typesetting drastically changed the service-bureau industry, threatening for a time to put it out of business entirely. Because layout programs made it possible for designers to control typesetting, they were suddenly expected to do so, and so their workload—and learning curve—suddenly increased. At the same time, the fact that "anybody" could do layout jeopardized, at least for a time, certain kinds of bread-and-butter business, such as newsletters. If the boss' assistant could do it, why pay a designer?

A new kind of business, multimedia, required developing skill in yet another class of programs, such as Macromedia Director, and yet another new way of thinking. The word *interface,* and all that it implied, made its appearance.

By the mid-nineties, designers were seeing still another new kind of business—Web design—sucked away by younger, cheaper workers who were often computer technicians without design skills. These "geeks" charged less to work in a medium where, despite explosive growth, the payoff for great design—or anything else, for that matter—wasn't very clear.

Also in the nineties, important but unglamorous venues for design quietly made their appearance: touch-screen kiosks in public places, intranets for corporate networks, and other forms of business communication that were mainly focused on making large amounts of information available through technical tools and streamlined presentations.

On the creative side, the film industry, along with high-end advertising endeavors, presented new opportunities for certain designers: those who had developed an interest in 3-D graphics, computer animation, and digital special effects.

Thus, although every industry in existence has been affected by computers, graphic design has changed almost completely. It's hard to imagine a greater contrast than that between the designer of the early eighties—surrounded by waxers and rubylith—and the designer of today, who has probably mastered several major design applications along with hardware hookup and troubleshooting.

How has the industry gotten to its current level of expertise? For the most part, by exhibiting extraordinary energy and initiative. Virtually every design shop in the world uses computers for prepress and typesetting, and most also use them for design. A tremendous number of conventionally trained

designers have developed expertise in computer applications, interface design, and even programming. They have educated themselves about technology on the fly so that they can educate—and market effectively to—potential customers. They have also welcomed into their ranks thousands of software-trained young people without resentment or resistance.

The design results have been remarkable, as will hopefully become obvious in the pages that follow. Although much that we see today is deliberately retro in style or heavily influenced by pioneering movements such as constructivism, much feels genuinely new. A fresh appreciation of organic shapes is notable, along with an expanding sense of space on paper and on screen. There is also a challenge to contain more than ever before—more stimulus, more objects, more possibilities—within a design, and this requires designers to balance entropy and energy with structure and form.

It is equally remarkable that all of this has taken place in a field where there seems to be no settled curriculum and in which, according to some who were conventionally trained, young designers are no longer even being taught design principles. To the extent that that is true, even more credit is due the transitional generation, which hires younger people and, in many cases, trains them as well.

If there is one change that is not for the better, it is what some designers call the "good enough" phenomenon. When all of life is speeded up and we become used to the poor resolution of images and type that we see on computer monitors and laser printer output, high quality in a final printed product no longer seems so important, at least to some clients. Many designers deplore this and mourn the loss of production quality as a routine measure of excellence.

Yet as we look to the future, it seems likely that quality will return at some point, because it will become attainable more quickly—and thus more affordably—than it is now. Technology keeps changing, and that will likely help print in the long run.

What will not change is that, having become linked to new technology, design will stay linked. And that, in turn, may make it increasingly difficult to say exactly what a designer actually is. In fact, perhaps the greatest challenge of all will be for designers to explain what they do—that is, how they see and how they think—in a way that makes sense whether the context is print, multimedia, the Web, 3-D environments, computer animation, or the new kinds of design that the future will undoubtedly bring.

Karen D. Fishler

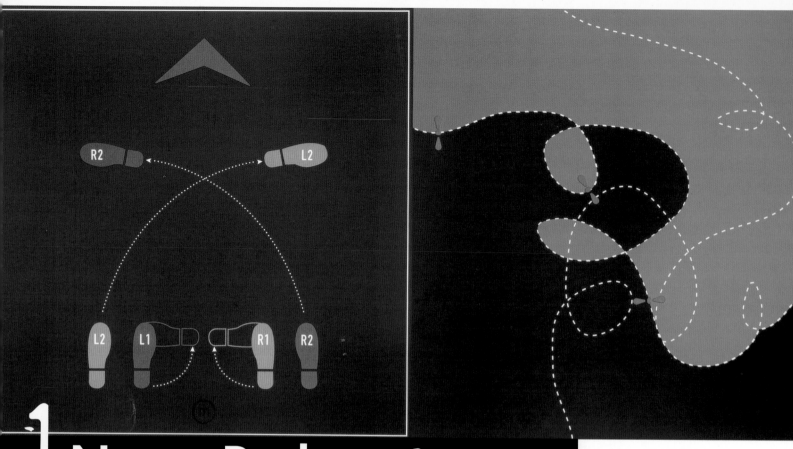

1 New Rules for the Design Process

Many designers currently in business didn't learn to design on computers. But most use them now; even if they don't literally sit at the keyboard themselves, they've hired assistants or associates who do.

The advent of the computer in the mid-eighties injected an element of speed—speed of doing business and speed of change—never seen before. On top of that, massive changes in the global business environment mean a new ability to reach audiences through direct mail and television.

These events create intense conditions for graphic designers. Work must now stake out terri-

tory in the new and demanding overlap between marketing and design; keep up with technology, not just with aesthetics; be appropriate for ever more venues as logos multiply around us; and in some cases even be suitable for execution by the client. The designers themselves must adapt to unfamiliar environments like the Web, where technology can dominate the design and the work process.

Also, the line between marketing, consulting, and design is starting to blur. Although some design firms have always positioned themselves as providers of strategic business advice, being asked (and even required) to provide that kind of advice

is becoming more common. For many client companies, design is, quite literally, a business problem. A retailer out of touch with the marketplace has a problem that simply has to be solved: the company must connect with its customers, or all other efforts are wasted. For an increasing number of image-savvy corporate marketing directors, an outside design firm can help a company rediscover who it is and what it's doing.

Along with the increasing value of image in a world in which everything has at least a face, and often an interface as well, designers have discovered the pressures and opportunities of "keeping up" with technology. Like a host of other businesses, design firms must frequently upgrade their computers and familiarize themselves with the digital technologies in which their young audiences are fluent.

And, as clients grow attuned to what computers can do in their own businesses, they become more demanding of designers' computers. It is nearly impossible now to go into a presentation with roughs: presentation materials must be much closer to "real" (and the development work nearly done), so that when the client makes a selection the effort can shift to execution. Where once there were design comps, there are now layout files printed in color. This reality—a result of fevered reorientation around computers—means designers have to do more (and faster) work up front to keep up with their clients.

Today's many marketing venues also impose new technology-related challenges on designers. Will a logo appear only in print, or might it show up on the client's Web site? If the latter is even a possibility, a good designer will locate corporate colors that translate to the limited palettes of the Internet.

For designers working on a Web site or a multimedia project, the rules have changed, too. In a world where everything connects with everything, issues of navigation have become editorial and marketing questions.

Is all of this enough? Apparently not. New layout programs don't just make for faster work and better production control—they make it possible for assistants to produce company newsletters and corporate design departments to create company collateral themselves. Thus, many designers take on the role of consultant, creating a design system for clients to use under their ongoing guidance. The ability and willingness to educate clients in this way is just one more responsibility designers did not have ten years ago.

It may seem as if design is sinking under the weight of all these technology-induced pressures, but the reality is just the opposite. If anything, new challenges in the business environment heighten both the importance of design and its potential.

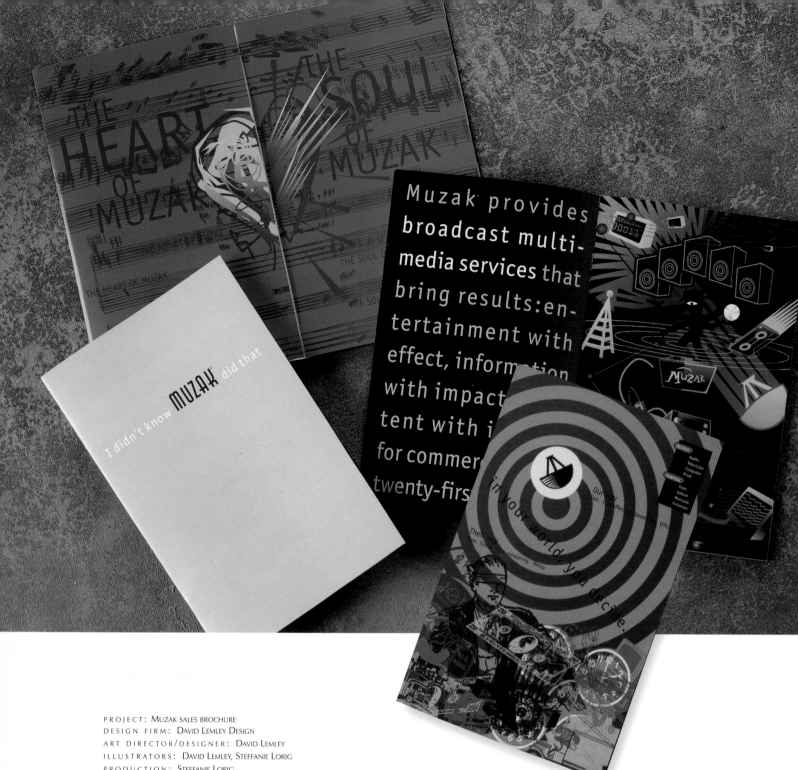

PROJECT: MUZAK SALES BROCHURE
DESIGN FIRM: DAVID LEMLEY DESIGN
ART DIRECTOR/DESIGNER: DAVID LEMLEY
ILLUSTRATORS: DAVID LEMLEY, STEFFANIE LORIG
PRODUCTION: STEFFANIE LORIG
CLIENT: MUZAK

For Muzak, overall corporate image was a problem. Although eighty percent of its business involves doing other things, the company had the image of elevator-music supplier. As in so many cases in the nineties, design turned out to be the answer.

The company initially asked David Lemley Design for a sales brochure; they wound up asking the firm to help reposition itself as the technology company it is. Like many design firms, David Lemley Design has become more and more of an advisor to clients over the last several years. Lemley developed a capabilities marketing brochure, hip and complex, full of intense color, featuring words on many layers and technology-related images. It was all delivered in a customer-focused, nineties, new-yet-retro way. Although completed in early 1996, the brochure is still being used.

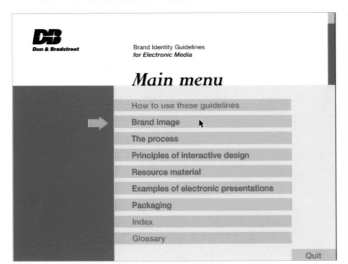

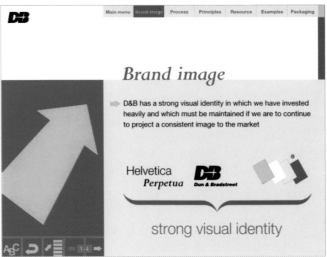

PROJECT: DUN & BRADSTREET BRAND IDENTITY GUIDELINES FOR ELECTRONIC MEDIA CD-ROM
DESIGN FIRM: SAMPSON TYRRELL ENTERPRISE
ART DIRECTOR: PIP LLEWELLIN
DESIGNERS: PAUL MYNARD, BEN TOMLINSON
CLIENT: DUN & BRADSTREET LIMITED

Increasingly, designers are called upon not just to manage branding and identity for their clients, but to make sure their clients can continue the job. Last year Dun & Bradstreet asked Sampson Tyrrell Enterprise to help it adapt a visual identity system—designed primarily for print— for onscreen use.

The resulting CD-ROM targets Dun & Bradstreet marketing employees and the vendors they work with. It shows staff how to reinforce an already-strong identity across digital media, a task that is more and more the purview of internal marketers. Deep and detailed, the CD-ROM serves as both a tutorial and a library of resource materials. It also contains examples of successful Dun & Bradstreet electronic product demonstrations.

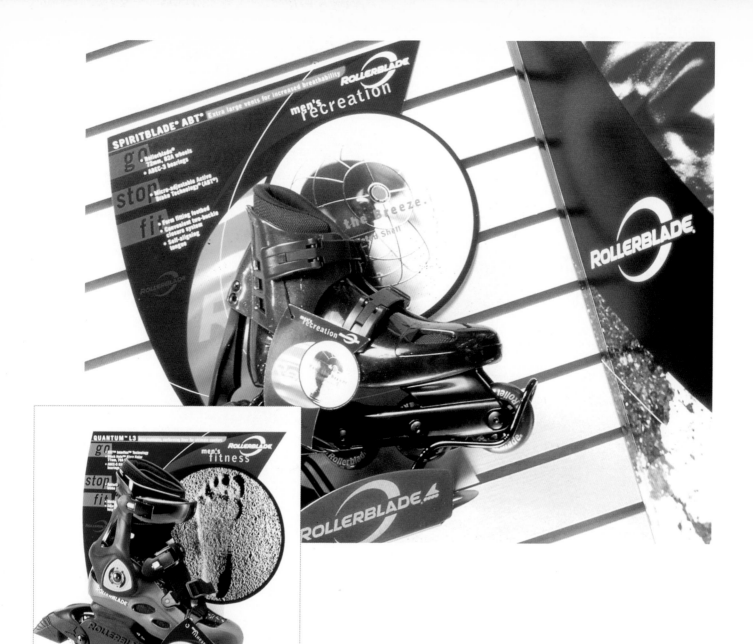

PROJECT: ROLLERBLADE RETAIL PROGRAM
DESIGN FIRM: DESGRIPPES GOBÉ & ASSOCIATES
DESIGN DIRECTOR: LORI YI
SENIOR DESIGNERS: THOMAS DAVIDSON, JOY LIU
JUNIOR DESIGNER: PEGGY WONG
CLIENT: ROLLERBLADE

Desgrippes Gobé & Associates encounters numerous situations in which a redesigned image solves a client's business problem—such was the case with Rollerblade, which created the inline skating industry but had seen its brand name become generic. Last year, the firm created this program of retail-display items to reposition Rollerblade as the market leader.

Great attention was paid to the attributes of each color, because Rollerblade needed to "speak" to a number of consumer segments within the inline skating category. The dark blue, for example, was sporty yet authoritative, while the vibrant orange exuded movement. The designers created curved backing cards to "activate" the logo around and behind the skates; signs for either side of the skates allowed Rollerblade to visually mark out retail "territory."

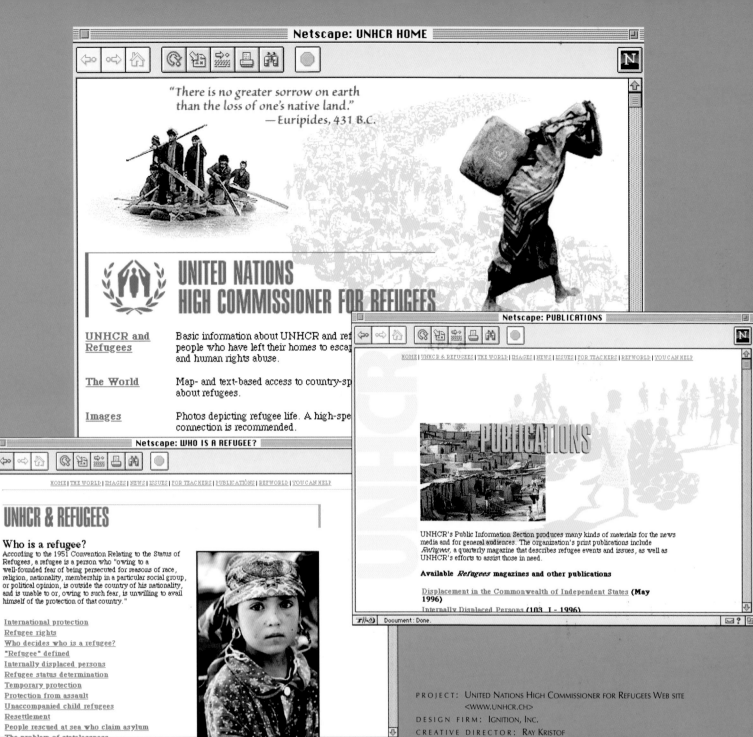

PROJECT: UNITED NATIONS HIGH COMMISSIONER FOR REFUGEES WEB SITE
 <WWW.UNHCR.CH>
DESIGN FIRM: IGNITION, INC.
CREATIVE DIRECTOR: RAY KRISTOF
INFORMATION DESIGNER AND PROJECT DIRECTOR: AMY SATRAN
PHOTOS: UNITED NATIONS HIGH COMMISSIONER FOR REFUGEES PHOTO ARCHIVE
CLIENT: UNITED NATIONS HIGH COMMISSIONER FOR REFUGEES

Ignition took on a major challenge with this Web site for an agency of the United Nations. The designers were charged with using images to communicate information about refugees—without being sensationalistic—and including a massive information database.

The client also told them they had to design for the lowest common denominator in terms of computer hardware, browser capability, and modem speed, so that the information would be widely available. Satran selected images that work well in silhouette, as duotones, and in posterized palettes for low-bandwidth viewers. The designers also created text-based parallel pages for browsers with no graphics capability. And to keep download times minimal, they went to extraordinary lengths to keep image file sizes small.

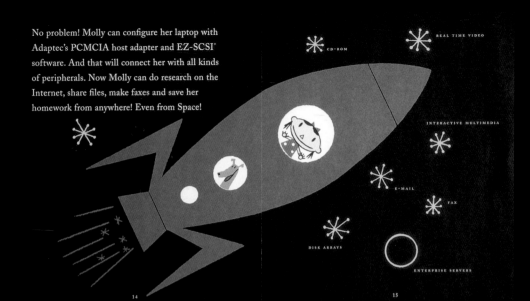

No problem! Molly can configure her laptop with Adaptec's PCMCIA host adapter and EZ-SCSI® software. And that will connect her with all kinds of peripherals. Now Molly can do research on the Internet, share files, make faxes and save her homework from anywhere! Even from Space!

CD-ROM

REAL TIME VIDEO

INTERACTIVE MULTIMEDIA

E-MAIL

FAX

DISK ARRAYS

ENTERPRISE SERVERS

14

15

ABC&D

All About
Being Connected
to Data

But Data, being a smarter than average dog, uses Adaptec PCI-UltraSCSI multichannel host adapters and high performance network interface cards to beat the bandwidth bottleneck.

Data whizzes down the hill at lightning speed! Data is playing with the gang before Wally even realizes it.

Wow!

PROJECT: ADAPTEC, INCORPORATED 1996 ANNUAL REPORT
DESIGN FIRM: CAHAN & ASSOCIATES
ART DIRECTOR: BILL CAHAN
DESIGNER: KEVIN ROBERSON
ILLUSTRATOR: RICHARD MCGUIRE
COPYWRITERS: LINDSAY BEAMAN, KEVIN ROBERSON
CLIENT: ADAPTEC, INCORPORATED

Cahan & Associates' breakthrough annual reports show how profoundly designers can change the perception of businesses—and how much design business has emerged from the high-tech industry. This report for Adaptec, Incorporated had a special mission: to make it crystal-clear that, in addition to making so-called SCSI devices, the company creates technology to move digital data.

Cahan and his team made the assignment fun with a children's-book motif that explained in "See Jane run" language how Adaptec's products benefit customers. They included portraits of the chairman of the board and the president/CEO, but in the same "kid" style used in the three opening "chapters." The irony of using such an old-fashioned approach for a high-tech client, says the designer, did not escape him.

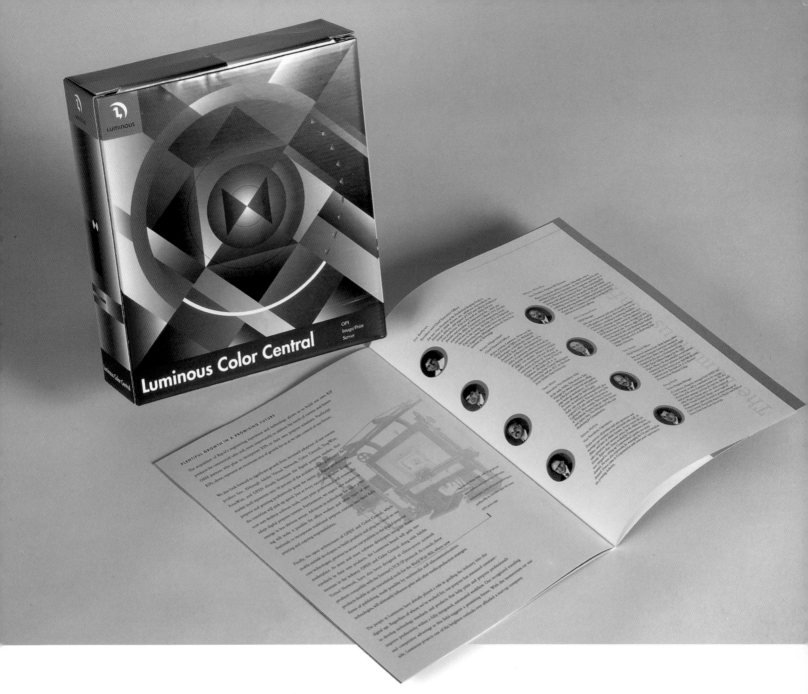

PROJECT: LUMINOUS IDENTITY AND MARKETING APPLICATIONS
DESIGN FIRM: DIETZ DESIGN CO.
ART DIRECTOR/DESIGNER: ROBERT DIETZ
ILLUSTRATORS: JIM FRISINO (ONSCREEN ADS), ROBERT DIETZ (PRODUCT BOXES)
CLIENT: LUMINOUS TECHNOLOGY CORPORATION

In an era of marketing that includes Web sites, devising a corporate identity can call for technical savvy. Luminous Technology Corporation, a prepress software company, asked Dietz to help develop its identity even before its 1995 spin-off from Adobe Systems Incorporated.

Dietz created a logo, logotype, and stationery system, as well as trade-show signs and product boxes. The nature of Luminous's business also meant doing work intended solely for the computer monitor: ónscreen ads that run during program installations, splash screens that run during application startups, application-specific icons for the company's Web site, and numerous icons for dialog boxes tied to individual operations within the applications. Dietz created all onscreen materials at the Web's 72-dpi resolution, and all colors were chosen to be Web-safe.

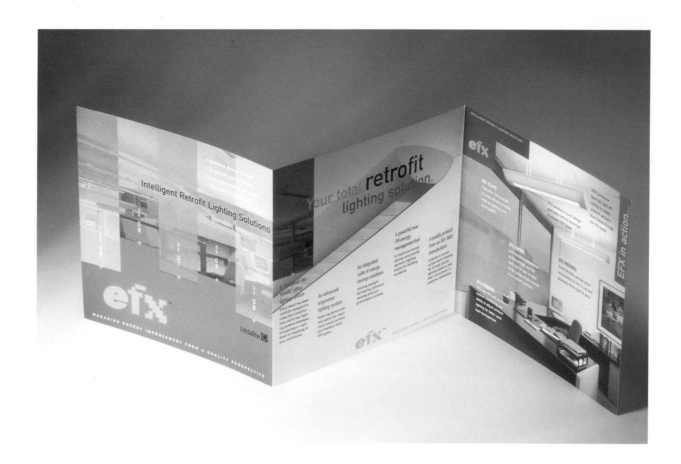

PROJECT: LEDALITE EFX PRODUCT BROCHURE
DESIGN FIRM: BAU WOW DESIGN GROUP
CREATIVE DIRECTORS: DANIELA WOOD, YVES ROUSELLE
DESIGNERS: DANIELA WOOD, NORRIE MATTHEWS
PHOTOS: JOHN SINAL
CLIENT: LEDALITE ARCHITECTURAL PRODUCTS LTD

Redefinition and repositioning were the goals when Ledalite Architectural Products Ltd., approached the Bau Wow Design Group for a brochure and booth design. A British Columbia manufacturer of light fixtures for large customers such as transit systems and airports, Ledalite wanted to showcase the company's new technology for retrofitting systems—and make it better known for its high-quality engineering.

The resulting brochure's grid structure conveys the company's engineering-driven perspective and attention to detail. The piece is softened, however, by duotones in the photos and by a warm silver that makes the company more approachable. The booth consisted mostly of digital printouts laminated onto hard, thin plastic boards, fastened in turn to a metal frame.

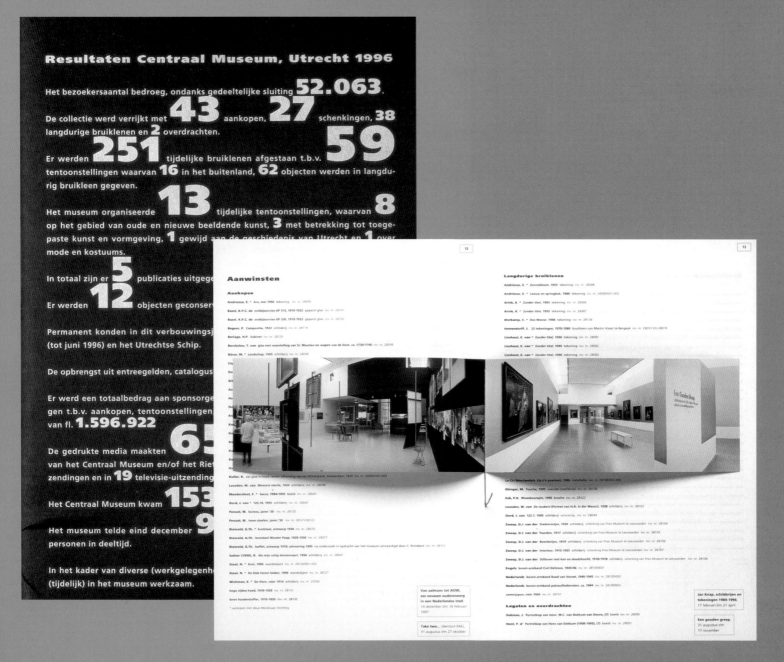

PROJECT: CENTRAAL MUSEUM 1996 ANNUAL REPORT
DESIGN FIRM: WILD PLAKKEN
DESIGNER: LIES ROS
PHOTOS: ERNST MORITZ, JASPER WIEDEMAN, HANS WILSCHUT
CLIENT: CENTRAAL MUSEUM, UTRECHT

This charming annual report for a Netherlands museum shows how designers can successfully use a potentially strange approach.

To keep costs down and the focus on the color pages that showed the museum's exhibits, designer Lies Ros printed the usual annual returns on the front cover, using silver ink on black paper. She set the numbers in larger sizes, treating them as huge successes—a slightly tongue-in-cheek approach the client appreciated. The full-color pages (in three sizes) printed separately from the text, and the pieces were later hand-bound with red string, saddle-style. A short print run made this binding process possible.

PROJECT: ALTA BEVERAGE WATER BOTTLE PACKAGING
DESIGN FIRM: HORNALL ANDERSON
 DESIGN WORKS, INC.
ART DIRECTOR: JACK ANDERSON
DESIGNER: JACK ANDERSON, LARRY ANDERSON,
 JULIE KEENAN
ILLUSTRATOR: DAVE JULIAN
CLIENT: ALTA BEVERAGE COMPANY

As once-new categories become more competitive, design firms must identify ever more insightful ways of differentiating their clients' products. Hornall Anderson did just that for this 1996 packaging project for a new bottled spring water. The designers captured a regional feeling when they emphasized the Canadian mountains, the water's source.

Although Times Roman was the face used for the company (and product) name, a brush-like stroke on the right-hand slope of each "A" suggested snow-covered mountain faces. The ice-blue "glow" around the name reinforces the theme. A circular swirl below the name hints at a whirlpool, or perhaps whirling snow. Finally, the proprietary bottle shape includes a ripple design, reminiscent of flowing water.

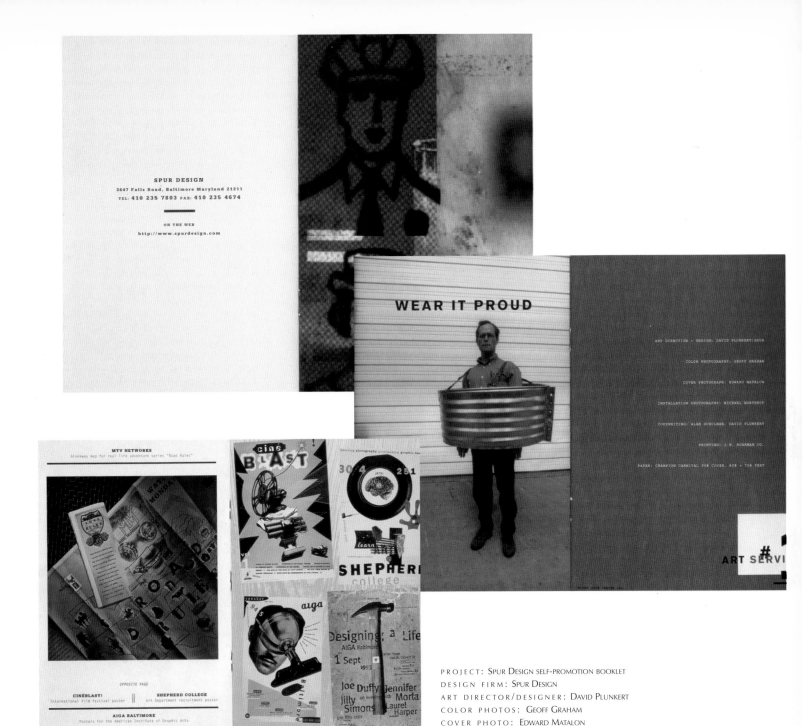

SPUR DESIGN
3647 Falls Road, Baltimore Maryland 21211
TEL: 410 235 7803 FAX: 410 235 4674

ON THE WEB
http://www.spurdesign.com

WEAR IT PROUD

ART DIRECTION + DESIGN: DAVID PLUNKERT/SPUR

COLOR PHOTOGRAPHY: GEOFF GRAHAM

COVER PHOTOGRAPH: EDWARD MATALON

INSTALLATION PHOTOGRAPHY: MICHAEL NORTHRUP

COPYWRITING: ALAN SCHULMAN, DAVID PLUNKERT

PRINTING: J.W. BOARMAN CO.

PAPER: CHAMPION CARNIVAL 80# COVER, 80# + 70# TEXT

ART SERVI

MTV NETWORKS
Glyceway map for real-life adventure series "Road Rules"

OPPOSITE PAGE

CINÉBLAST! SHEPHERD COLLEGE
International film festival poster Art Department recruitment poster

AIGA BALTIMORE
Posters for the American Institute of Graphic Arts

PROJECT: SPUR DESIGN SELF-PROMOTION BOOKLET
DESIGN FIRM: SPUR DESIGN
ART DIRECTOR/DESIGNER: DAVID PLUNKERT
COLOR PHOTOS: GEOFF GRAHAM
COVER PHOTO: EDWARD MATALON
INSTALLATION PHOTOGRAPHY: MICHAEL NORTHRUP
COPYWRITERS: ALAN SCHULMAN, DAVID PLUNKERT
CLIENT: SPUR DESIGN

You might expect a design firm that uses computers extensively to produce slick, computerized-looking promotional materials, but sometimes it's more effective to try something else. In 1996, after designers and illustrators Joyce Hesselberth and David Plunkert joined forces to found Baltimore's Spur Design, they created this double-sided book, the firm's first major self-promotion piece.

In choosing the words "art serving industry," says Plunkert, he kept in mind the need to ground the firm's fresh, sometimes funky-looking and rather computer-dependent illustrations in something business could relate to. To create a texture that would be interesting to hold, he used three different stocks, and designed pages with one, two, three, and four colors in order to show the firm's ability to handle color.

PROJECT: GUINNESS DRAUGHT PACKAGING AND LOGO
DESIGN FIRM: PRIMO ANGELI INC.
CREATIVE DIRECTORS: PRIMO ANGELI,
 CARLO PAGODA
ART DIRECTOR: CARLO PAGODA
DESIGNERS: PHILIPPE BECKER, SANDRA RUSSELL,
 COCO QIU
TYPOGRAPHER: ANTON KIMBALL
CLIENT: GUINNESS IRELAND GROUP

This project illustrates the dangers of a shifting marketplace to even well-established businesses, and how design has become central to their ability to thrive. Primo Angeli Inc. was asked to help Guinness address a market that was growing younger and saw the renowned beer-maker as old-fashioned. The result, introduced last year, is a textbook example of design as a business tool.

Keeping certain elements of existing "brand equity"—the harp symbol, the brewer's signature, and the familiar black, gold, red, and white colors—the designers added a fifth color, a dark gray, for a new, background "textural" version of the traditional Guinness harp. They also slimmed down the letters in the name "Guinness" for a more contemporary look.

without a strategy you're dead mate

PROJECT: Text 100 annual report (print and Web versions)
<www.text100.com/annualreport1997>
DESIGN FIRM: Dietz Design Co.
ART DIRECTOR: Robert Dietz
DESIGNERS: Robert Dietz, Denise Heckman
ILLUSTRATOR: Doug Herman
COPYWRITERS: Text 100, Robert Dietz
PHOTOS: Keith Brofsky
CLIENT: Text 100 Group PLC

With this annual report for a British-based international public relations consulting firm whose primary market comprises the high-tech sector, designer Robert Dietz aimed for the closest possible relationship between the print and online versions, both of which he designed.

He proportioned the printed pages horizontally, mimicking the dimensions of a monitor. In addition, he designed tab headings in the lower-case lettering seen in the "location" field of a Web browser. A photographer snapped section-opener photographs from browser windows in which scanned images were displayed; then the photographs were produced via Hexachrome printing, which can mimic the red-green-blue color space of the monitor. The Web site was meant to seem very much an electronic version of similar information, but the navigation elements allowed non-linear access.

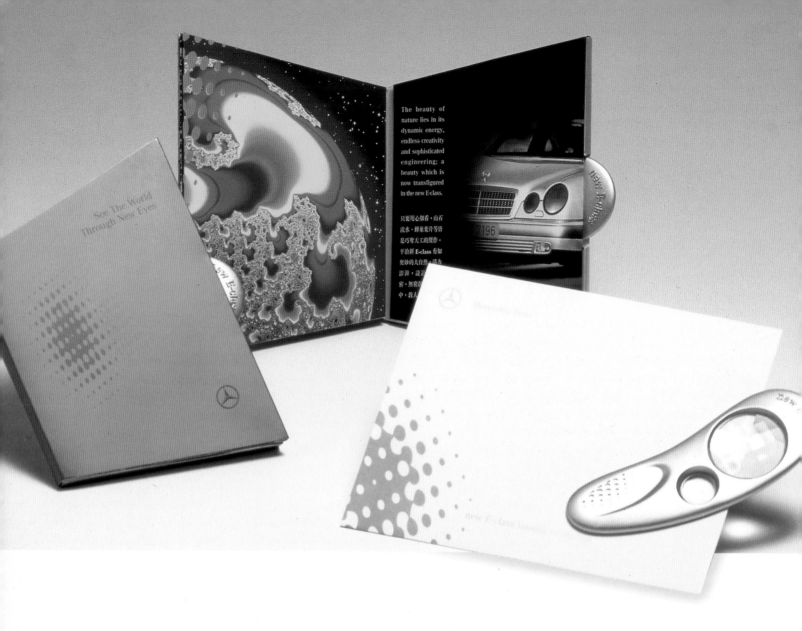

The beauty of nature lies in its dynamic energy, endless creativity and sophisticated engineering; a beauty which is now transfigured in the new E-class.

只要用心細看，山石流水，蜂巢葉片等皆是巧奪天工的傑作。平治新 E-class 有如奧妙的大自然，活力澎湃，設計精密，無窮無盡中，教人嘆為觀止。

PROJECT: "SEE THE WORLD THROUGH NEW EYES" MERCEDES-BENZ INVITATION BROCHURE
DESIGN FIRM: BURSON-MARSTELLER
ART DIRECTOR: GRACE KAO
DESIGNER: KEITH LEE
CLIENT: ZUNG FU COMPANY LIMITED

Designers worldwide create marketing materials that work for their local markets, yet they use the same tools and find inspiration in similar places. This invitation, in the form of a brochure, marked the introduction of the Mercedes-Benz E-class automobile to the Hong Kong market at a Mercedes show last year. It drew a parallel between the sophistication of nature's designs and the sophistication of the new E-class design.

Searching for ideas of expanded vision, the designers came across the hand-held kaleidoscopic "lens" on a shopping trip, and had a similar one locally manufactured with a special handle—then enclosed one with each copy of this trapezoidal brochure with its interior accordion fold. Photographs of nature were overlaid with a stylized grid from an E-class headlight; the special lens was tucked into a slot in the back.

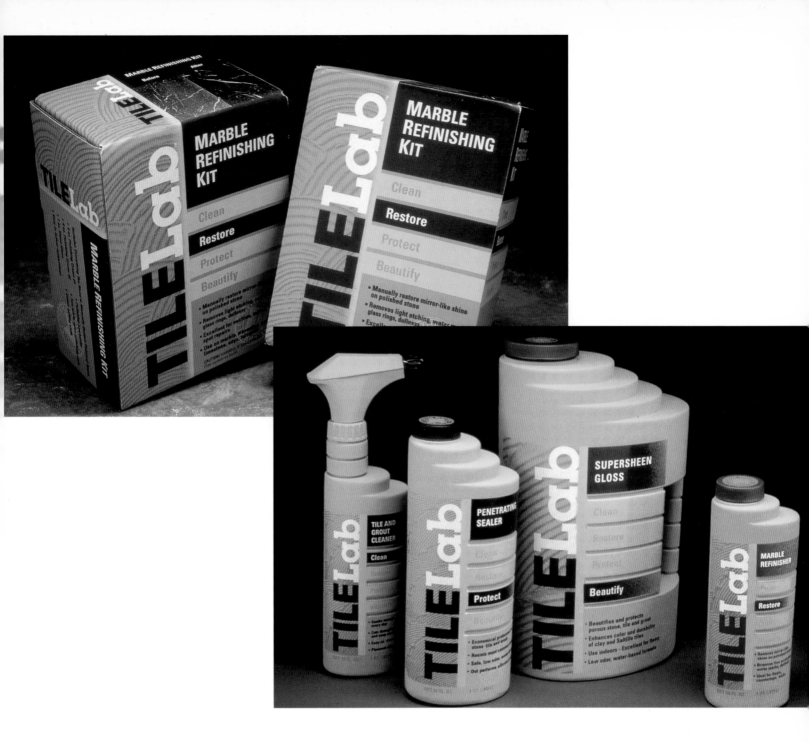

PROJECT: TILELAB BRANDING AND IDENTITY PROGRAM
DESIGN FIRM: HORNALL ANDERSON DESIGN WORKS, INC.
ART DIRECTOR: JACK ANDERSON
DESIGNERS: JACK ANDERSON, LISA CERVENY, BRUCE BRANSON-MEYER, ALAN FLORSHEIM
CLIENT: CUSTOM BUILDING PRODUCTS

When Custom Building reformulated an existing line of tile and stone care products in 1997, they asked Hornall Anderson to help differentiate a resulting sub-brand called TileLab. The designers devised a proprietary bottle shape suggesting geometric patterns in tile and stone, as well as the "steps" needed to care for such materials.

Color coding on the bottles helps the customer identify each product. Finally, the typography and grid system are strong and clear, giving the whole product line a clean, geometrical feel. Because of these qualities, the highly visible color scheme, and the busy look of competing products, the reformulated line stood out with unusual clarity—a very successful example of design triumphing over potential business obstacles.

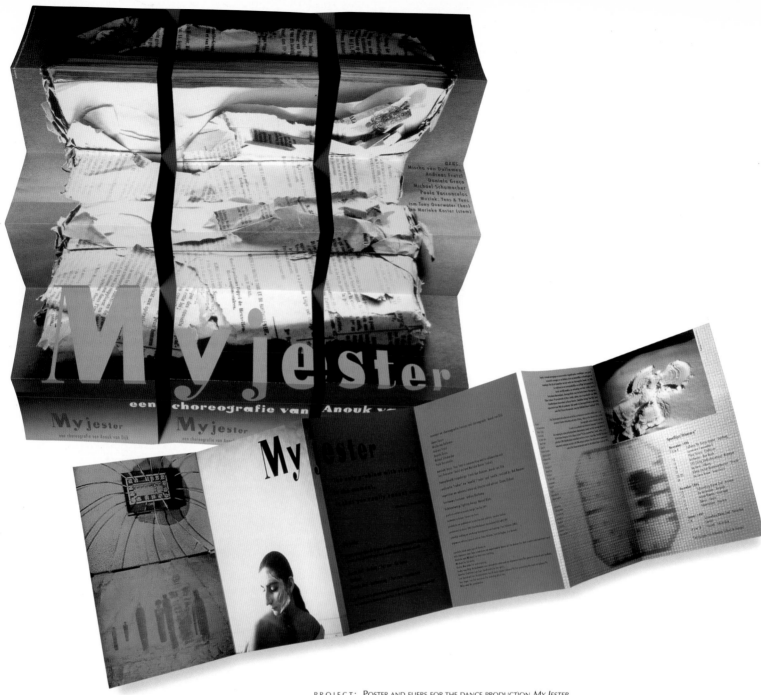

PROJECT: POSTER AND FLIERS FOR THE DANCE PRODUCTION *MY JESTER*
DESIGN FIRM: WILD PLAKKEN
DESIGNER: LIES ROS
PHOTOS: JANINE HUIZENGA, LIES ROS
CLIENT: DANS WERKPLAATS AMSTERDAM

Creating effective communications pieces for cultural groups demands an artistic mind combined with a production manager's parsimony; fortunately, computers make this a little easier.

Asked to develop a piece that connected with the subject of the dance (memory and how it works), designer Lies Ros used a package of old newspapers in different languages on the front of the poster. Because the budget for the project was small, she had the flier, with its evocative images and credit and calendar information in Dutch and English, printed three times lengthwise on the back of the poster. The poster was then cut to yield three fliers per poster.

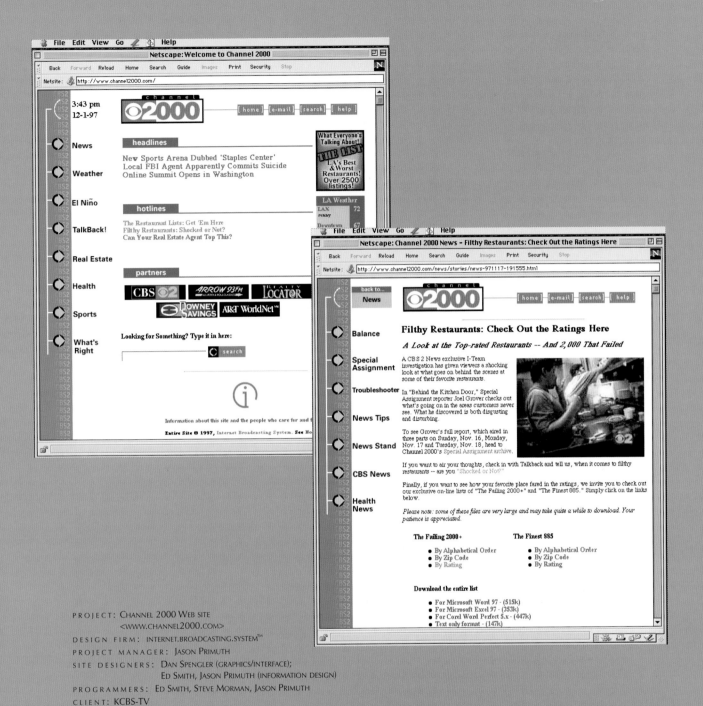

PROJECT: CHANNEL 2000 WEB SITE
<WWW.CHANNEL2000.COM>
DESIGN FIRM: INTERNET.BROADCASTING.SYSTEM™
PROJECT MANAGER: JASON PRIMUTH
SITE DESIGNERS: DAN SPENGLER (GRAPHICS/INTERFACE);
ED SMITH, JASON PRIMUTH (INFORMATION DESIGN)
PROGRAMMERS: ED SMITH, STEVE MORMAN, JASON PRIMUTH
CLIENT: KCBS-TV

This Web site for a Los Angeles, California television station—developed by a Minnesota company—illustrates how deep the Web-design business has become in just a few short years. Although the design firm has a varied client base, one of its strengths is creating complex sites for television stations, such as this one for a CBS affiliate.

The project includes local stories with a lot of "back" information that can't easily be broadcast on the air, such as the lists of restaurants rated for their cleanliness by an investigative team, noted on the screen on the right. Also part of the site are video and audio clips, and interactive elements like online chats, surveys, and e-mail contacts.

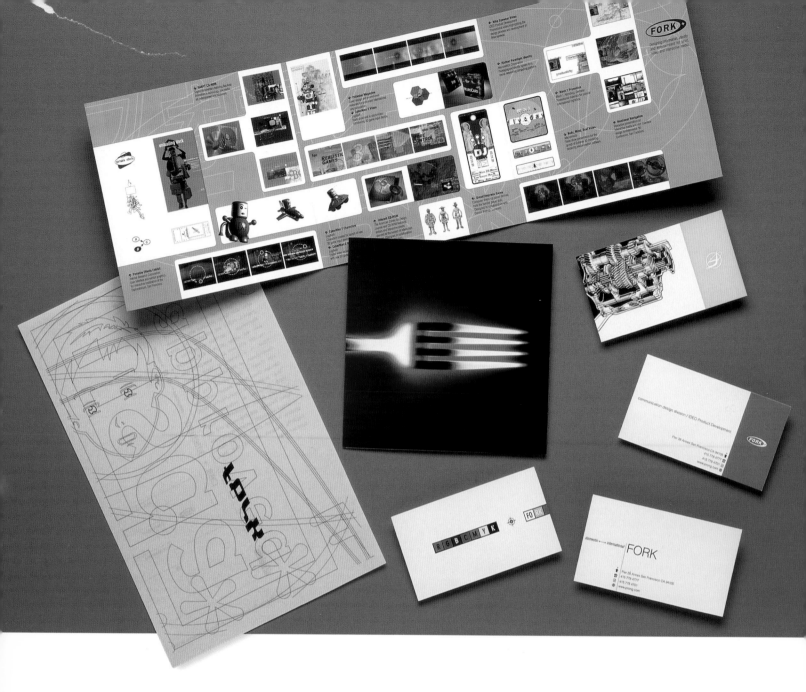

PROJECT: FORK GRAPHIC IDENTITY
DESIGN FIRM: FORK, A DIVISION OF IDEO PRODUCT DEVELOPMENT
DESIGNERS: PETER SPREENBERG, SAMUEL LISING, DENNIS POON
CLIENT: FORK, A DIVISION OF IDEO PRODUCT DEVELOPMENT

IDEO, a product design firm with strong roots in the high-tech field, last year created Fork, a new division formed for print, video, and interactive communication design. The identity for the new division illustrates that a single logo is no longer the only way to go.

Four different business cards display three styles for the word "Fork," and a capital "F" logo-mark as well. A translucent insert sheet explains the company's history and purpose; it carries three different logo styles. A three-panel brochure carries three styles that appear elsewhere . . . and a fourth that isn't seen on the other pieces. Confusing? Not really; the market for Fork's services understands change and might find a traditional identity boring.

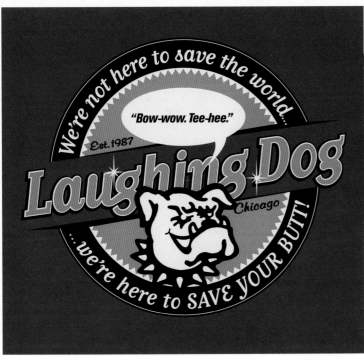

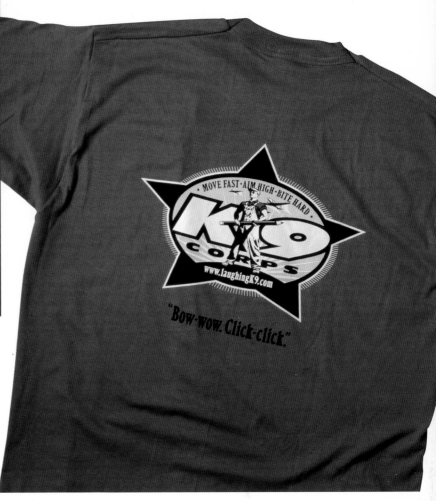

LAUGHING DOG CREATIVE, INC.

PROJECT: LAUGHING DOG CREATIVE LOGOS
DESIGN FIRM: LAUGHING DOG CREATIVE, INC.
DESIGNERS: FRANK EE GRUBICH ("SAVE YOUR BUTT!" AND "K9 CORPS");
FRANK EE GRUBICH AND PAUL GRACIAN ("DIGITAL DOG")
ILLUSTRATION: CSA ARCHIVES ("K9 CORPS"; MODIFIED FROM ORIGINAL)
CLIENT: LAUGHING DOG CREATIVE, INC.

These projects from Laughing Dog Creative show another example of logo multiplication. An established firm increasingly involved in interactive design, Laughing Dog also has a sense of humor.

The logo at top left, dating from 1996, was an expertly crafted retro-style emblem with a comical tag line, used for the promotional T-shirts the company produces every year. The "Digital Dog" logo at lower right, also from 1996, aims at repositioning the firm to reflect its growth into electronic media; this mark, shorn of the radiating spokes, made it onto the firm's business cards, which repeat the winking dog until the card looks like a circuit board. Yet a third logo, another T-shirt emblem, was done in 1997.

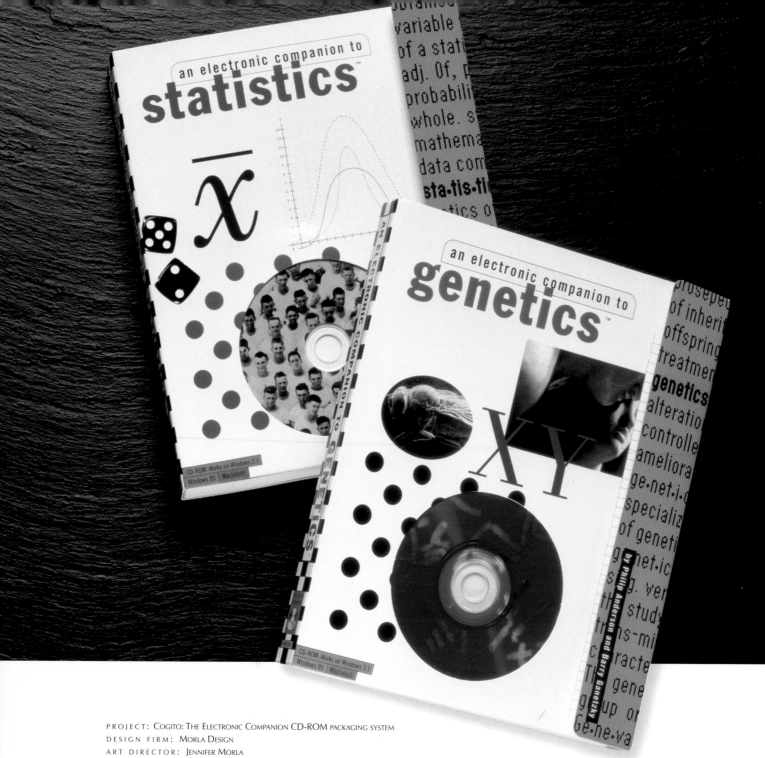

PROJECT: COGITO: THE ELECTRONIC COMPANION CD-ROM PACKAGING SYSTEM
DESIGN FIRM: MORLA DESIGN
ART DIRECTOR: JENNIFER MORLA
DESIGNERS: JENNIFER MORLA, ANNE CULBERTSON
CLIENT: COGITO LEARNING MEDIA

This 1996–97 project by Morla Design illustrates some of the extra wrinkles that designers work with in the nineties. The Cogito "Electronic Companion" series is a set of CD-ROMs devoted to science-related subjects on a college level.

The products needed to pop off the shelves in bookstores already over-loaded with software packaging and book covers. They also had to appeal to students in a way that respected their intelligence yet got their attention. And the design criteria dictated that the concept be applicable to future titles to be produced by Cogito's editorial staff. The compartmentalized layout allows new images to be substituted easily. Each "slot" thus has its own type of image pre-assigned—technical, conceptual, or typographic.

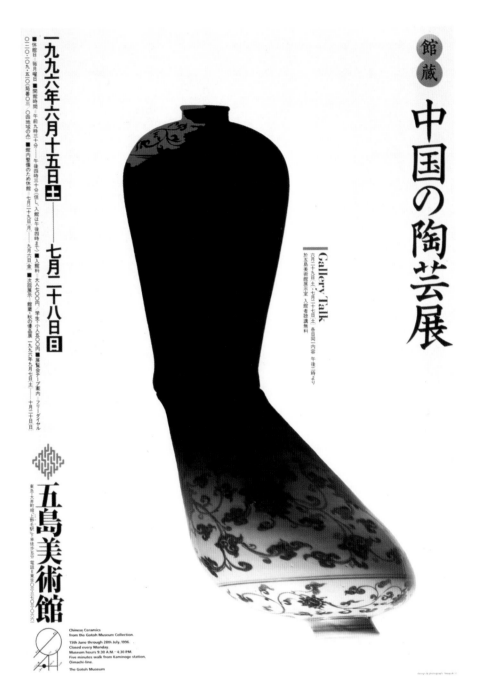

PROJECT: POSTER FOR CHINESE CERAMICS FROM THE
GOTOH MUSEUM COLLECTION EXHIBITION
DESIGN FIRM: UNO, YASUYUKI DESIGN STUDIO INC.
DESIGNER: YASUYUKI UNO
CLIENT: THE GOTOH MUSEUM

Computer-based design is blamed for a great deal of work that shows off digital effects rather than an evolved design sensibility. Yet well-trained designers can use computers to create elegant, even eerie effects. The client for this 1996 poster wanted the event, a ceramics exhibition, to appeal to the general public, not just ceramics aficionados.

Uno made a water pot from the collection into a silhouette, with just a hint of the original surface design rendered in reverse: black on blue. Then he inserted a photo of the real pot, with its correct blue-on-white design in evidence, as a shadow of the silhouetted version. The effect tricks the observer, just for a moment, into thinking of pottery slightly differently.

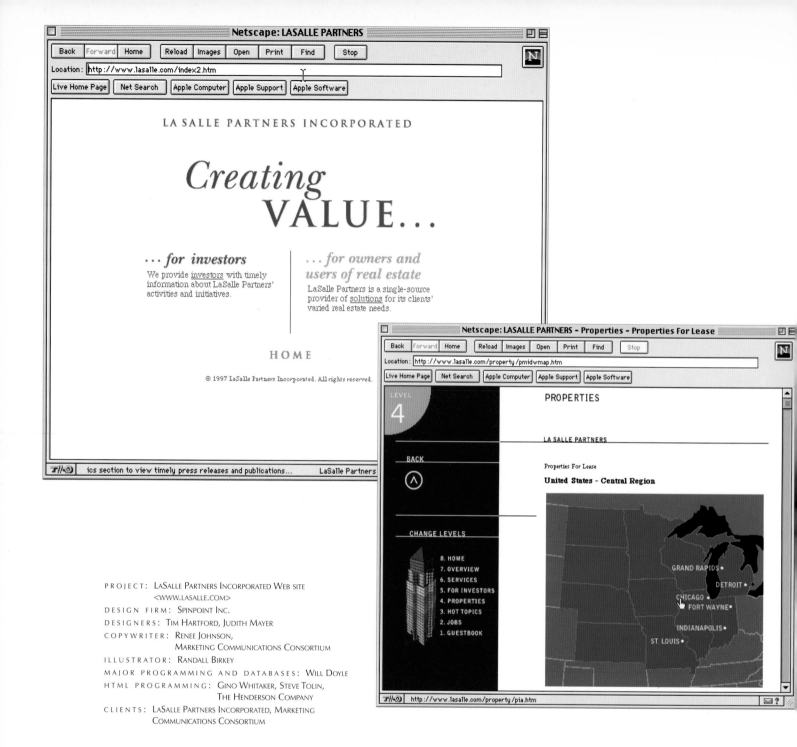

PROJECT: LaSalle Partners Incorporated Web site
<www.lasalle.com>
DESIGN FIRM: Spinpoint Inc.
DESIGNERS: Tim Hartford, Judith Mayer
COPYWRITER: Renee Johnson,
Marketing Communications Consortium
ILLUSTRATOR: Randall Birkey
MAJOR PROGRAMMING AND DATABASES: Will Doyle
HTML PROGRAMMING: Gino Whitaker, Steve Tolin,
The Henderson Company
CLIENTS: LaSalle Partners Incorporated, Marketing
Communications Consortium

This 1997 Web site for an international commercial real-estate management, investment, and consulting company is an additional example of how much businesses need designers who have technological capability or can create virtual "teams."

La Salle, a firm that manages and consults on properties in the United States, Mexico, Europe, and Asia, has a conservative, professional demeanor. Thus a flashy, youth-oriented site wasn't appropriate. Hartford and Mayer of Spinpoint—the technology-oriented spinoff of Hartford Design, Inc.—devised a classical-looking, type-based image. Then they used the metaphor of an office building as the guiding concept for the site; each floor is a different "section." Viewers can also use a search engine to locate properties for sale in either the U.S. or Mexico.

PROJECT: PLATINUM DESIGN PROMOTIONAL BROCHURE
DESIGN FIRM: PLATINUM DESIGN
ART DIRECTOR/DESIGNER: KATHLEEN PHELPS
PHOTOS: PAUL LACHENAUER
CLIENT: PLATINUM DESIGN

The essence of simplicity, this promotional brochure conveys a powerful and carefully crafted message to the potential corporate client: the designers understand businesses' marketing needs.

Understated photography appears consistently on right-hand pages, with the project noted on the outer edge. Bold headlines lay out the business strategy behind the design decisions made for each project, and the client appears on the left. The copy explains in detail why each significant design decision was made. While many marketers have a heightened appreciation of design in the contemporary business climate, clients who aren't so experienced can't help but note the connection between business objectives and the design process—an important advantage for a design firm with a corporate clientele.

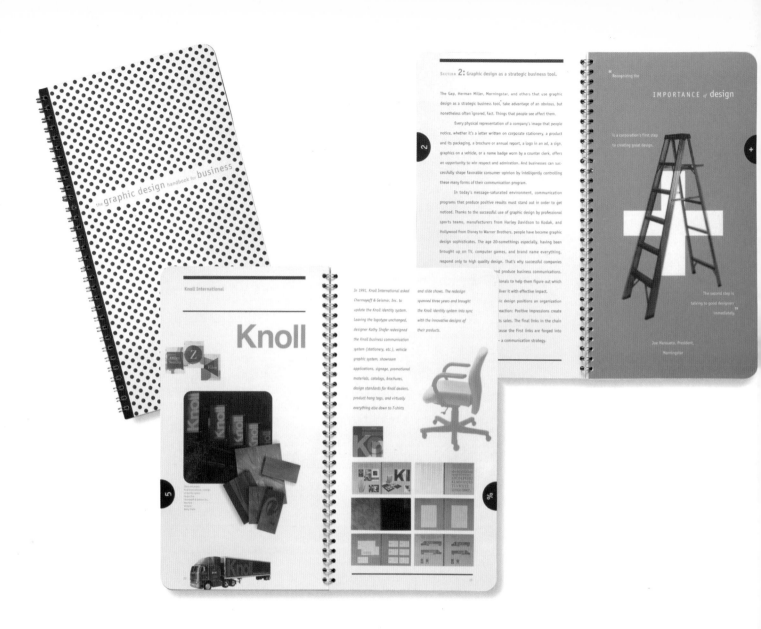

PROJECT: *THE GRAPHIC DESIGN HANDBOOK FOR BUSINESS*
DESIGN FIRM: HARTFORD DESIGN, INC.
DESIGNER: TIM HARTFORD
COPYWRITER: CHUCK CARLSON
PHOTOS: KIPLING SWEHLA
CLIENT: AMERICAN INSTITUTE OF GRAPHIC ARTS/CHICAGO CHAPTER

The nineties have seen a better understanding of design in the business community. Yet there remain business leaders who don't understand design's power to help them.

Hartford produced this handbook for AIGA's Chicago chapter in 1996. It served as both a membership benefit and an education tool for members' clients; member designers could give it to companies who wanted to maximize the effectiveness of graphic design in order to reach business goals. It featured topics like "Graphic Design as a Business Tool," "How to Work with a Graphic Designer," and "How to Measure Success." Quotes by business leaders are sprinkled throughout, and there are case studies that bring the idea to life.

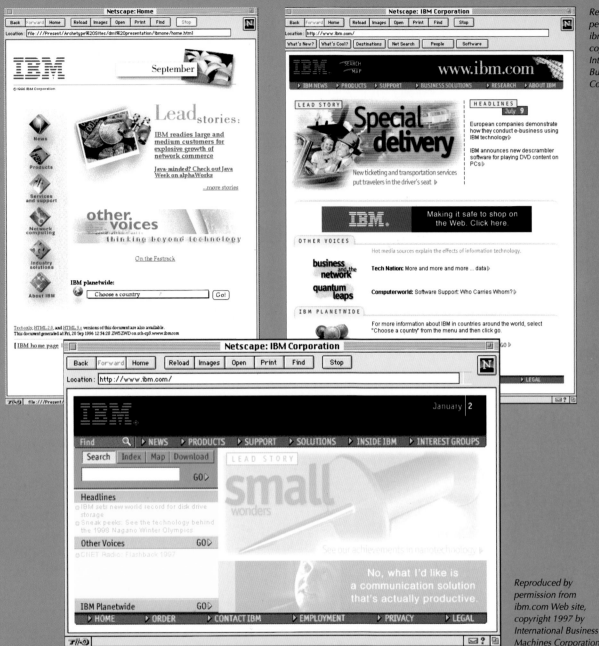

PROJECT: IBM WEB SITE
<WWW.IBM.COM>
DESIGN FIRM: STUDIO ARCHETYPE
CREATIVE DIRECTORS: JOHN GROTTING, MARK CRUMPACKER
CREATIVE INTEGRATORS: JUDITH HOOGENBOOM, ERIC WILSON, WENDY SMITH
DESIGNERS: BOB SKUBIC, PHILIP KIM
CLIENT: INTERNATIONAL BUSINESS MACHINES CORPORATION

Projects like this massive redesign of IBM's Web site are why designers of interactive work began calling themselves "information architects," a phrase widely attributed to Studio Archetype principal Clement Mok and one never heard before the computer era.

In 1996 (top left), the existing home page had a white background and a "lead story." After a competitive audit, the designers devised a rigorous visual vocabulary that made the site more compelling (top right). Eventually, research showed that the interface should move from its editorial focus to become more task-oriented. Some pages were redesigned in 1997 (center) to work more as a software application would, with simulated pop-down menus and faster, more intuitive search functions.

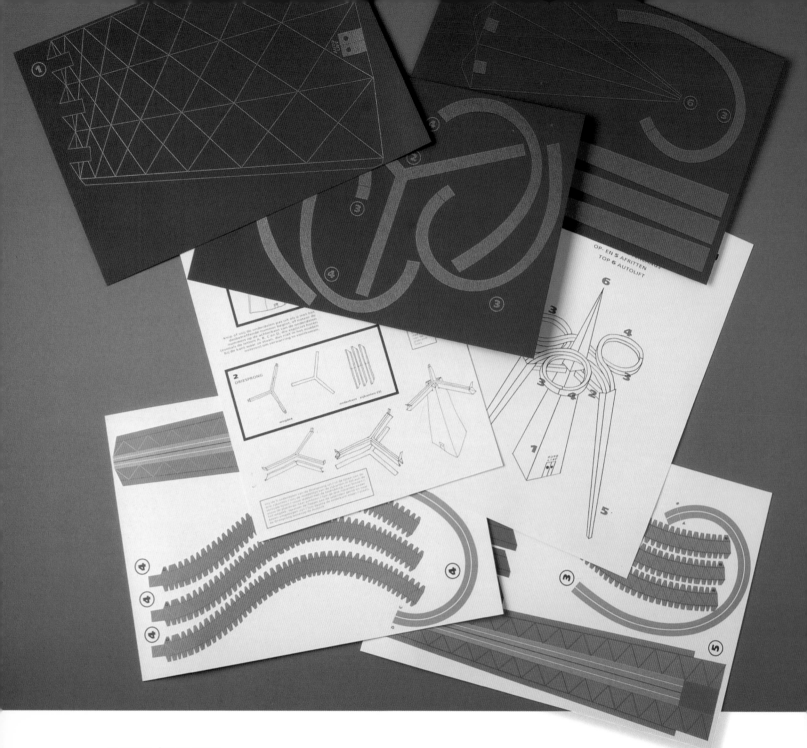

PROJECT: ANTI-CAR CUTOUT
DESIGN FIRM: WILD PLAKKEN
DESIGNER: LIES ROS
CLIENT: ROSTRA COMMUNICATIE FOR RIJKS WATER STAAT

Creating this elaborate 1994 project, described as a "designer's dream to make," would have been far more tedious without software tools. Lies Ros was asked to create a gift for engineers who attended a conference on quality management.

Her answer was this cut-out "anti-car flyover," put together using Macromedia FreeHand and Macintosh-based fonts. The idea, she says, was not just a designer's dream, but a boy's dream as well (the audience for the piece was largely male). And, because it was intended for quality engineers, it had to be challenging. There are seven pieces in the package, including the hand-drawn "manual." The recipients were to cut the pieces out, then assemble them into the three-dimensional final product.

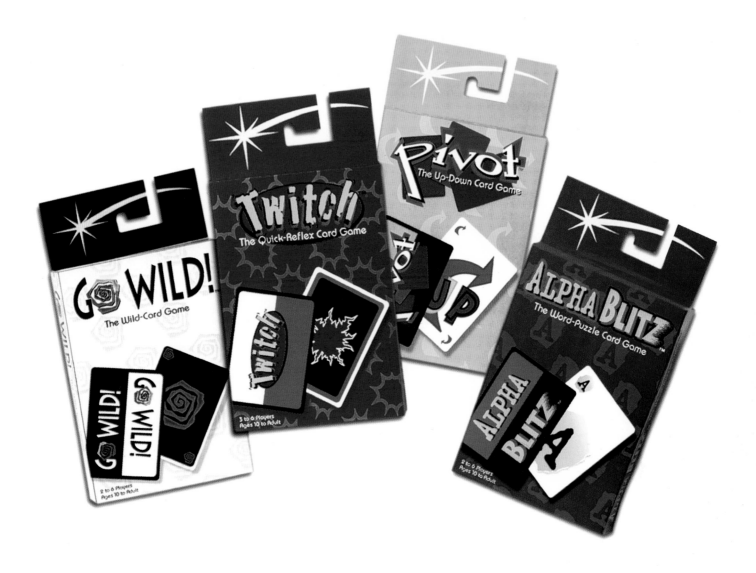

PROJECT: WIZARDS OF THE COAST® CARD GAME COLLECTION
DESIGN FIRM: WIZARDS OF THE COAST®
CREATIVE DIRECTOR: RICH KAALAAS
ART DIRECTOR: JAYNE L. ULANDER
DESIGNER: CRAIG HOOPER
ILLUSTRATOR: CHRISTOPHER RUSH
PRODUCTION MANAGER: JOY FORTNEY
CLIENT: WIZARDS OF THE COAST®

Wizards of the Coast® is best-known for the trading-card game Magic: The Gathering® (see page 92), but these card games debuted under Wizards' own name, with the company-logo star as the signature element.

Modular packaging gave retailers a choice between box or rack display. A strong color palette meant Wizards could add or drop new games; because colors had meaning within the games, it was important that they be pure, so each color was built with only two CMYK colors. Wizards' ability to create new lines and develop existing ones quickly and reliably has everything to do with digital technology; the company's art and production departments simply could not do their jobs without computers.

2 Space and Time

It's hard to say how it first began, but the space inhabited by a design is different than it used to be, and the viewer, whether through eye or mouse-hand, moves around and through that space differently—and, above all, faster.

Ironically, print magazine designers may have set things in motion in the eighties with the practice of alternating lines for headlines and subheads within the same type block, differentiating the two elements by font size and by face rather than by keeping all the headline words together and separate from the subhead. This was but one example of what has become routine: violating what is still the traditional arrangement of elements in a top-down hierarchy. Now we may see headlines sitting off to the side, skating slantwise across a page or a spread, standing up sideways, or butting up against or even running into the text. In situations where headlines or slogans do run into the text, they may become a background element, material that's deliberately placed on a different level than body copy. This makes the space implicitly three-dimensional rather than flat—an important change in viewpoint for designers as they move into other media like film, video, and interactive design.

The means of denoting emphasis has changed as well. Instead of an entire headline being sized bigger than body copy, the words in a headline

may be in several different sizes; if the reader has a silent inner voice reading aloud in the mind, that voice will speak differently when the most important word in a headline pumps itself up bigger than the others. This relaxation of word decorum has been liberating for designers, who are now free to set lines of type not only in any appropriate "new" typeface (see "The Word," page 94), but also so that the words speak with almost audible changes of volume as they dance across the page—or across the screen or around the box, bottle, or other piece. The sense of movement that typifies both printed and interactive pieces has found its way into television advertising and feature filmmaking as well; moving type is seen frequently now in both ads and film titles, where changes through time take the type alterations pioneered by print designers one step further.

It's also understood now that the reading experience must take account of constraints on the viewer's time. Callouts are still used in brochures, but more common is for key phrases to be colored, boxed, or otherwise highlighted; the viewer's eye goes to them instantly, as if they were magnets, small versions of headline news.

Finally, the multiplication of words, especially when the words are embedded in a sea of images, is a way of destroying grids and other organizing principles. Commonly in such compositions, some words are in focus while others are blurred, and boundaries for all practical purposes cease to exist; hierarchy is unclear and clues are less than obvious. There is an analogy here to the metaphorically three-dimensional navigation of the World Wide Web, in which viewers click off on tangent trails, or drill "down" to deeper levels of detail, at their whim. It's not really clear where we're going, and designers may simply be portraying that.

At the same time, there's an echo of urban entropy in this way of showing visual meaning, a suggestion of decaying buildings and too much noise, an overstimulation through television and street signs and other visual information that seemingly comes at us randomly yet all at once. If it's true that information overload is a disease of our time, then designers seem to have a lock on how to portray it, yet they get messages across despite the confusion; it helps that readers, at least so far, seem almost endlessly adaptable and accepting. Over the next decade or two, it will be interesting to see how levels of meaning begin to organize themselves differently and adopt new styles of visual dress—and how readers react.

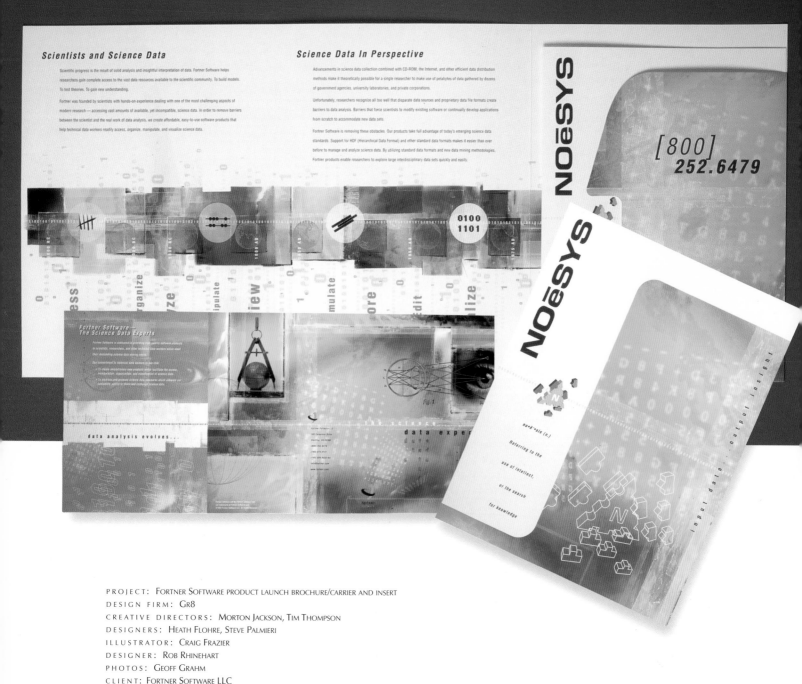

PROJECT: FORTNER SOFTWARE PRODUCT LAUNCH BROCHURE/CARRIER AND INSERT
DESIGN FIRM: GR8
CREATIVE DIRECTORS: MORTON JACKSON, TIM THOMPSON
DESIGNERS: HEATH FLOHRE, STEVE PALMIERI
ILLUSTRATOR: CRAIG FRAZIER
DESIGNER: ROB RHINEHART
PHOTOS: GEOFF GRAHM
CLIENT: FORTNER SOFTWARE LLC

To launch a software application for scientists, Gr8 last year designed a three-panel brochure that also functioned as a folder, along with a product insert that slipped into the folder pocket.

Outside the folder are grids of numbers slanting off into the distance; the human eye with an antique-looking diagram of refracting light; a few words; and hundreds of pale, outlined little shapes that could be tape outlining microscope slides, or pieces of inorganic matter in the process of breaking up. The whole arrangement seems to float in a golden yellow medium that bleeds off all four sides. Inside, more symbols, numbers, and words bubble along what might be a work-process timeline. The product insert recaps some of these elements and lays out specific product information. The whole project nicely captures the disorganized yet still connotative way that visual information is currently being arrayed.

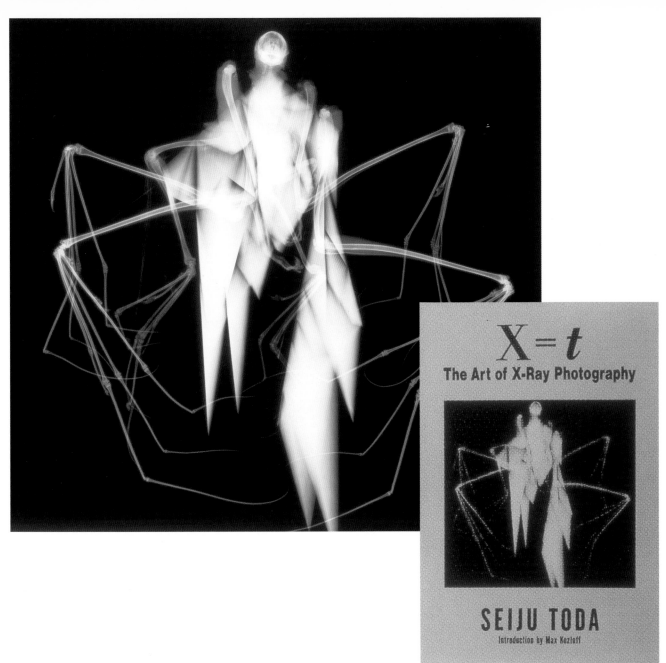

PROJECT: *X = T* POSTER
DESIGN FIRM: TODA OFFICE
DESIGNER: SEIJU TODA
CLIENT: TODA OFFICE

X = t, the book this 1995 poster promotes, was produced by the designer and uses X-ray photographs as art images. X-ray images allow us to see within, and that is the effect of the poster as well.

In part, this is because of the ghostly nature of the image; technology has accustomed us to looking at things we cannot see with our eyes, but Toda makes the sensation new. In part, too, we experience a disjunction because of the insect's unexpected size. The small, unidentified insect on the cover (a praying mantis, perhaps?) is greatly magnified for the poster's main image. Toda uses size reversals in some of his other work, as well; see page 50.

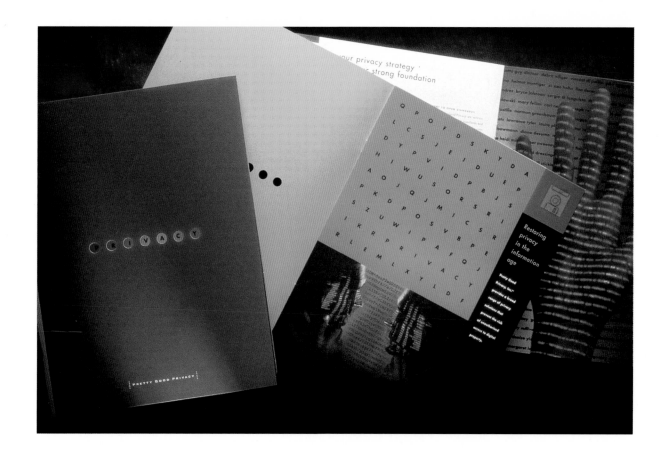

PROJECT: PRETTY GOOD PRIVACY, INC. CAPABILITIES BROCHURE
DESIGN FIRM: HORNALL ANDERSON DESIGN WORKS, INC.
ART DIRECTOR: JACK ANDERSON
DESIGNERS: JACK ANDERSON, DEBRA HAMPTON, HEIDI FAVOUR, KATHA
 DALTON, JANA WILSON, MICHAEL BRUGMAN
PHOTOS: E. WILLIAMS, JR.
CLIENT: PRETTY GOOD PRIVACY, INC. (PGP)

Pretty Good Privacy provides commercial encryption software, and when the company incorporated in 1996, it wanted a brochure that would not only introduce the company, but also educate potential clients about the importance of encrypting their data.

To symbolize the scrambling function of the company's software, Hornall Anderson embedded the word "privacy" in a grid of type that hides it once the front cover is opened. Inside images show electronic data flowing across faces and a hand, evoking a sense of unease about the amount of data "out there" about ourselves and our employers. These images form a backdrop for the more informational material in the piece, a kind of second "space" inhabited by the worry related to the subject matter.

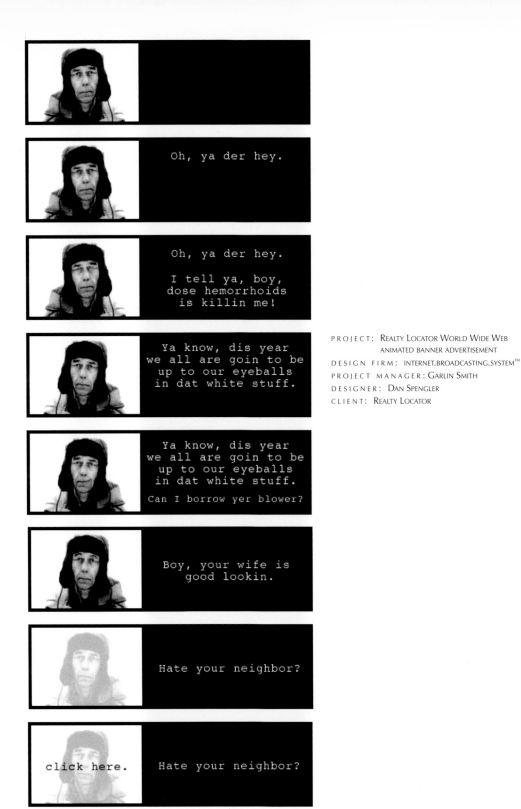

PROJECT: REALTY LOCATOR WORLD WIDE WEB
ANIMATED BANNER ADVERTISEMENT
DESIGN FIRM: INTERNET.BROADCASTING.SYSTEM™
PROJECT MANAGER: GARLIN SMITH
DESIGNER: DAN SPENGLER
CLIENT: REALTY LOCATOR

Banner ads using GIF animation are only about two years old. But they have already become an important way for a Web-design firm to show its programming, design, and concepting abilities—as well as to compete successfully in an arena traditionally dominated by advertising agencies.

This 1997 ad for a national American firm was one of several that played to a humorous problem experienced by potential clients: annoying neighbors. In only a few short seconds, an animated banner ad must capture the Web site viewer's attention, get a message across, and induce the viewer to click on the ad so as to reach the advertiser's own Web site.

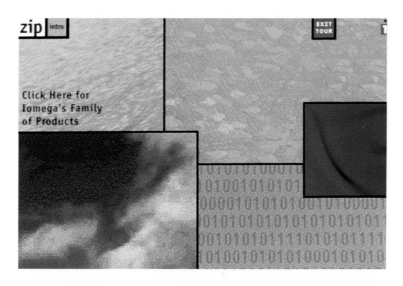

because it's your stuff.™

PROJECT: IOMEGA ZIP DRIVE TOUR
DESIGN FIRM: FITCH INC.
PROGRAM MANAGER: ALEX SUBRIZI
DESIGNERS: CHRIS PACIONE, ED CHUNG, GLENN HOFFMAN
COPYWRITERS: SARAH SPART, MIKE MOONEY
CLIENT: IOMEGA CORPORATION

The 1995 rollout of Iomega's Zip drive, a removable storage device for the personal computer, included this interactive tour.

The software loads automatically during the setup procedure, and starts with a voice-over introduction. Then the viewer encounters a visual "map" on which he or she can click to get more information on the company's products, how to order them, software included with the drive, common questions, and registration. The product launch coincided with a market repositioning for Iomega developed jointly by both the client and Fitch, where design *per se* is integrated with product development and consulting on business strategy. In keeping with Iomega's newly approachable image, the Zip tour is playful, practical, and easy to navigate.

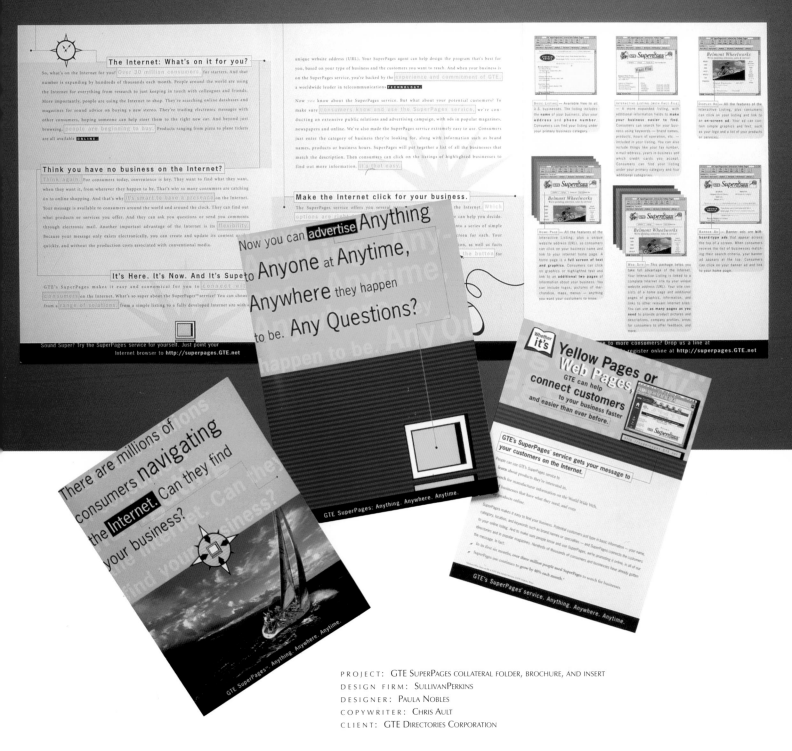

PROJECT: GTE SUPERPAGES COLLATERAL FOLDER, BROCHURE, AND INSERT
DESIGN FIRM: SULLIVANPERKINS
DESIGNER: PAULA NOBLES
COPYWRITER: CHRIS AULT
CLIENT: GTE DIRECTORIES CORPORATION

This 1996 collateral package for GTE helps market SuperPages, a Web site for viewers searching for businesses.

In promoting online business, it employs some of the techniques used by online designers. Sentences are short. Key ideas are bolded and/or highlighted in blocks to jump out at time-starved readers. The blocks in turn dot the page in a non-linear pattern, suggesting some of the meandering, non-hierarchical ways information is arranged in Web sites. The writing style is informal, as befits the medium the pieces are marketing. And behind each set of front-page headlines, pale ghost-words float, almost unnoticeable except in how they suggest the endless proliferation of online information.

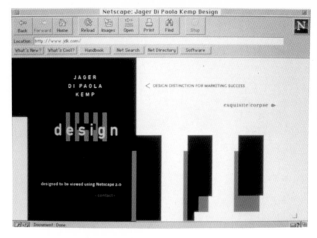

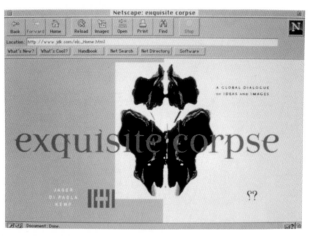

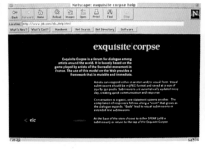

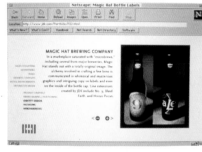

PROJECT: JAGER DI PAOLA KEMP DESIGN WEB SITE AND THE EXQUISITE CORPSE "ART SITE"
<WWW.JDK.COM>
DESIGN FIRM: JAGER DI PAOLA KEMP DESIGN
CREATIVE DIRECTOR: MICHAEL JAGER
DESIGN DIRECTORS: DAVID COVELL, MARK SYLVESTER
DESIGNERS: CHRIS BRADLEY, DAVID COVELL, MARK SYLVESTER
PRODUCER: CHRIS THOMPSON
PROGRAMMER: KEVIN MURIKAMI
CLIENT: JAGER DI PAOLA KEMP DESIGN

This two-headed Web site was created in 1995 as a marketing tool for the studio and as a forum for designers and artists. The Jager Di Paola Kemp portion of the site includes a design manifesto and a changing project portfolio.

The Exquisite Corpse site, named after a dadaist icon, poses questions such as, "How do you remember?" Responses are posted along a "spine" that grows as the dialogue expands. Respondees can submit artwork, which other viewers reach by clicking small "buds" next to the artists' names. The slow accumulation of ideas, questions, and artwork is organic in character—yet exists only in cyberspace. This kind of time and space has only existed for a few years.

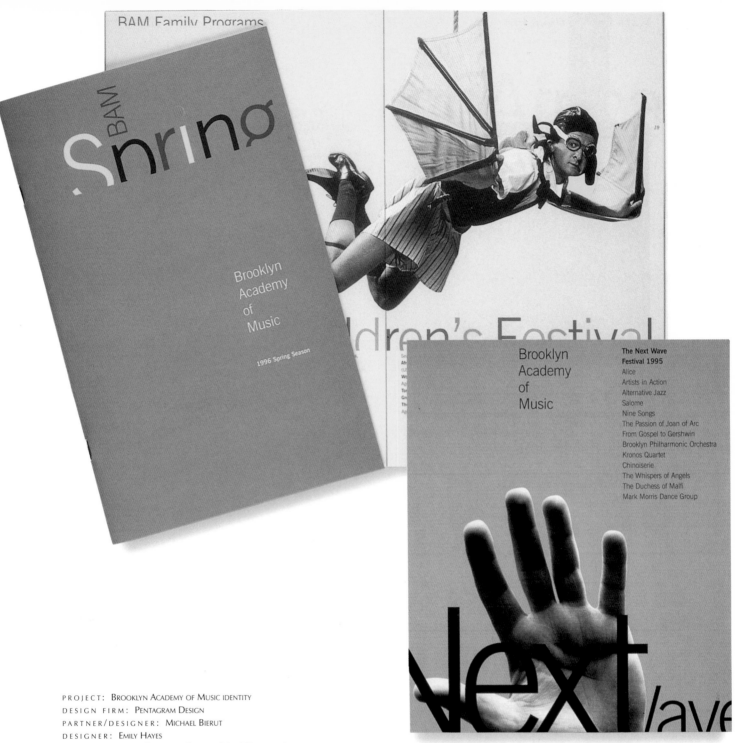

PROJECT: BROOKLYN ACADEMY OF MUSIC IDENTITY
DESIGN FIRM: PENTAGRAM DESIGN
PARTNER/DESIGNER: MICHAEL BIERUT
DESIGNER: EMILY HAYES
PHOTOS: TIMOTHY GREENFIELD-SANDERS (NEXT WAVE HAND); VARIOUS
CLIENT: BROOKLYN ACADEMY OF MUSIC

The Brooklyn Academy of Music, an important venue for avant garde and cross-disciplinary music, dance, theater, and art performances, asked Pentagram to devise a new visual presentation of the school coinciding with a refurbishment of its main facility.

The designers organized layouts for various printed pieces around a motif of wide stripes, introducing the new look with materials for the academy's 1995 Next Wave Festival of dance and music. Type was partly concealed to suggest something coming over the horizon, a metaphor for the festival's focus on emerging talent, but it remains effortlessly readable. The "peeking-out" typographic style worked differently but equally well for the spring 1996 season: Brighter colors were selected, and the type suggests emerging flowers.

Milk for 25,000 homes

OVERNIGHT,
HUNDREDS OF TRUCKS TRAVEL
THE TOLLWAY
BRINGING AGRICULTURAL PRODUCTS
FOR OUR BREAKFAST TABLES
FROM AREA FARMS, MAKING SURE
FRESH FOOD
REACHES MARKET EACH
MORNING.

The Illinois Tollway 9 1996 Annual Report

ALL IN A DAY'S WORK

PROJECT: ILLINOIS STATE TOLL HIGHWAY AUTHORITY 1996 ANNUAL REPORT
DESIGN FIRM: FROETER DESIGN COMPANY, INC.
ART DIRECTOR/DESIGNER: CHRIS FROETER
COPYWRITER: JEANETTE LOCURTO
PHOTOS: TONY ARMOUR
CLIENT: ILLINOIS STATE TOLL HIGHWAY AUTHORITY

New and more imaginative approaches to information make it possible to produce creative work even on seemingly mundane subjects. This 1996 annual report covers the public agency that collects highway tolls in Illinois. The client wanted the designers to communicate the value of the tollway system to the state and regional economy.

To achieve this, the designers produced a simple, three-color piece. But they cleverly used varying type sizes to maintain the reader's interest and establish the importance of certain sentences. On some pages, they violated a sacred rule by placing very small type in the center of an image, noting the number of people served in a given business sector, such as the dairy industry.

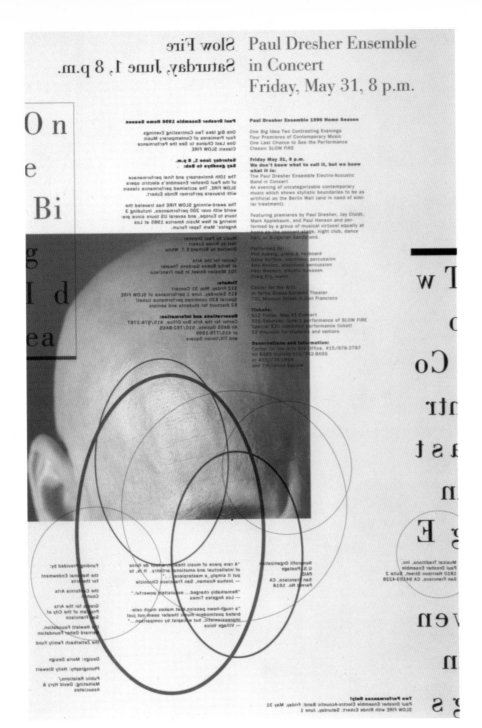

PROJECT: PAUL DRESHER ENSEMBLE POSTER
DESIGN FIRM: MORLA DESIGN
ART DIRECTOR: JENNIFER MORLA
DESIGNERS: JENNIFER MORLA, CRAIG BAILEY
PHOTOS: HOLLY STEWART PHOTOGRAPHY
CLIENT: PAUL DRESHER

This 1996 piece shows how unusual reading styles have become the norm. The project is a single poster for two different performances by the Paul Dresher Ensemble. Morla Design was asked to weight each event equally, and to reflect the artists' experimental character.

The designers used a simple typographic palette of Franklin Gothic and Bauer Bodoni, and only black ink. The poster is split in half vertically, with information about one performance on each side of the dividing line. But the information segments read backwards to each other, and, because the poster is printed on vellum, both are visible at once. An ambiguous photo and seven ovals and circles complete an arresting, absorbing, seemingly unfinished composition.

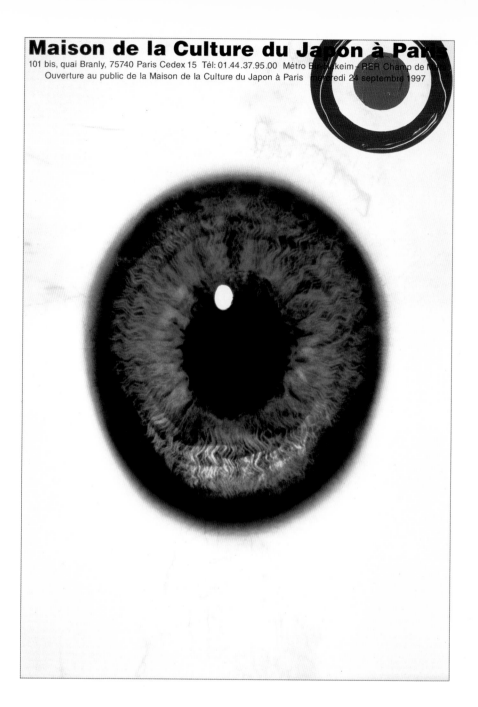

Maison de la Culture du Japon à Paris
101 bis, quai Branly, 75740 Paris Cedex 15 Tél: 01.44.37.95.00 Métro Bir-Hakeim - RER Champ de Mars
Ouverture au public de la Maison de la Culture du Japon à Paris mercredi 24 septembre 1997

PROJECT: MAISON DE LA CULTURE DU
 JAPON À PARIS POSTER
DESIGN FIRM: TODA OFFICE
DESIGNER: SEIJU TODA
CLIENT: THE JAPAN CULTURAL INSTITUTE IN
 PARIS (THE JAPAN FOUNDATION)

For this 1997 poster, Toda used the oversized image of an eye because, as he points out, "field of view" is the most important element in cultural exchanges.

The close-up—so extreme the pale veins can be seen in the white of the eyeball—is reminiscent of the enormous images we see on billboards, in trade shows, and in other situations where visibility to distant viewers is important. This reversal of sizes even allows the wavy blue lines in the eye's iris to look somewhat like the ocean, as if the eye were the Earth, seen from space.

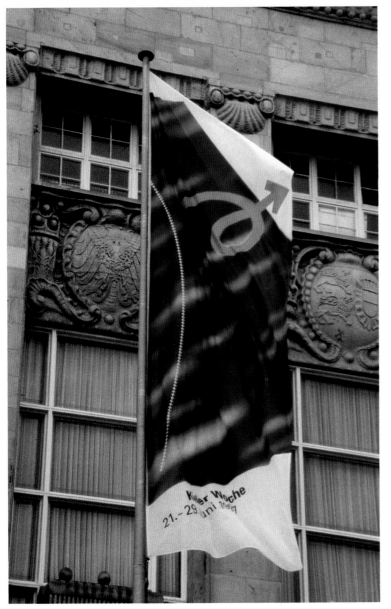

PROJECT: KIELER WOCHE IDENTITY
DESIGN FIRM: L DESIGN, PIPPO LIONNI
DESIGNER: PIPPO LIONNI
PHOTOS: FLORIANT KLEINEFENN
CLIENT: CITY OF KIEL

Dramatic differences in the scale of new communications tools can pose a challenge to designers.

For the city of Kiel's 1997 international regatta week identity, Lionni created an irregular blue polygon, with blurred streaks suggesting water. Curving orange arrows imply the trajectories of the competing yachts. A white line, composed of tiny arrows, roughly bisects the polygon; because it is not specific, it suggests both the finish line and the curve of a wind-filled sail. This approach, which depends more on allusion than on representation, keeps the composition simple. It therefore works as well on enormous banners hung from buildings as it does on telephone cards and—in even simpler form—on wristwatches.

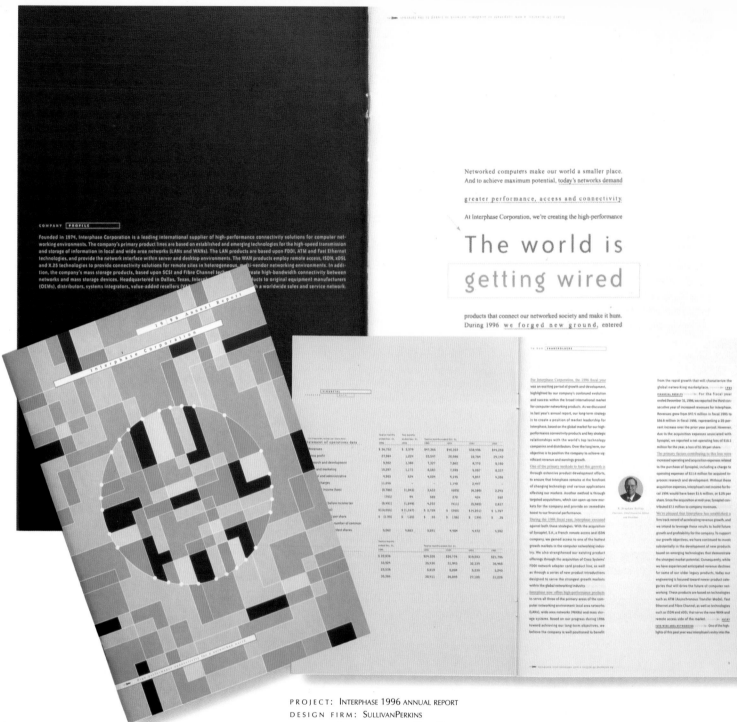

PROJECT: INTERPHASE 1996 ANNUAL REPORT
DESIGN FIRM: SULLIVANPERKINS
DESIGNER/ILLUSTRATOR: KEVIN BAILEY
COPYWRITER: MELTZER & MARTIN
PHOTOS: GERRY KANO
CLIENT: INTERPHASE CORPORATION

This annual report for a computer network products company immediately establishes the client's business environment with a cover illustration that, while abstract, unmistakably represents a computer circuit board.

On the first page, the designer establishes conventions for highlighting material: boxing, enlarging size, and underlining. On page 3 and beyond, he uses underlining to begin each new paragraph. These techniques, while unorthodox in traditional terms, recall online conventions for drawing attention to important material that became almost routine in the mid-nineties. Underlined text, after all, is one of the things that signifies an active link on a Web page. In print, associations like these can immediately mark a piece as high-tech-related.

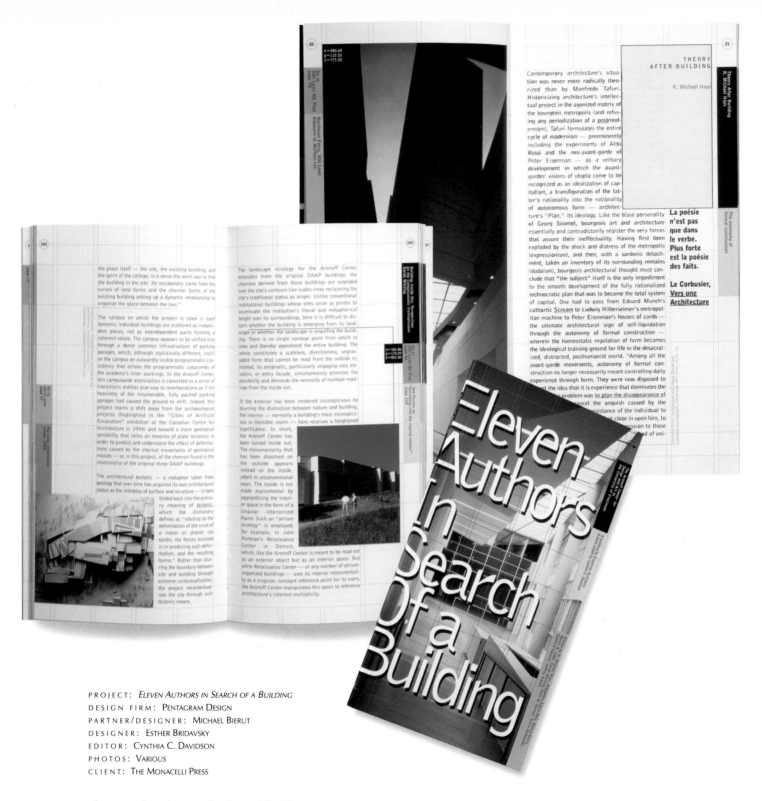

PROJECT: *Eleven Authors in Search of a Building*
DESIGN FIRM: PENTAGRAM DESIGN
PARTNER/DESIGNER: MICHAEL BIERUT
DESIGNER: ESTHER BRIDAVSKY
EDITOR: CYNTHIA C. DAVIDSON
PHOTOS: VARIOUS
CLIENT: THE MONACELLI PRESS

Eleven Authors in Search of a Building is a collection of critical essays about architect Peter Eisenman's Aronoff Center for Design and Art at the University of Cincinnati and was published at the time of the building's dedication in 1996. The building itself comprises dynamically joined boxes that collide and connect in space.

The book approximates this structure with multiple photographs and a visible grid, or series of boxes, through which the reader moves. Plans and photographs are cross-referenced throughout the book, linking with each other like rooms in a building or pages in a Web site. The designers also used the grid to engineer callouts and footnotes, which conveniently appear crosswise to the text in magenta.

SIMPLE TO ORDER

SIMPLE TO DISTRIBUTE

SIMPLE TO STREAMLINE

[6]

WALLACE MAKES SAVING MONEY SIMPLE BY LETTING CUSTOMERS OFF-LOAD THE DAY-TO-DAY ADMINISTRATION OF INFORMATION MANAGEMENT SUPPLIES.

There's a lot of work in managing supplies. One customer's research found that while accounting for only 15% of their total purchase costs, supplies took up 78% of their transactions. Wallace provides supplies management services that make the purchasing manager's job easier and generate significant cost savings for the company.

The following pages describe how Wallace can assume tasks such as ordering, distributing and streamlining, and provide examples of how companies of varying sizes are benefitting.

WALLACE 1997 ANNUAL REPORT

WALLACE MAKES IT SIMPLE

PROJECT: WALLACE COMPUTER SERVICES, INC. 1997 ANNUAL REPORT
DESIGN FIRM: FROETER DESIGN COMPANY INC.
ART DIRECTORS: TIM BRUCE, CHRIS FROETER
DESIGNER: TIM BRUCE
COPYWRITER: BRAD SAMSON
PHOTOS: TONY ARMOUR
CLIENT: WALLACE COMPUTER SERVICES, INC.

In the age of information overload, designers can use overload itself as a design tool, as is shown by this effective annual report. The client makes, manages, and distributes business supplies.

The designers photographed an office and labeled everything in it that the client could supply. The message on the opposite page restates the company's mission and its strength of simplifying life for its customers—yet the message would not be nearly as clear if the office were not staring the reader in the face, cluttered with supplies and words. A similar technique is used farther in, where the "simplification" message appears on the left, and a mind-numbing list of client-supplied services bisects the page on the right.

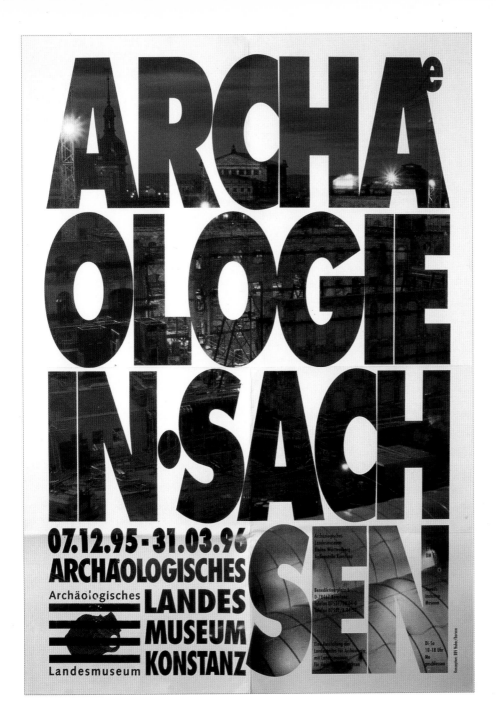

PROJECT: ARCHÄOLOGY IN SACHSEN POSTER
DESIGN FIRM: KOMMUNIKATIONS-DESIGN BBV
CREATIVE DIRECTOR/DESIGNER: SIEGRUN NUBER
ART DIRECTOR: MICHAEL BAVIERA
CLIENT: ARCHÄOLOGISCHES LANDESMUSEUM
BADEN-WÜRTTEMBERG, KONSTANZ

Instead of designing the type separately from the imagery, this poster from 1995 includes a photo of the German city of Sachsen inside the type (Futura and Futura Condensed).

The idea shows that archaeology is a process in which information typically remains fragmentary and is rarely completed. In an analogy to the painstaking efforts of archaeologists, the viewer looking at the poster has to complete the picture mentally. This device has become almost mainstream in the last few years, but remains effective. It is sometimes seen in motion picture titles. There, as here, the letter forms—almost always sans serif—become a window into another reality, reversing the norm in which words are superimposed on the image layer.

Click Eddie to watch his induction into the Wall Street Hall of Fame as seen on *Wall Street Week With Louis Rukeyser*

Look here for investor questions that have crossed our desk.

 (Image)

Brown Capital Management, Inc. is a small, established and highly focused, entrepreneurial investment management firm with over $3 billion under management. We are dedicated to providing high quality service to individuals and institutions.

We attribute our success to providing our clients with consistently good, long-term investment performance to grow their asset base, and to having a seasoned and dedicated team of investment professionals who effectuate Brown Capital's sound, time-tested investment discipline. Brown Capital's management team averages over 18 years of investment experience and is careful, thoughtful and conscientious in its search for undervalued growth companies.

BROWN CAPITAL MANAGEMENT

BCM MARKET PERSPECTIVES

Isn't the process of stock picking just another form of gambling?
click Eddie for the answer
click here for video

Eddie C. Brown

Ed Brown is founder and President of Brown Capital Management, Inc. Ed has over 27 years of investment experience, having served as a Vice President and Portfolio Manager for 10 years at T. Rowe Price Associates immediately prior to starting his own firm.

Ed received a Bachelors of Science in Electrical Engineering from Howard University, a Masters of Science in Electrical Engineering from New York University and a Masters of Business Administration from Indiana University School of Business. He also has two professional designations, Chartered Financial Analyst (CFA) and Chartered Investment Counselor (CIC).

Ed is active in community affairs. He is currently a member of the Board of Directors of the Baltimore Community Foundation (where he served as treasurer and chaired the investment committee for the foundation's $60 million endowment), the Walters Art Gallery, and the Living Classroom Foundation, and a member of The Presidents' Roundtable.

For the past eighteen years he has been a regular panelist on the nationally televised public broadcasting program, *Wall Street Week with Louis Rukeyser* . Eddie was Wall Street Week's sole 1996 Hall of Fame inductee, joining legends such as John Templeton, Peter Lynch and Milton Friedman.

Robert E. Hall

Bob Hall has over 34 years of investment experience, having served as a Partner and Portfolio Manager for Emerging Growth partners for 7 years. He was also with T. Rowe Price Associates for 18 years as a Portfolio Manager. Bob joined Brown Capital Management, Inc. in September 1993.

Bob received a Bachelors Degree in Engineering from The Johns Hopkins University, and a Masters in Business Administration from Harvard Graduate School of Business.

Bob is active in community affairs. He was a Trustee for the Peabody Institute from 1981-1986.

the company
management team
mutual funds
news
contact

prospectus/application performance navs

PROJECT: BROWN CAPITAL MANAGEMENT, INC. WEB SITE
 <WWW.BROWNCAPITAL.COM>
DESIGN FIRM: GR8
CREATIVE DIRECTOR: TIM THOMPSON
DESIGNER: HEATH FLOHRE
CLIENT: BROWN CAPITAL MANAGEMENT, INC.

This Web site demonstrates that it is possible to surprise the viewer pleasantly, while at the same time staying recognizably within the boundaries of readers' experience.

Launched in 1997, the site uses several different images of the founder in the upper left-hand portion of its home page. The various files gradually replace each other, and each has a different caption, so the reader has several mini-stories to read. The menu in the lower left has a rollover feature—it activates a subhead when the mouse passes over an item—"management team," for example, changes to "manager bios." The managers show up in a group photo; click on one of their faces and you see the individual's bio.

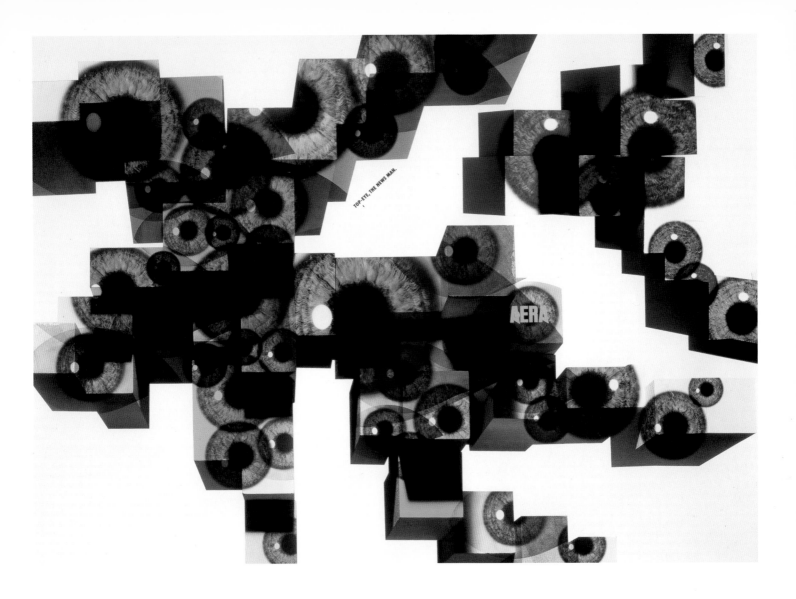

PROJECT: POSTER FOR *TOP-EYE* MAGAZINE
DESIGN FIRM: TODA OFFICE
DESIGNER: SEIJU TODA
CLIENT: ASAHI SHIMBUN PUBLISHING CO.

This poster for a news magazine uses several means of playing with the viewer's expectations.

The words referring to the magazine are set very small, almost tucked away in the background near the center of the piece. Otherwise the frame is dominated by what seems a sea of eyeballs—and, in a reference to the magazine's ability to gather information, the eyes seem to be all-seeing. The eyeball images are repeated over and over again, yet they also have a fragmented appearance, perhaps echoing one of the realities of contemporary urban life. Because the eyeball images are mounted, so to speak, on the fronts of cubes, the poster creates an impression that the viewer is entering into an imaginary, somewhat disquieting, three-dimensional space.

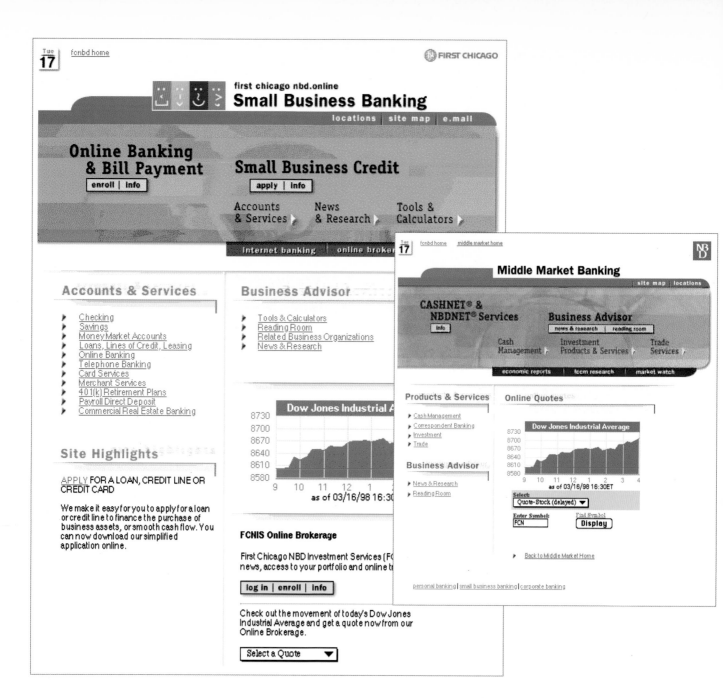

PROJECT: FIRST CHICAGO NBD ONLINE WEB SITE
DESIGN FIRM: FITCH INC.
PROJECT MANAGERS: SHERIE BAUER, COLETTE MOTL
DESIGNERS: SHERIE BAUER, COLETTE MOTL, STEVE SIMULA, SUZANNE WALSH
PRODUCTION TEAM: TOM HOLLYER, PETE TOCHMAN, HENRY SHILLING, TONY RAMOS, JASON OLESZCZUK
CLIENT: FIRST CHICAGO NBD

These screens are sectional "home" pages from the First Chicago NBD Online Web site, which Fitch is redesigning. This complex project highlights how critical it is for designers to think about the user's experience at every step and every level in virtual environments.

To keep that experience manageable, the designers reduced the number of the pages in the site, which had been as high as a thousand. The client's online services group builds the extensive databases involved and runs the site; Fitch establishes the design language and creates templates that allow the in-house group to apply the developing navigational structure and look-and-feel. More evolution, in the form of true online banking (not merely information), is planned.

PROJECT: *WHAT'S WRONG WITH THIS BOOK?*
DESIGNER/WRITER: RICHARD MCGUIRE
CLIENTS: RICHARD MCGUIRE, VIKING

This lively children's book, published last year, had its genesis in a cover the designer created for *The New Yorker*'s April 1, 1996 issue, in which there were ninety-six things wrong. His agent suggest he do a book based on the same idea, and this was the result.

Every page has a trick to it that can be solved by turning the book upside down or turning the page to get another view of the same situation. With its bright colors and constantly changing characters, the book might seem a little psychedelic, but it seems truer as a reminder of the unpredictability and uncertainty of the business landscape around us.

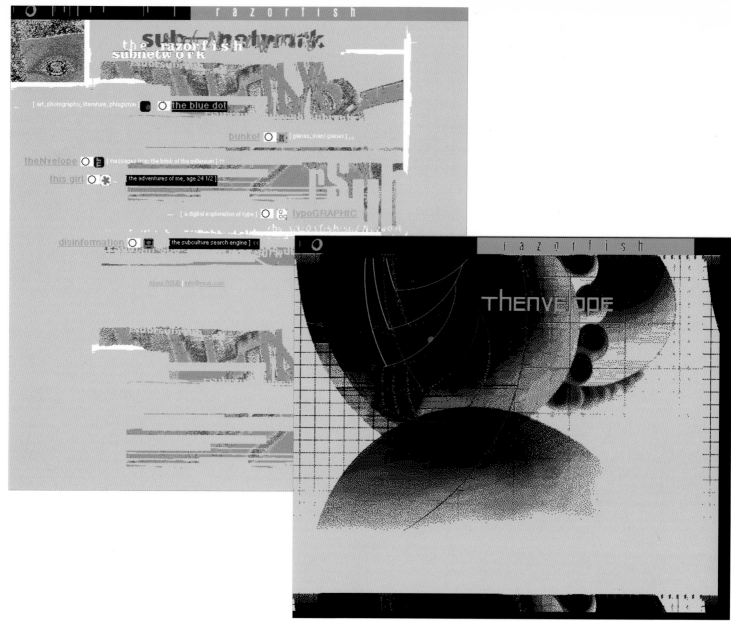

PROJECT: The Razorfish Subnetwork
 <WWW.RSUB.COM>
DESIGN FIRM: Razorfish
PRODUCERS: Peter Mattei, Lisa Shimamura
MAIN INTERFACE DESIGN: Thomas Müeller
CHANNEL DESIGN: Craig Kanarick, Stephen Turbek, Hillary Evans, Jose Caballer, Alex Smith
IMPLEMENTATION: Melinda Fletcher, Neith Preston, Alex Clifton
CLIENT: Razorfish

In the past, some designers have created their own content by writing, designing, and publishing books about design. Increasingly, designers heavily involved in online design are creating content by writing, designing, and posting Web sites about all sorts of things.

Razorfish's subnetwork, for example, can be accessed directly or through the company's corporate site. The "network" branches off into half a dozen directions, with subsites devoted to games, culture, technology, an online diary, and typography. This kind of undertaking allows a technology-based design firm to establish an ongoing online presence and show what it can do. It is one way designers are countering the way the Web's democratic technology has allowed software enthusiasts to "design" Web sites without formal design training.

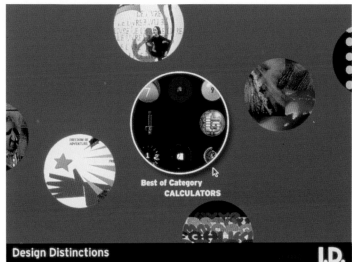

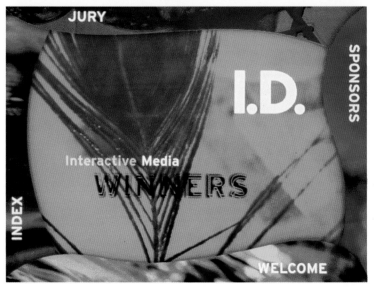

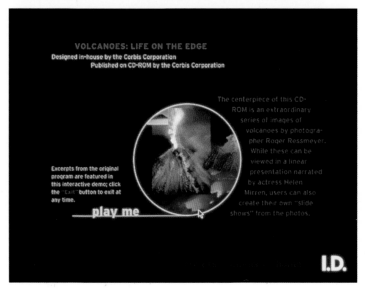

PROJECT: I.D. *Magazine 1996 Design Review Interactive Media Winners* CD-ROM
DESIGN FIRM: Fitch Inc.
PROGRAM MANAGER: Sherie Bauer
DESIGNERS: Steve Simula, Colette Motl, Floris Keizer (Fitch Inc.);
A. Arefin, Andrea Fella, Melissa Dallal (*I.D.* magazine)
PROGRAMMERS: Henry Schilling, Tony Ramos
CLIENT: *I.D.* magazine

This CD-ROM is among the more successful attempts to create a 3-D-like environment without an aggressively obvious 3-D approach.

It employs original music, much of it having a vaguely Asian and/or digital sound. There is some video at the beginning, as the titles come up and then fade away, accompanied by unidentifiable, brightly colored shapes that melt into one another. At the main screen, the winners are accessible if the viewer clicks on the words "Winners," located in a colored panel in the center. The panel is replaced by circles containing images from winners; each of these can be clicked on. Here, as elsewhere in the CD, moving the mouse takes the viewer smoothly around the possible selections.

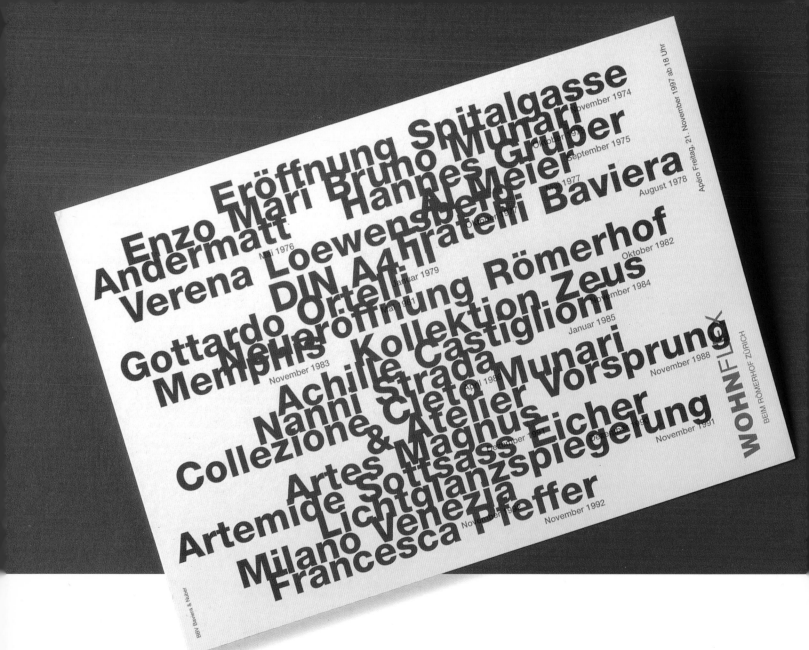

PROJECT: WOHNFLEX INVITATION CARD
DESIGN FIRM: KOMMUNIKATIONS-DESIGN BBV
CREATIVE DIRECTOR: MICHAEL BAVIERA
ART DIRECTOR/DESIGNER: SIEGRUN NUBER
CLIENT: WOHNFLEX

Kommunikations-Design BBV designed this invitation for a 1997 celebration of home furnishings and accessories displayed in a high-end Zurich store over a twenty-year span.

To parallel the process at the store itself, where featured designers and collections succeed each other, each designer or collection name runs into the next. Designed simply with Helvetica and two colors, the card serves as a map, since the designers and collections shown in the seventies appear at the top, those shown in the eighties in the middle, and those from the nineties at the bottom. Perhaps the most effective thing about the piece is that, despite the crowding of the type, there is really no difficulty telling one item from another.

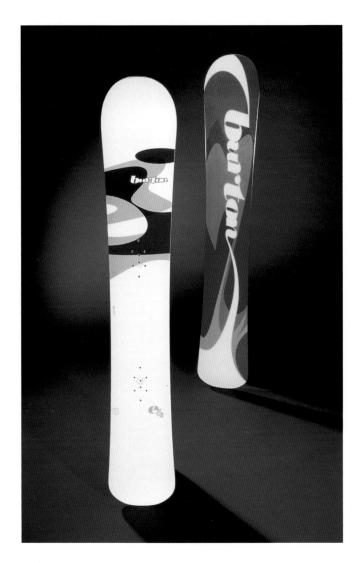

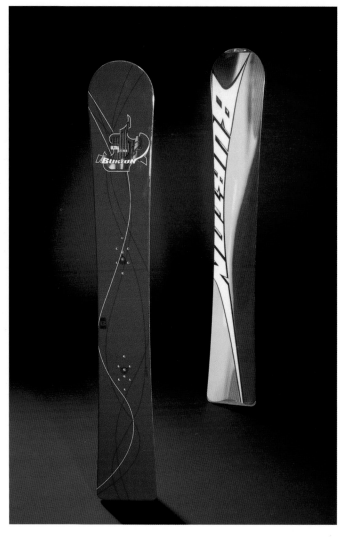

PROJECT: BURTON SNOWBOARD GRAPHICS
DESIGN FIRM: JAGER DI PAOLA KEMP DESIGN
CREATIVE DIRECTOR: MICHAEL JAGER
DESIGN DIRECTOR: DAVID COVELL
DESIGNERS: JIM ANFUSO, DAN SHARP, GEORGE MENCH, JOHN PHEMISTER
CLIENT: BURTON SNOWBOARDS

Since snowboards have a larger width than traditional downhill skis, they have become a target for graphics. Those graphics change frequently, too; board manufacturers put out new designs every year. Burton Snowboard graphics come from paintings, drawings, photographs, and digital images.

The designers study manufacturing techniques and try to think of interesting, cutting-edge artwork; those techniques include sublimation, screening, etching, foil embedding, and exposing the wooden core of the board as part of the design. In this environment, a traditional, unchanging corporate logotype is undesirably stodgy, and the board designs make use of numerous typefaces, most of them customized.

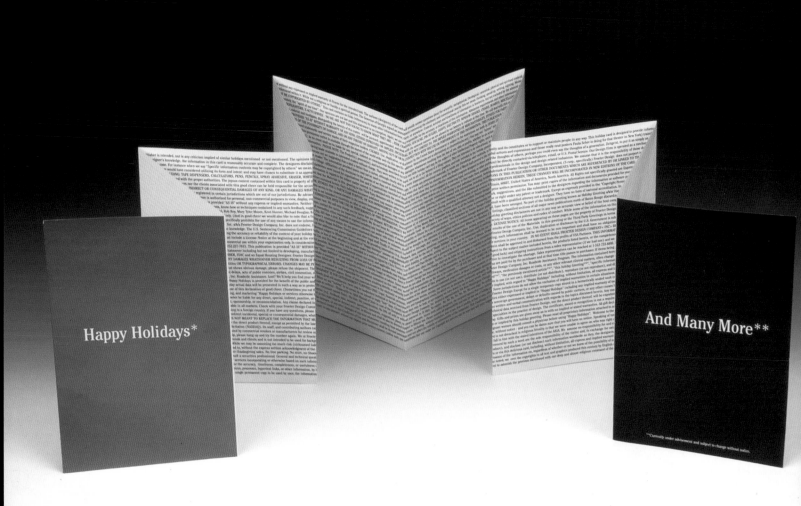

PROJECT: HAPPY HOLIDAYS CHRISTMAS CARD
DESIGN FIRM: FROETER DESIGN COMPANY, INC.
DESIGNERS: TIM BRUCE, CHRIS FROETER, PAUL BICHLER
CLIENT: FROETER DESIGN COMPANY, INC.

This clever, light-hearted piece takes advantage (in every sense of the word) of digital typesetting technology.

Printed offset in two colors on 45-pound paper, the card is nothing more than two end panels ("Happy Holidays" and "And Many More") with a sea of type in between set in QuarkXPress. The streaming lines of tiny words lampoon the "fine print" found on so many consumer products, and incorporate material downloaded by the designers from the Internet after a search on "disclaimers." Would it have been possible to do this project using conventional methods? Certainly. Would any designer have bothered? Probably not.

PROJECT: PLANET DESIGN COMPANY ad for *THE ALTERNATIVE PICK/SPIRIT BOOK*
DESIGN FIRM: PLANET DESIGN COMPANY
DESIGNERS: KEVIN WADE, MARTHA GRAETTINGER
COPYWRITER: JOHN BESMER
CLIENT: PLANET DESIGN COMPANY

This ad ran in Storm Music Entertainment's sourcebook *The Alternative Pick* for 1996, which was designed by Planet Design. The headline reads, "To attract attention, many designers rely on the photocopy machine. We, on the other hand, went out and skinned a guy."

The image *was* made on a photocopier, of course; one of the firm's principals laid his face on the copier glass and rolled it as the light moved across, so he would be copied from one ear to the other. The ad was bound into *The Alternative Pick* as a double-page spread. The piece is outrageous, but not as much as one might think. The "alternative" sensibility includes a certain amount of space, body, and time distortion.

3 Color

Is color becoming more than it used to be, or less? This isn't as frivolous a question as it seems; in fact, the answer is that it's both more *and* less, depending on the situation—and on whom you talk to.

Color as designers use it today is influenced by both trends and technology. On a cultural level, colors are frequently louder and brighter than they used to be, as more products are aimed at the young, whose color associations derive primarily from the screen (both computer and television). As San Francisco designer Lucille Tenazas points out, it's significant when what you see—and therefore the colors you become aware of and use—are less often from nature and more often from machines. It's perhaps this change more than any other that accounts for the fact that the colors we see around

us more and more—in advertisements, signage, television promotion spots, even clothing—are often bright and supersaturated. We can probably expect this effect to intensify, because cultural references build on themselves.

There's another reason we're seeing more bright colors, which is that technology is both a liberator and a captor where color is concerned. As any designer knows after venturing into the world of the Web, color is restricted on the Internet; woe betide the site-creator who fails to make his or her colors Web-safe. Since the Web defines the leading edge of both technology and culture, colors in printed products to some degree have adopted the look of those Web-safe colors, even if they aren't actually taken from the so-called browser CLUT (Color Look-Up Table).

Thus there's a "Web effect" even in the world of brochures, stationery, and annual reports. (Interestingly, although most designers find it impossible to be imaginative with color on a Web site, Seattle-based Robert Dietz has found a way to use dithering to create the effect of non-CLUT colors on the Web; see page 75.)

At the same time, digital technology has led to the development of hexachrome printing, whose color-separation scheme plays to the red, green,and blue of the computer screen, allowing printed paper to display colors remarkably like those seen on the computer monitor in vividness and intensity. Thus even where technology creates new possibilities for print, it tends to create them in a way that makes things look more like the digital world.

In a culture of seemingly simplified color, designers often achieve complexity and movement by arranging intense colors in jammed-together compositions, where you can count many hues that are either wildly complementary or closely related; this may be an unconscious effort to create television-like movement on a two-dimensional surface. Software effects such as gradations alter the communication very little, but show off the designer's technical skill at manipulating color. Images of technology abound; some are contemporary, while others, conveyed through the line art and flat color of retro style, recall an era when technology was newer and consumers had a more naive attitude toward it.

A countervailing trend in color has been the exploration of earth tones—perhaps as a protest against a too-technology-oriented culture, perhaps as a legacy of the environmental movement of the last several decades, or both. In unsophisticated hands this color style means the umpteenth combination of moss green, russet orange, off-white, and black. At the high end, it means beautiful blacks leavened with infinite forms of brown, from the palest beige to the richest chestnut, that recall us to the natural world. (This branch of color is sometimes used for a completely different purpose, though: to depict youthful alienation and urban disintegration. Everyone has seen a rock group posed in black leather against abandoned or threatening city surroundings.)

As in any era, the hardest thing for designers seems to be thinking beyond the forces that act on them in order to reach a more timeless relationship to color. It's hard, in part, because some clients don't want timelessness; these clients are in industries in which change is constant, and the designer must use color to show the company's easy command of that pace. At the same time, color is an extremely important part of branding, that watchword for the nineties, and branding requires long-range thinking.

Thus designers are in a special position—at least occasionally—to bring their own independent thinking to the many questions that color raises. These questions are especially important given the accumulated weight of all the color associations we take into our brains every day. Fortunately, even if they don't put it to themselves exactly that way, many designers do approach their color choices thoughtfully. And, of course, as technology continues to improve computers, color as we experience it in the digital world may gradually become more like that of the natural and analog worlds.

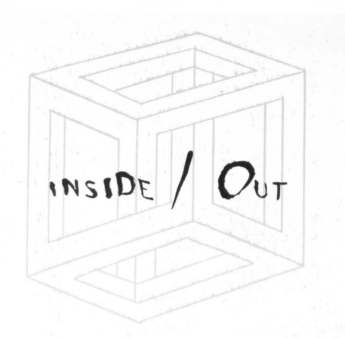

PROJECT: *Inside/Out* POSTER
DESIGN FIRM: SPUR DESIGN
DESIGNERS: JOYCE HESSELBERTH,
 DAVID PLUNKERT
PHOTO: ROB TREGENZA
CLIENT: CINEMA PARALLEL

Cinema Parallel presents **a film by Rob Tregenza** A Parallel Pictures and Baltimore Film Factory Production
Producers J.K. Lareckson and Tom Garvin Co-Producer Gill Holland Associate Producers Robert Sutton and J.C. Davidson
Featuring Frederic Pierrot, Stefania Rocca, Berangere Allaux, Tom Gilroy, Mikkel Gaup, Steven Watkins

Official Selection—Cannes 1997

As computers have made so much designed material slick and smooth, some designers have gone the other way, showcasing seemingly low-tech design that looks touched, perhaps even made, by human hands. Color choices in these situations can be funky indeed, as in this 1997 movie poster.

Spur Design's Joyce Hesselberth and David Plunkert used an M. C. Escher figure, and scanned in a photo of a dog against grass from the film, bitmapping it and enlarging it. Then they created a color-broken mechanical from laser prints from their own printer. The printing itself was black and a Pantone ink; Plunkert remembers the latter as simply "yellow."

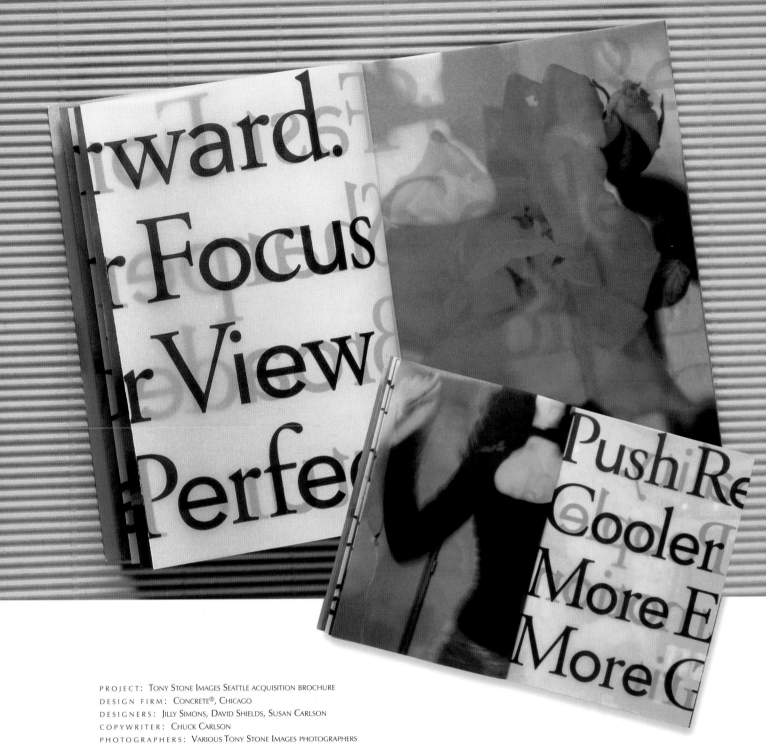

PROJECT: TONY STONE IMAGES SEATTLE ACQUISITION BROCHURE
DESIGN FIRM: CONCRETE®, CHICAGO
DESIGNERS: JILLY SIMONS, DAVID SHIELDS, SUSAN CARLSON
COPYWRITER: CHUCK CARLSON
PHOTOGRAPHERS: VARIOUS TONY STONE IMAGES PHOTOGRAPHERS
CLIENT: TONY STONE IMAGES

This direct-mail announcement of the acquisition of Seattle-based Allstock by Tony Stone Images serves as a mini-portfolio for the stock agency, and tells readers of the benefits of the new arrangement.

For the interior pages, Jilly Simons and her design team had images printed on one side of a 17-pound, satin-finish paper, then had each piece folded over. One "side" of a page therefore consists of a first translucent image, while the other "side" consists of a second image, seen ghosting through the first side, and vice versa. The result is an unusual color presentation; you might expect the colors in paired images to interfere with one another, but instead the technique renders each photo moody and striking—in some cases the colors are deepened, in others made more ethereal.

as we keep zeroing in on the results our clients aim for,

on work they can rely on and feel proud of, the Toolies don't seem

far away at all. Electronics, in fact, have made us very

close to what we hear is the real world. We know it's out there.

in fact, we have many clients who keep coming to visit our world.

they like it here.

PRINTS

Communication today is an artform - and printing is its own pallet, its own canvas. Or should be, we think.

BUCK McCAIN—WESTERN ARTIST

PROJECT: ARIZONA LITHOGRAPHERS BROCHURE
DESIGN FIRM: BOELTS BROS. ASSOCIATES
DESIGNERS: ERIC BOELTS, JACKSON BOELTS, KERRY STRATFORD
COPYWRITER: SARA HARRELL
PHOTOS: STEVEN MECKLER
PRODUCTION: MICHELLE RAMIREZ
CLIENT: ARIZONA LITHOGRAPHERS

At a time when designers evoke all things new and disjunctive by using intense, high-contrast color, Boelts Bros. Associates emphasizes continuity.

Although technically savvy, the Arizona-based firm eschews computer effects for their own sake, and a good amount of white space is a hallmark of their style. In addition, all three principals are artists; this, and their proximity to the muted shades of the desert, make them sensitive to natural hues. The colors they chose in this four-color marketing piece for Arizona Litho are easy on the eyes and, in keeping with the brochure's historical themes, seem lasting; in fact, although the piece was done in 1994, it is still used as the lithographer's primary marketing message.

PROJECT: CELCIUS FILMS INCORPORATED IDENTITY
DESIGN FIRM: SEGURA INC.
DESIGNER: CARLOS SEGURA
CLIENT: CELCIUS FILMS INCORPORATED

Chicago artist, typographer, and designer Carlos Segura accomplished a lot with very little in this identity for a new independent film company.

Composed of only two colors—black and a deep red—the geometric design incorporates a dot pattern executed in Adobe Photoshop, red lines of two thicknesses (thin and very thin), a small line drawing, and cool white expanses. The dot pattern, in particular, gives the stationery set a strong character. The white openings create a sense of dimension, both receding and zooming toward the viewer. They also have a precise, technical feeling, recalling film-roll sprockets, film labs, and line screens. Film started out as black and white, so there's a historical association, too. Finally, like much of Segura's work, the dots are slightly spooky-looking, giving it an indefinable but memorable quality.

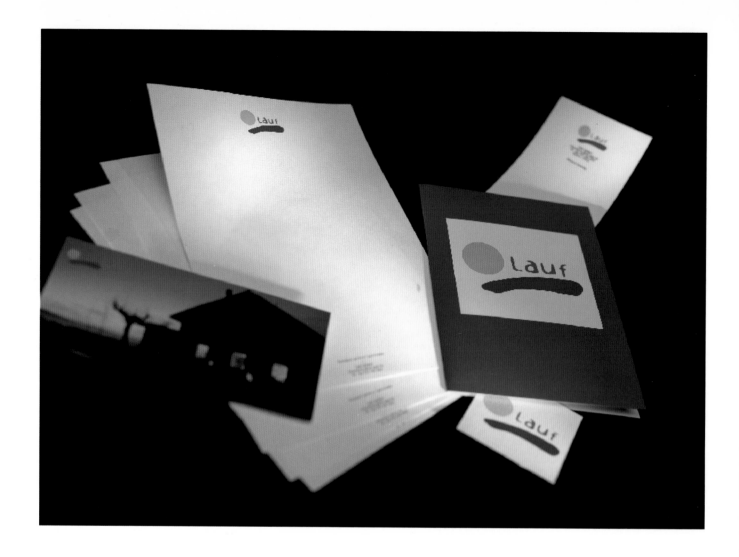

PROJECT: LAUF IDENTITY SYSTEM
DESIGN FIRM: MEDIA ARTISTS INC.
DESIGNER: FABIA PASINELLI
PHOTOS: ROB GUSSENHOVEN
CLIENT: LAUF

Creating new associations with traditional color groupings becomes more difficult as designed materials proliferate around us, but in a design climate so changeable it can induce exhaustion, the successful attempt can seem quite fresh—and for some clients, it's the right approach. One such client is Lauf ("the walk"), a Swiss restaurant whose growing popularity prompted it to ask Media Artists Inc. for a makeover of its rustic image.

Reworking the primary colors, designer Fabia Pasinelli used red for the logo, but deepened it until it was autumnal, almost brown. Yellow and blue are perhaps the most overused combination employed to suggest the alpine countryside, but here the rich yellow of the sun is a surprise, while the dense blue swash underneath ties the composition together and gives it authority.

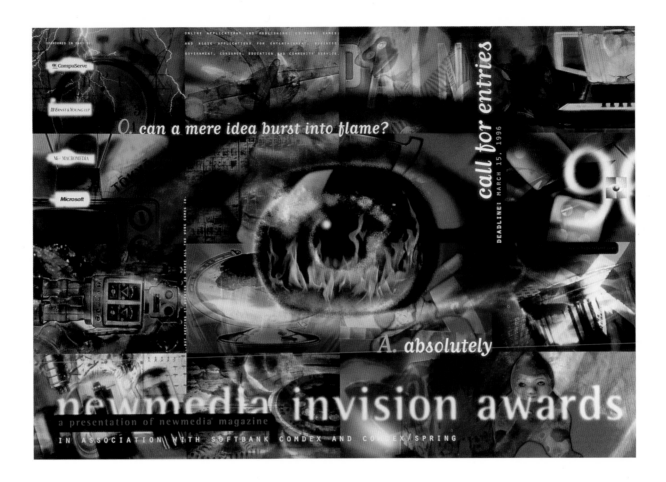

PROJECT: *NEW MEDIA* 1996 INVISION AWARDS CALL FOR ENTRIES
DESIGN FIRM: CRONAN DESIGN
ART DIRECTOR: MICHAEL CRONAN
DESIGNER: ANTHONY YELL
CLIENT: *NEW MEDIA* MAGAZINE

In 1996, in its second year of designing the call for entries for *New Media* magazine's Invision awards program, Cronan Design portrayed the Web as a layered, multidimensional information environment for the user.

Dividing a large sheet of 65-pound paper into panels, the designer assigned multiple images to each panel; the end result involved some eighty images. The self-mailing poster was folded several times, the informational side (printed in black and metallic silver on white) flying the piece. Opening the poster revealed its extraordinary array of colors. If anything represents the nineties approach to color, this piece surely does—its supersaturated hues, dense textures, and contiguous but unrelated images are a brilliant, revealing look at how technology has made an artificial world assume a heightened reality.

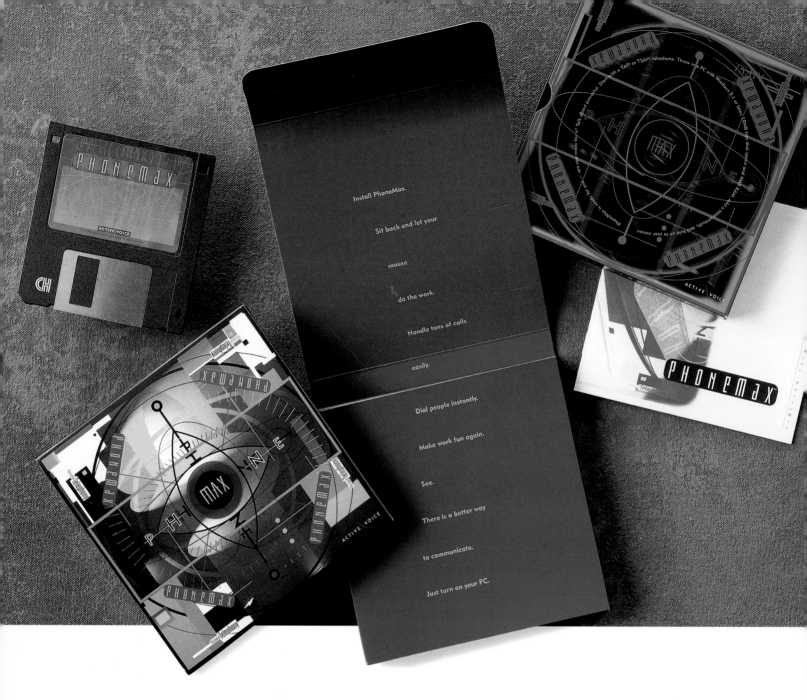

Install PhoneMax.

Sit back and let your

mouse

do the work.

Handle tons of calls

easily.

Dial people instantly.

Make work fun again.

See.

There is a better way

to communicate.

Just turn on your PC.

PROJECT: PhoneMax packaging
DESIGN FIRM: David Lemley Design
DESIGNER: David Lemley
CLIENT: Active Voice

Active Voice, which makes telephone software for computers, released PhoneMax—software that makes it possible to use voice mail on a PC—in 1996.

When David Lemley designed the packaging, he deliberately chose for one side of the box a blue that seemed high-tech and tuned-in, but had enough authority to feel "safe." On the other, he used color to indicate complexity, a technique used by many designers working on high-tech projects; this second outside surface presents a series of multiple, layered colors, their brightness contrasting with the smoother deep blue of the other side. Lemley says he thinks of the colors as day versus night, representing the many tasks that the software allows the user to handle.

who we are

We are a multidisciplinary design firm founded by creative director and principal Robert Dietz.

We located our offices in one of Seattle's most important high-tech areas: the historic Pioneer Square district, wh
kids." These "knowledge workers" are employed by the extraordinary number of Web-development, multimedia

Why is this significant? Because the stimulating environment and the concentration of talent here match our own
area, Northern California's Silicon Valley, San Francisco's Multimedia Gulch, and Silicon Alley in New York C

Our creative staff is as strong as our choice of location:

Robert Dietz
Founder and principal

Robert is fully trained in the traditional design disciplines and brings to his work a certainty in the power
give clients a way to see well-executed design incorporated not only into traditional media, but into new
advantage of all the opportunities available in today's market -- and keeps clients from having to repeat th
for lack of an experienced design partner.

This "bridging" approach is possible because of Robert's thor nology. He began s
formal training in two computer languages as well as HTML a d in the multimedia
bureau, where he was trained in computer troubleshooting at t ackground gives hi
multimedia and Internet design field.

After receiving his B.F.A. in Graphic Design at the University 8, Robert joined Te
he was responsible for art directing and designing projects fro and identity work t

He left TMA to take the Creative Director position at Seattle's a prominent recordi
and video packaging, as well as interactive marketing material omas Dolby, Jan H

Robert has won awards from the American Institute of Graphi esign Association, t
has been published in *Adobe Magazine* and in *Print*, *How*, *Ch g*, and *DTP Japan*

In 1995, Robert founded Dietz Design Co. and now art direct Web-site design to

who
we are

our
work

contact
us

PROJECT: DIETZ DESIGN CO. WEB SITE
<WWW.DIETZDESIGN.COM>
DESIGN FIRM: DIETZ DESIGN CO.
ART DIRECTOR: ROBERT DIETZ
DESIGNERS: ROBERT DIETZ, KRISTIE SEVERN
CLIENT: DIETZ DESIGN CO.

Robert Dietz positioned his company as one that handles both traditional and new media, and unlike most designers who get into interactive projects, Dietz himself has programming ability—along with some ingenious ways of dealing with the online environment's limitations.

For the company's own Web site, which he put up in late 1996, he wanted to include colors beyond the 216 included in the so-called browser CLUT. Instead of resigning himself to those colors, he used the phenomenon of dithering to simulate other, more interesting colors, such as the gray-green in the navigation bar, which is composed of a pixel-level checkerboard pattern of two blues and a pale umber (all three of them "Web-safe" colors), executed with the "pattern fill" command in Adobe Photoshop and repeated over and over.

PROJECT NAME: MABO COMPANY PRESENTATION
DESIGN FIRM: MEDIA ARTISTS INC.
ART DIRECTOR: MICHAEL CONNELL
DESIGNER: JOE CONNELL
PHOTOS: STUDIO GIANNI
CLIENT: BOTTONIFICIO MABO S.R.L.

In an era when "attitude" means straying outside the lines, a disciplined approach to color can convey exactly the opposite, allowing designers to demonstrate a client's ability to focus and its sustained attention span—both of which remain important in business.

The button manufacturer Mabo, which supplies the fashion industry, makes buttons of myriad colors, but when the client asked Media Artists for a piece that would present the company as a whole, it wanted the designers to capture its customer service philosophy and sophisticated production technology. Media Artists worked with a subtle black-and-white color scheme that included duotone photographs; to imply quality, the designers judiciously used silver.

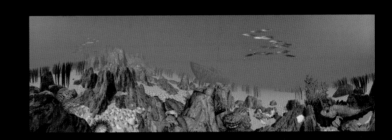

PROJECT: *WAYPOINT 1* CD-ROM
DESIGN FIRM: GYRO INTERACTIVE
DESIGNER: WAYNE RANKIN
PRODUCER/SYSTEMS INTEGRATOR: JOHN SWALES
CLIENT: MUSEUM OF VICTORIA

It takes a high level of artistry and technical sophistication to work with digital color in an animated interactive environment; when successful, the results literally glow, and the viewer suspends disbelief. One example is *Waypoint 1*, an imaginative CD-ROM done in 1996 by Gyro Interactive, a new-media offshoot of RankinBevers Associates, for the Museum of Victoria as a means for the museum to reach out to new audiences.

In one portion of the CD-ROM, prehistoric vistas, complete with dinosaurs, open up for the viewer; in another, brightly colored fish swim at the bottom of the sea. Not as false as cartoon colors but definitely different from those seen in print or the real world, these colors—to which we have habituated so quickly—create a whole new visual sensibility.

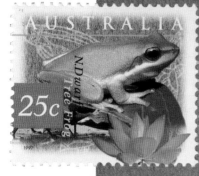

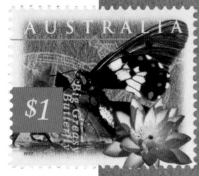

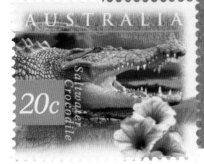

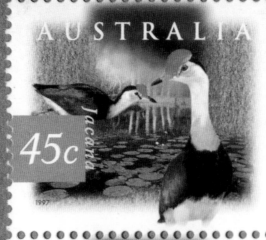

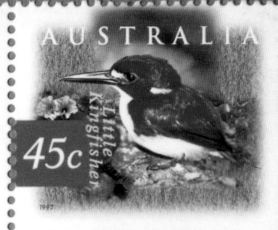

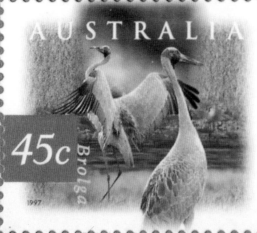

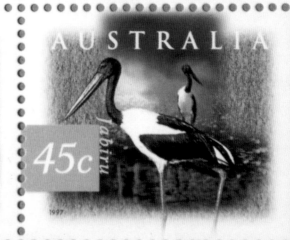

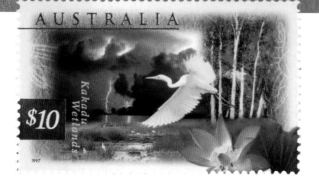

PROJECT: AUSTRALIAN WILDLIFE STAMPS
DESIGN FIRM: RANKINBEVERS ASSOCIATES
DESIGNER: WAYNE RANKIN
CLIENT: AUSTRALIA POST
ACKNOWLEDGMENT: NATIONAL PHILATELIC COLLECTION, AUSTRALIA POST

Few think of postage stamps as being problematic in terms of color, but Wayne Rankin was dissatisfied with illustrations commissioned for football stamps on behalf of Australia Post, so he improved both the color and the sense of movement in them using Adobe Photoshop.

When the time came to do wildlife stamps in 1997, he did even more computer work on the photographs he dealt with, compositing as many as twelve images in some of the stamps and enhancing the color balance and the detail. It was even possible to take the stamps through the prepress process with hi-resolution files, putting the post office on the front lines of digital technology.

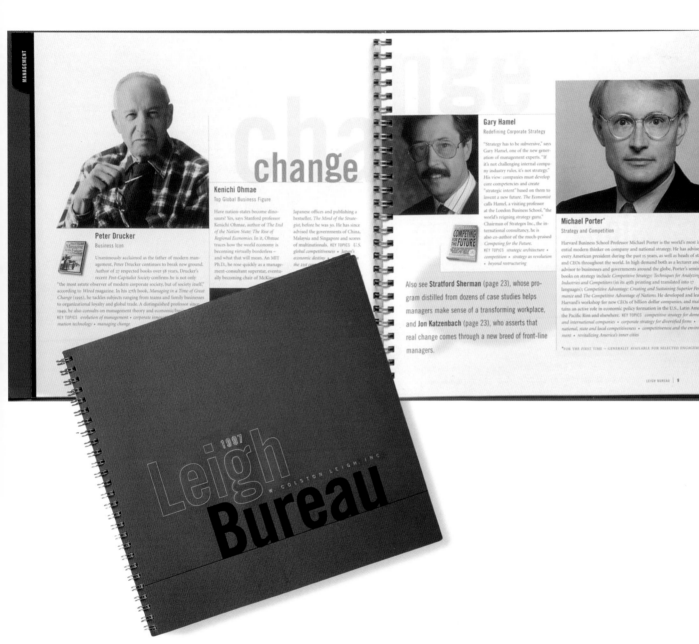

PROJECT: LEIGH BUREAU 1997 CATALOG
DESIGN FIRM: CARBONE SMOLAN ASSOCIATES
PRINCIPAL: LESLIE SMOLAN
DESIGNER: JOHN NISHIMOTO
EDITORIAL CONSULTANT: JULIE MOLINE
CLIENT: LEIGH BUREAU

Since desktop publishing became a reality in the eighties, designers have been overusing colored type. This beautiful piece from Carbone Smolan Associates shows the payoff for exercising discretion when technology makes combining color and type almost too easy.

In overhauling the 1997 catalog for the Leigh Bureau, a prominent speakers' organization, the designers used different-colored tabs for the catalog's six sections, with type reversed out in white. Headline type within each section matches its tab's color. The scheme's beauty is in its execution; differing shades of the section colors provide variety, there is plenty of white space, and the blacks and warm grays of the covers and tab pages make a relaxing, neutral framework.

PROJECT: MARGO CHASE DESIGN "CLICHÉ CARDS"
DESIGN FIRM: MARGO CHASE DESIGN
CREATIVE DIRECTOR/DESIGNER: MARGO CHASE
CLIENT: WESTLAND GRAPHICS, MARGO CHASE DESIGN

Although Los Angeles designer Margo Chase is best known for her cutting-edge custom typography for the entertainment business, she did a piece in 1997 that puts color out in front: a set of "cliché cards," which were a co-promotion with Westland Graphics.

Chase sketched the lettering, then scanned and refined it in Adobe Illustrator and Photoshop, with additional texture in Specular Infini-D. Remarkably, the six cards are four-color; some of their snap comes from spot gloss UV varnish, but the almost science-fictiony shine, translucence, and dimension given to the letters by the software treatment enhance the odd, slightly "off" colors dramatically, taking the idea of computer-manipulated color to an outlandish limit.

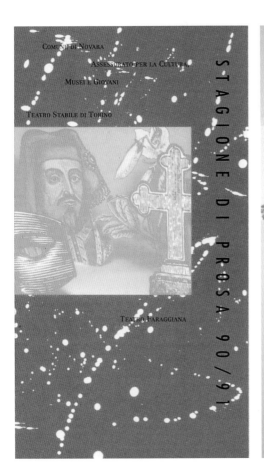

COMUNE DI NOVARA

ASSESSORATO PER LA CULTURA

MUSEI E GIOVANI

TEATRO STABILE DI TORINO

TEATRO FARAGGIANA

STAGIONE DI PROSA 90/91

IL MEDICO DEI PAZZI

Di Eduardo Scarpetta
Con Carlo Giuffré e Angela Pagano
Regia di Antonio Calenda
Teatro d'Arte
DAL 29 GENNAIO AL 3 FEBBRAIO

Dalle moltissime commedie scritte da Eduardo Scarpetta per la propria compagnia, quasi tutte sono, secondo la bella abitudine dell'epoca, riduzione di testi preesistenti, per lo più francesi. Con sovrana indifferenza, Scarpetta adattò e poi attribuì a sé stesso opere che, oltralpe, si sapeva benissimo di chi fossero. E disse suo anche questo Medico dei Pazzi che appartiene, invece, ad un tedesco. ● Il nuovo del teatro di Scarpetta, in qualche misura, consiste nella presenza di un "suo" personaggio, quel Felice Sciosciamocca che si ritrova in tante farse e commedie e che è, a modo suo, il surrogato del tramontante Pulcinella. Per il resto, la commedia vive di un suo ritmo irresistibile, naturalmente quello della grande farsa popolare che non esita di fronte a nessuna stravaganza e che fa dell'improbabilità la sua forza più vera. ● Il Medico dei Pazzi è commedia di grandi risorse farsesche, tutta giocata, com'è, sull'effetto dello sbalordimento, sulla "convenzionalità" della sorpresa e sulla stravaganza dei personaggi. Vertice della commedia è il secondo atto, nel quale ogni radice straniera viene dimenticata e Scarpetta si abbandona agli estri di una napoletanità travalicante e irrefrenabile, facendo affondare il suo Sciosciamocca, e altri con lui, in un mare di confusioni e di spropositi. ● Il Medico dei Pazzi è uno degli esempi più eloquenti di un genere teatrale che alla precisione del meccanismo chiedeva la sua efficacia e affidava la sua fortuna.

A CHORUS LINE

Versione italiana
Di James Kirkwood e Nicholas Dante
Regia di Saverio Marconi e Roy Smith
Compagnia della Rancia
DAL 12 AL 17 FEBBRAIO

A Chorus Line è il musical che ha resistito sulla scena di Broadway per il maggior numero di repliche consecutive: 6137, dal 15 aprile 1975 al 30 Aprile 1990, data annunciata come di definitiva chiusura. ● Sebbene tratti delle speranze, paure, frustrazioni e insicurezze di uno specifico gruppo di ballerini che fanno una audizione per la fila , il Musical abilmente esprime gli stati d'animo di quanti sono stati "in fila" nello sforzo di presentare se stessi e le proprie qualifiche per un lavoro. ● Nato da un'idea di Michael Bennett, che nel 1975 riunì in uno studio alcuni ballerini e raccolse in trenta ore di registrazione le loro confessioni, "A Chorus Line" è essenzialmente una serie di ritratti umani. Pungolato da un regista inflessibile (Zach), ogni aspirante rivela verità che, si suppone, aiuteranno a compiere la sua scelta finale: e così conosciamo Cassie, già ballerina solista ora aspirante alla fila, Val, che ha ampliato con il silicone la gamma dei suoi talenti, Paul, umiliato alla sua prima esperienza di attore in un locale di travestiti, Sheila, che si è data alla danza perché "tutto è bello nella danza". ● L'universalità delle sensazioni descritte, la spettacolarità tipica del musical di Broadway, la freschezza e la bravura dei giovani interpreti sono stati i segreti di tanto successo. Cerchiamo di riproporli nell'edizione italiana. ●

PROJECT: Stagione de Prosa brochure
DESIGN FIRM: Tangram Strategic Design
CREATIVE DIRECTOR: Enrico Sempi
ART DIRECTORS/DESIGNERS: Enrico Sempi, Antonella Trevisan
PHOTOS: Enrico Sempi, others
CLIENT: Comune di Novara

Done in the early nineties, this brochure for a city-sponsored theater group shows a lively—and successful—disdain for traditional color relationships.

The orange used by the designers for the soft-focus images spreads beyond the objects themselves, warming the whole page. The inset photos are printed in a gentle brown and the initial drop-caps are done in purple, also used on the cover. The designers wanted a more expressive approach than is typical in this kind of piece; it's hard to see how they would have succeeded so well had they used a more traditional color combination.

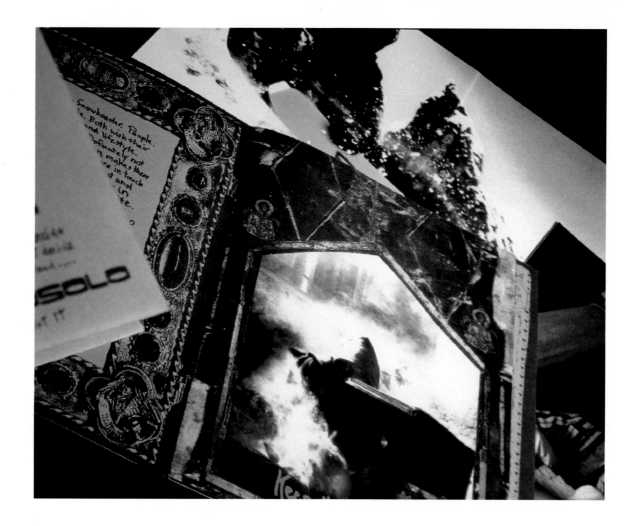

PROJECT: CERROSOLO IMAGE BROCHURE
DESIGN FIRM: MEDIA ARTISTS INC.
ART DIRECTOR/DESIGNER: MICHAEL CONNELL
ILLUSTRATOR: MARIO SACCHI
PHOTOS: XANDI KREUZEDER
COPYWRITER: J. C. MARIBONA
CLIENT: CERROSOLO GMBH

In the nineties, brown or sepia seems to symbolize real life as opposed to cyberspace. Yet it is so often combined with black and moss green, beige, or off-white that it's difficult to imagine it having anything fresh to say. Still, when Cerrosolo, a late entry into the snowboard clothing market, asked Media Artists for an image brochure, the designers turned to the most organic of all colors.

The resulting brochure was very different from the full-color, action-shot-filled pieces that typified other snowboard clothing makers' marketing. Dense with magical and religious images and poetic copy, the brochure suggests a mystical world—and is all the more effective for being executed (primarily with four-color process) in rich browns and sepias, with their antique look and mysterious shadows. It's hard to imagine standard full color working as well.

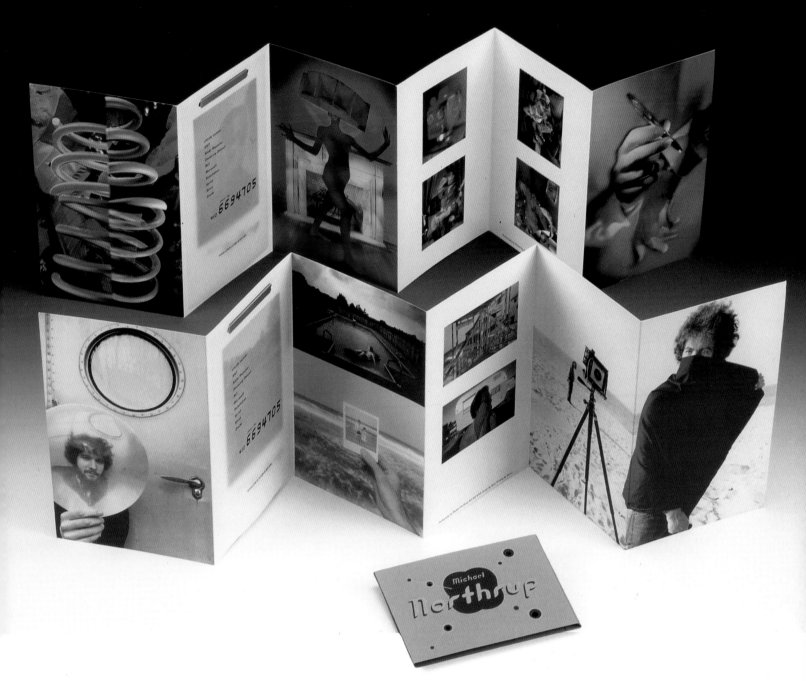

PROJECT: MICHAEL NORTHRUP PROMOTION
DESIGN FIRM: SPUR DESIGN
ART DIRECTORS/DESIGNERS: JOYCE HESSELBERTH, DAVID PLUNKERT
PHOTOS: MICHAEL NORTHRUP
CLIENT: MICHAEL NORTHRUP

It used to be that if a designer was having a client pay for color printing, a piece would probably be full-color throughout. Nowadays, color and black-and-white images coexist far more casually and comfortably.

This three-piece promotion for a Baltimore-area photographer, for instance, consists of two accordion-folded brochures—one full-color throughout, one in mixed full-color and black-and-white duotones—held together by a slide-off paper band. Color helps differentiate the aesthetics of the two brochures: one is filled with intensely colored images made using a photography method Northrup developed that includes a strobe wand; the other has both duotone black-and-white and full-color images that are more relaxed in tone, almost like snapshots. The band was printed in two colors (black and a PMS silver) on brown wrap paper.

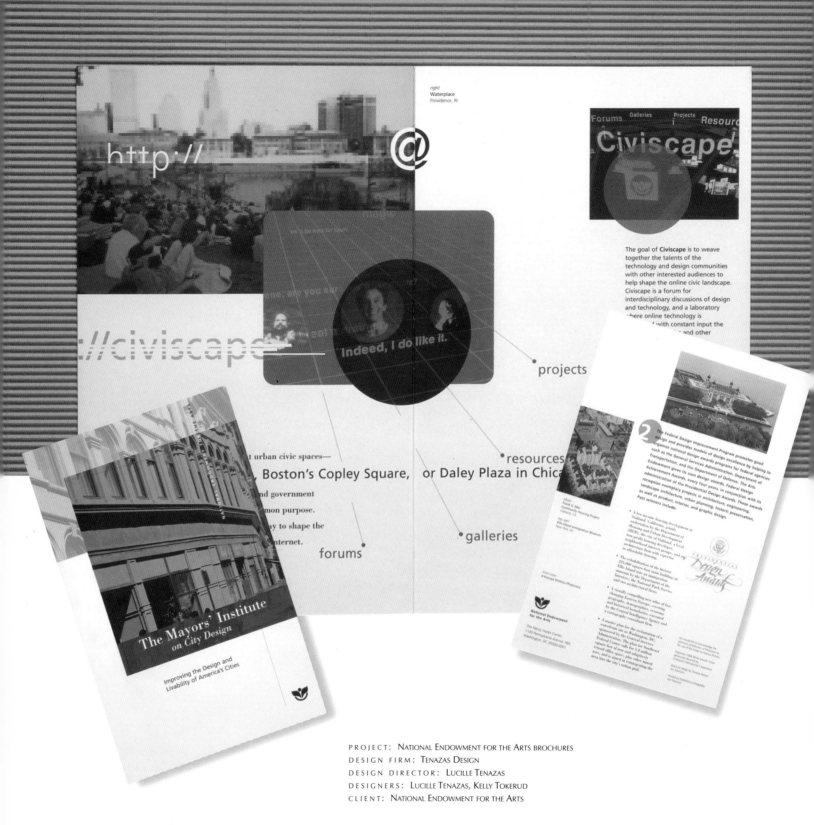

right
Waterplace
Providence, RI

http://

@

Forums Galleries Projects Resour

Civiscape

The goal of **Civiscape** is to weave
together the talents of the
technology and design communities
with other interested audiences to
help shape the online civic landscape.
Civiscape is a forum for
interdisciplinary discussions of design
and technology, and a laboratory
where online technology is
with constant input the
and other

///civiscape

Indeed, I do like it.

• projects

t urban civic spaces—

Boston's Copley Square,

d government

mon purpose.

ay to shape the

nternet.

• resources
or Daley Plaza in Chica

• galleries

forums

The Mayors' Institute
on City Design

Improving the Design and
Livability of America's Cities

PROJECT: NATIONAL ENDOWMENT FOR THE ARTS BROCHURES
DESIGN FIRM: TENAZAS DESIGN
DESIGN DIRECTOR: LUCILLE TENAZAS
DESIGNERS: LUCILLE TENAZAS, KELLY TOKERUD
CLIENT: NATIONAL ENDOWMENT FOR THE ARTS

**The ubiquitous computer-based images
we see in the nineties have led to a
computer-based color aesthetic as well,
in which colors are intense and super-
saturated, and often match those that
can be digitally displayed. Some design-
ers worry that a color sense based on
nature is being lost; one of them is
Lucille Tenazas, who is known for her
beautiful typography and unconventional
images.**

Tenazas's color aesthetic is subtle, as reflected in this series of
brochures done for the National Endowment for the Arts in 1997,
under the heading "Leading Through Design." The color in each
brochure is distinct, but somehow the palettes seem related, and rather
than intruding on the eyes and demanding attention, they allow the
viewer to approach them—much as the colors of nature do.

PROJECT: COMMUNICATIONNET LETTERHEAD
DESIGN FIRM: TANGRAM STRATEGIC DESIGN
CREATIVE DIRECTOR/ART DIRECTOR/DESIGNER/PHOTOS: ENRICO SEMPI
CLIENT: CARTIERA DI CORDENONS

One of the paradoxical qualities of color in the age of computer-based design is that, although variety is somewhat constrained by what computers can display, color can still be imaginative and interesting.

In this 1995 letterhead design Enrico Sempi captured color sets that suggest a realm of energy and flow—the realm of the computer itself and the work that can be done within it—without ever being explicit or representational. Although the colors are intense, they are fuzzy around the edges, which softens them. Surprisingly, they are all nature colors as well: the brown of the earth and the blue of the sea in one design, and the yellow and orange of sunset in the other.

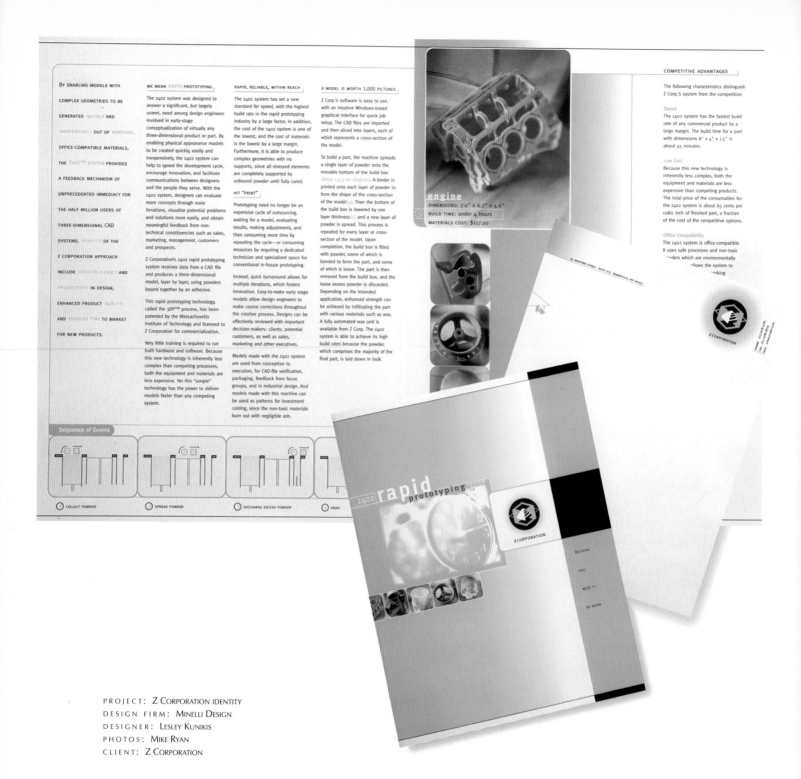

This identity, completed in 1997, was for a company producing a rapid prototyping machine for product-development firms.

The primary logo reflects the printer's three-dimensional layer-building process, while the gradations suggest its speed. The dark blue of the outer folder conveys credibility and stability, key characteristics in the rapidly changing high-tech environment. The most interesting element in the identity, though, may be the fluorescent pink used on everything except the folder. The color is bright, cheerful, young—all qualities associated with products like, say, surfboards. But it is also visually associated with polymers and other high-tech materials, which are pertinent to Z Corporation's product, and because of that, it has an association with the fabrication and manufacturing processes.

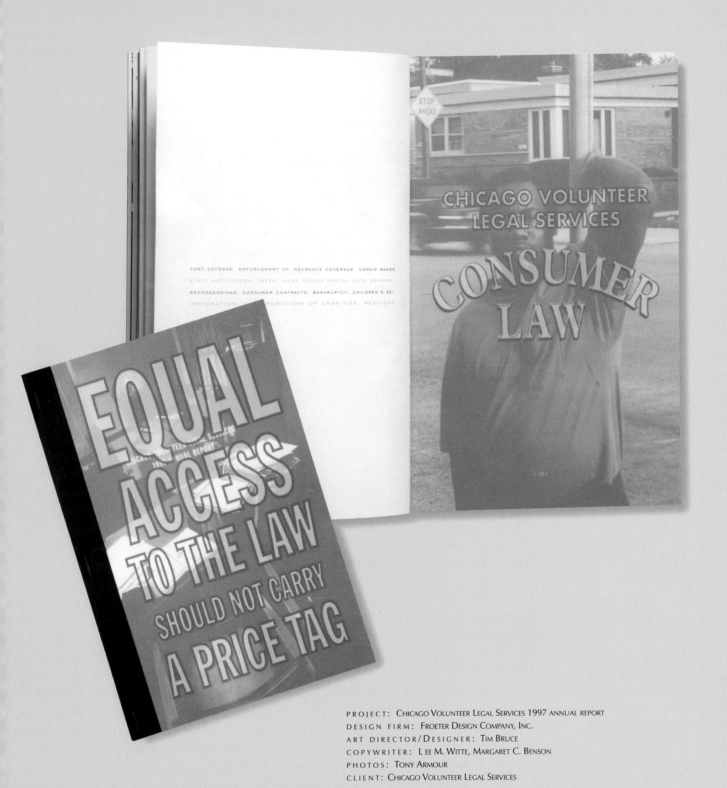

PROJECT: CHICAGO VOLUNTEER LEGAL SERVICES 1997 ANNUAL REPORT
DESIGN FIRM: FROETER DESIGN COMPANY, INC.
ART DIRECTOR/DESIGNER: TIM BRUCE
COPYWRITER: LEE M. WITTE, MARGARET C. BENSON
PHOTOS: TONY ARMOUR
CLIENT: CHICAGO VOLUNTEER LEGAL SERVICES

Given how difficult it is to escape from a consumer culture's intense colors, it can be instructive to see how effective lack of color can be. Froeter Design created this annual report for the state of Illinois' largest general law firm serving the working poor.

The report, produced in three Pantone colors, illustrates the group's achievements through the eyes of its clients. The front cover shows the overall message of the piece. The most striking element is the type on the translucent pages opening to each of the five practice areas. Typeset and then distorted on the computer to look old, they call to mind office doors of the thirties and forties and establish the unpretentious approach that CVLS employs.

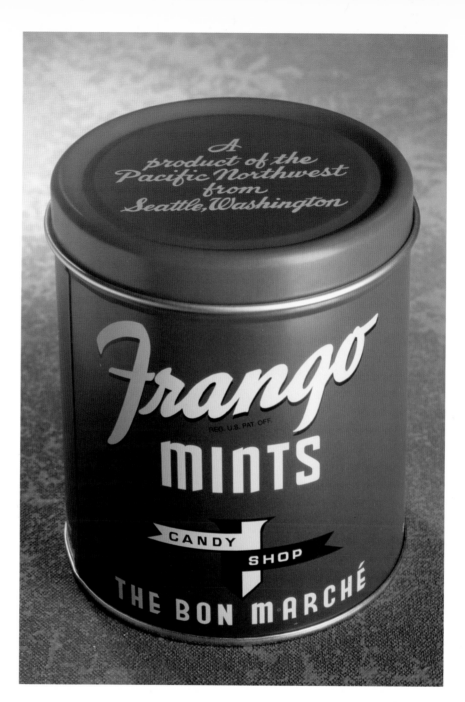

PROJECT: Frango Mints packaging
DESIGN FIRM: David Lemley Design
ART DIRECTORS: Robert Raible,
Kevin Gardiner
(The Bon Marché)
DESIGNERS: Alfred Dunn (ca. 1936),
David Lemley
CLIENT: The Bon Marché

Acknowledging the past gracefully is an art in itself, as this project shows. In 1995 the Seattle department store The Bon Marché asked David Lemley to transfer to it the brand heritage for Frango Mints from Frederick & Nelson, the failed department store that originally sold the legendary chocolates.

Lemley used vintage Frango packaging art as a starting point, and made only minor changes to the typography. He and his colleagues went to great lengths to achieve the distinctive, nostalgic green, running it twice for richness and including significant amounts of a dulling agent in the ink, so that the can would look like an old tin that had aged. The white is actually a warm gray that was allowed to be slightly runny. Lemley says the slight imperfections in the final product are, in this case, perfect.

Pull our chain.

informed creativity

Fitch is an international consulting organization with over thirty years of experience helping companies to achieve business success by design. We work in partnership with our clients to develop new products, new forms of communication, and new types of environments in response to their customers' needs.

Push our button.

®1998 Fitch Inc.

PROJECT: FITCH INC. WEB SITE
 <WWW.FITCH.COM>
DESIGN FIRM: FITCH INC.
PROGRAM MANAGER: STEVE SIMULA
DESIGNERS: STEVE SIMULA, SUZANNE WALSH
PROGRAMMERS: TONY RAMOS, HENRY SHILLING
COPYWRITERS: LORRAINE WILKIN, BILL FAUST
CLIENT: FITCH INC.

what we do

focus on fitch

who we work with

how we do it

who what how focus

back

we develop environments

we develop brands

we develop products

There are many ways to design a Web site, and many companies go the route of using intense colors. It's instructive, though, to see the opposite approach. Fitch Inc.'s site, launched in 1996, remains a model of restraint in terms of navigation, graphic style, and color.

The pages are almost monochromatic, taking their cue from the small, pale green placard that carries the Fitch name in black. Aside from that, there is the silver of the chain on the home page, the pale orange of the radiating lines on the mission-statement page, and the black of the type and icons. Even on the section pages, thumbnail monochrome project photos in purple, sepia, and blue don't expand the palette appreciably.

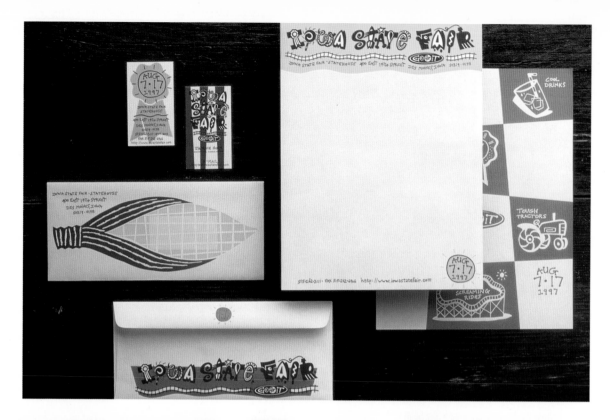

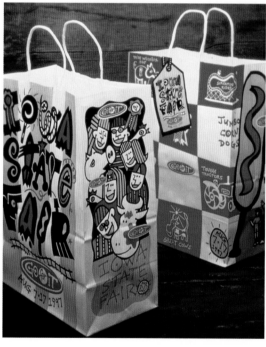

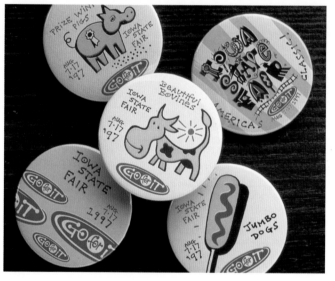

PROJECT: 1997 Iowa State Fair marketing campaign
DESIGN FIRM: Sayles Graphic Design
ART DIRECTOR/DESIGNER/ILLUSTRATOR: John Sayles
CLIENT: Iowa State Fair

Color "heritage" may matter even more now that changing economies are making so many traditional ways of living disappear. John Sayles used bright, flat colors effectively in the marketing campaign for the 1997 Iowa State Fair.

The campaign is filled with Sayles's original line art, done in a cheerful retro style. Virtually all the materials have a backdrop of red and white checks, associated with country tablecloths. Other icons of the Midwestern agricultural tradition are ears of corn, cows, and tractors. Sayles designed stationery, programs, brochures, shopping bags, T-shirts, buttons, billboards, and even a poster that could be printed as one large piece or three separate pieces, each of which works as a poster by itself.

The **communication core** is Gr8's WEB-BASED conference center which adds an important dimension to client service. It's our 24-by-7 virtual communications facility that serves as the central hub for all project-related communications.

.05 THE CORE

.05

By taking advantage of this forum, authorized members of the project team have **immediate on-line access** to all project related schedules, correspondence, content, graphic design, and multi-media elements, all the time.

To learn more about the **communication core**, click here.

Client Login:

Aerotek ▼

Name: []

Password: []

(Enter Private Client Area)

"Best Site Design"- Gr8 helps NGA win InternetWeek's BOTI Award

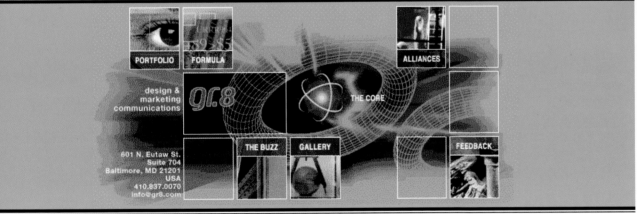

PORTFOLIO FORMULA ALLIANCES

design & marketing communications

gr8 THE CORE

601 N. Eutaw St.
Suite 704
Baltimore, MD 21201
USA
410.837.0070
info@gr8.com

THE BUZZ GALLERY FEEDBACK

sitemap graffitoactive8

PROJECT: GR8 WEB SITE
<WWW.GR8.COM>
DESIGN FIRM: GR8
CREATIVE DIRECTOR: MORTON JACKSON
DESIGNERS: MORTON JACKSON, HEATH FLOHRE, BECKY BOCHATEY, MATT AGRO
PROGRAMMERS: HEATH FLOHRE, CHRIS WALSH
COPYWRITERS: ART BALTER, JASON BARANOWSKI
CLIENT: GR8

This Web site illustrates how color can help create an electronic "space" in the Web environment.

The site uses a brilliant lime green as its signature color, paired with an unusual dark turquoise. Spinning away into the green void are two tilted toruses, their forms defined by line grids. The site is frame-based, and the toruses appear again in the upper right-hand frame whenever the viewer goes to a new section. There, the torus image is in moss green, paired with smaller lime-green elements and an image from the section in question. The colors are always odd together; such combinations have become a signal of screen-based environments.

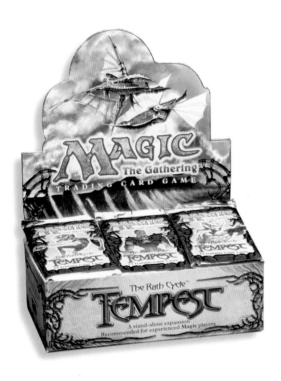
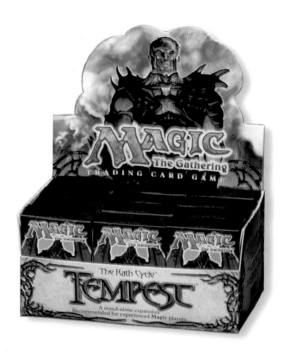

PROJECT: MAGIC: THE GATHERING® TEMPEST™ PACKAGING
DESIGN FIRM: WIZARDS OF THE COAST®
CREATIVE DIRECTOR: CHAZ ELLIOTT
ART DIRECTOR/DESIGNER: DANIEL GELON
ILLUSTRATORS: MARK TEDIN, ANSON MADDOCKS, KEV WALKER, MATT WILSON
CLIENT: WIZARDS OF THE COAST®

Fantasy-based games such as the popular Magic: The Gathering® have created an extremely successful aesthetic. In this context, colors have unexpected associations, as in this set of cards introduced last year with two different display boxes.

The design of these boxes was a little different for Wizards of the Coast®. Gelon wanted to give special emphasis to story and character elements. The back of each box therefore stands up to form a continuous illustration featuring the main characters and locations from the story background relevant to the Tempest™ set of cards. Red and blue are usually patriotic colors for Americans, but here they take on ominous associations because of the setting.

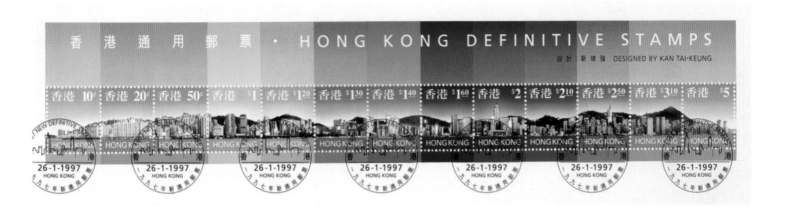

香港通用郵票 · HONG KONG DEFINITIVE STAMPS

設計：靳埭強　DESIGNED BY KAN TAI-KEUNG

PROJECT: Hong Kong definitive stamps
DESIGN FIRM: Kan & Lau Design Consultants
ART DIRECTOR/DESIGNERS: Kan Tai-keung
COMPUTER ILLUSTRATOR: Benson Kwun
PHOTOS: Kan Tai-keung, Hong Kong News Department
CLIENT: Hong Kong Post Office

This project, executed in Macromedia FreeHand and Adobe Photoshop, shows how well computer effects (so often misused) can work. The Hong Kong Post Office introduced the stamps last year for use during the transition from British to Chinese sovereignty.

The designer used a photograph of Hong Kong's coastline and marked thirteen vertical panels along its length. Then he established a horizontal "rainbow," beginning with a pinkish color on the left and progressing through the yellows, greens, blues, and purples, finally returning to the warm colors again on the right. Moving downward, the color gradually lightens until it meets the horizontal perforation that bisects the series. Then it begins strongly again, lightening downward until it ends in a white "blush" just above the land or buildings in each panel.

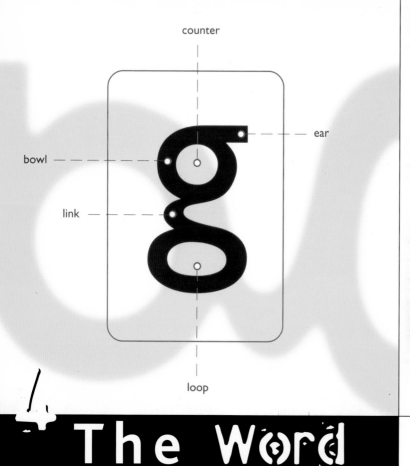

counter

ear

bowl

link

loop

Cap

Stalk

Volva

Mycelium

Rhizomorph

The Word

Of all the changes that digital technology has wrought, perhaps none has been as controversial among designers as the fact that it made typography accessible to anyone with a computer and the right program. Complaints were loud and long when "grunge" typefaces, made possible by type-design software, made their appearance in the early nineties. Complaints went on for years; it's still possible to find American designers, at least, who seem personally annoyed by grunge progenitor David Carson and his many imitators.

Since then, though, several things have happened. First, the public has become more adept at deciphering unconventional letter forms; in fact, some degree of "grunginess" in type has become more or less mainstream, especially in television and magazine advertising aimed at youthful markets, and thus less alternative.

Second, the Web has taught everyone concerned with type a degree of humility; when you can't control what type looks like to your ultimate reader, mutual recriminations about typeface design seem a little beside the point. What is possible on the Web in terms of type will eventually change, but even the newest, most advanced Web sites haven't exactly been typographers' dreams.

Third, designers of all generations have moved beyond the "type wars" debate to reach positions that accommodate each other to some degree. Older designers generally admit that the debate has been useful, while many younger ones have found themselves growing bored with garage typefaces and are gravitating back to traditional type, viewing it with new appreciation. And overall, during the nineties, computer type, which started its life looking sharp and clean-edged, has become loose, organic, and

seemingly hand-drawn, responding to the public's growing interest in anything that looks as if it were done by a human being.

Despite all these moves toward reconciliation, deep divisions remain, along with fundamental questions. Is it true, as grunge designers insisted, that people no longer read, or do they no longer read because the way things are designed makes reading too difficult? Is type a means of communication, or a graphic object? And what's more important to communicate: words and ideas or attitude and raw energy?

The answer in each case may well be "all of the above." For example, it's hard to believe that book design—the ultimate form of typographic communication—has suffered over the last five years; quite the opposite seems to be true. Yet it's undeniable that people find it harder to set aside time to read, and that attention spans in general are down, victims of the need for speed to which the world seems addicted. If people have learned to recognize grunge letter forms, it may simply be in self-defense as things speed up around them.

Even more interesting is the question of what's being communicated to whom. Visual communication nowadays is very targeted; "segmentation" is not just a factor in direct-response marketing, it's also a truism in a world where the Internet allows everyone to select what information he or she receives. In this context, type choices to some extent become a kind of code rather than a means of delivering universal messages: to communicate with eighteen-year-old males, use ultra-grunge and loud colors; to reach fifty-year-olds of both sexes, use traditional typefaces and increase the point size; and so on. When you're thinking about the psychographic projections for your client's product, even beauty itself, so often invoked as a quality that justifies traditional type design, is not the unimpeachable value it once was. Marketing is about getting the message across, not about being beautiful. At the other end of the scale are today's very young designers, who are often (their elders lament) not being trained in design principles at all, much less in the understanding of typography; how they will translate the demands of the marketplace remains to be seen.

There are other, even larger issues. Font-design software, combined with desktop publishing technology, makes it possible for computers to display a wide variety of languages, even as English has moved toward becoming the international language of business. Conversely, in an increasingly global economy, designers, especially those doing marketing work for corporations, are asked to produce materials in more than one language—sometimes in multiple languages. Some international designers have become somewhat accustomed to working with English, but for those without a multilingual background, the requirement that "type" include languages they themselves cannot read is often an experience with unexpected pitfalls. One American designer, producing part of a marketing brochure in an Asian language, found that the translation service he was working with couldn't be relied on to catch typos—he had to point them out himself over several rounds of review, using feedback from the client.

Finally, beyond the question of how type—wherever it appears—looks, there is the matter of how (and whether) people read on the computer screen. Some designers brusquely turn this discussion elsewhere, saying that "reading" doesn't accurately describe what people are doing when they're online and that the question isn't helpful. Others believe that people do, in fact, read material on computer screens, and that we need different ways of arranging words in the perceptual "space" represented by the computer before it's possible to know how to design typographically for the screen. Inevitably, this discussion will continue for some time, and the online public will contribute as much to it as designers themselves will. It's really here that typography's future lies—and that makes it perhaps all the more important that designers understand what they're doing when they design or use a typeface.

PROJECT: T-26 SUPPLEMENT NO. 19
DESIGN FIRM: SEGURA INC.
DESIGNERS: CARLOS SEGURA, SUSANA DETEMBLEQUE, JOHN ROUSSEAU, KRISTIN HUGHES
CLIENT: T-26

With this supplement, released in the summer of 1997, Segura's type foundry T-26—well known for its experimental computer type—took an interesting direction.

The collection of new fonts was packaged, as usual, cleverly: tabloid-sized "newspapers," with a font on each page in brown ink, sit in a thin yellow, gray, red, and white-checked cardboard box. More importantly, the fonts inside showed that Segura's international stable of designers was taking another look at traditional typefaces, and finding inspiration in them. These are still unmistakably nineties fonts (they have names like "Godlike" and "Leash"), but many are orderly in spirit and a few are quite beautiful.

it's about *people*,
not technology.

how people feel and what
they believe determines
what they will buy. *attitudes
determine* behavior. hint:
look for unrecognized human
needs. use them to create
new territory you can own.
the *answer* lies in leveraging
simple human emotions.

some things are beyond words.

PROJECT NAME: GVO BOOK #4: *SOME THINGS ARE BEYOND WORDS*
DESIGN FIRM: CAHAN & ASSOCIATES
ART DIRECTOR: BILL CAHAN
DESIGNER: KEVIN ROBERSON
PHOTOS: KEN PROBST
COPYWRITER: DANNY ALTMAN
CLIENT: GVO

When GVO, a product development company, asked Cahan & Associates to do a capabilities/case study brochure for it in 1996, the client may have envisioned the traditional 8¹/₂" x 11" (21.5 cm x 30 cm) glossy booklet. But Bill Cahan and his design team didn't feel a conventional design piece would do justice to GVO's unconventional approach to product research or its down-to-earth corporate culture.

Instead, Cahan's firm produced five tabloid-size booklets, each telling GVO's story in a slightly different way. This one is typical of the series: the paper quality and size are utilitarian, the design unpretty, the piece overall driven by ideas. News Gothic type was intentionally mistreated by faxing, photocopying, and so on to achieve a very "plain" effect, yet because of the copy, the brochure is a page-turner—a very un-design, nineties treatment.

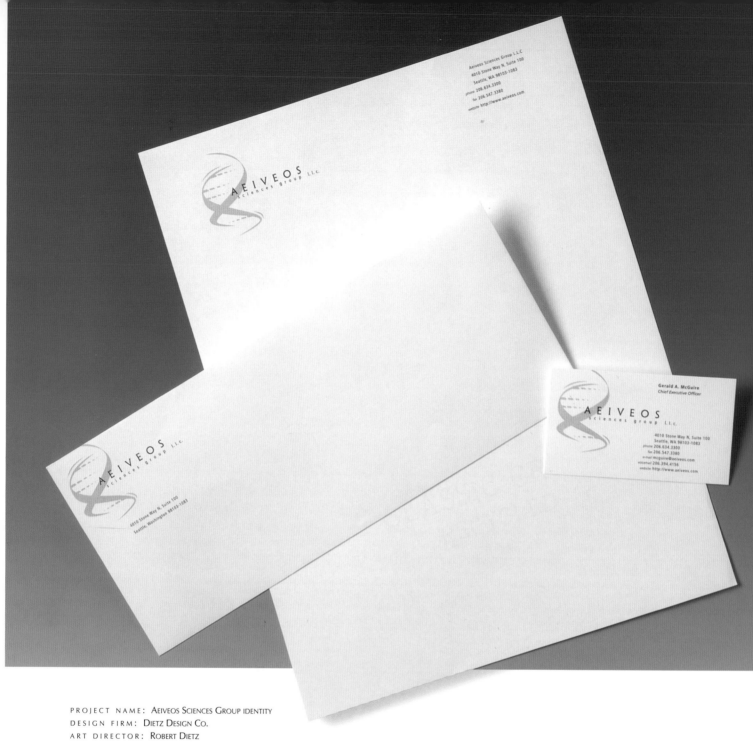

PROJECT NAME: AEIVEOS SCIENCES GROUP IDENTITY
DESIGN FIRM: DIETZ DESIGN CO.
ART DIRECTOR: ROBERT DIETZ
DESIGNERS: ROBERT DIETZ, KRISTIE SEVERN
CLIENT: AEIVEOS SCIENCES GROUP, L.L.C.

Robert Dietz's elegant 1997 identity for Aeiveos, a Seattle biotechnology research firm, began when the newly founded company asked him to design its Web site and he realized the company had no identity to work with.

For the logo image, he and co-designer Kristie Severn stylized the traditional double helix. For the main logotype, they selected the multiple master version of Adobe's Penumbra; its even strokes and understated serifs align the company name with the classical heritage it evokes (Aeiveos means "forever young" in Greek). The sans serif second line— lower case except for the modified capitals of "L.L.C."—complements the main logotype. For each identity he produces, Dietz says he "tries on" upwards of thirty typefaces—virtually impossible in the days of tissue-tracing by hand, but relatively simple on the computer.

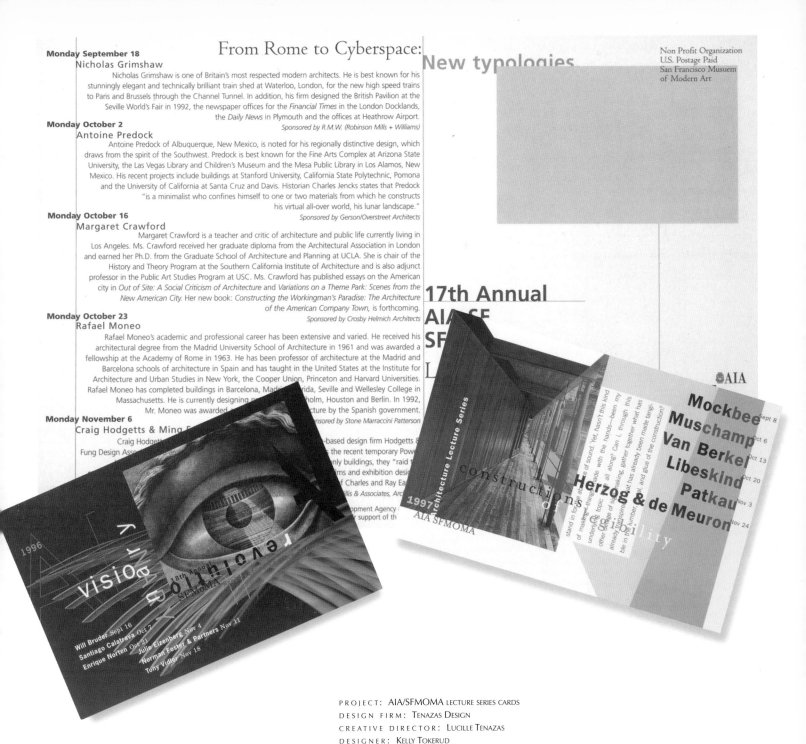

From Rome to Cyberspace: New typologies

Non Profit Organization
U.S. Postage Paid
San Francisco Museum
of Modern Art

Monday September 18
Nicholas Grimshaw

Nicholas Grimshaw is one of Britain's most respected modern architects. He is best known for his stunningly elegant and technically brilliant train shed at Waterloo, London, for the new high speed trains to Paris and Brussels through the Channel Tunnel. In addition, his firm designed the British Pavilion at the Seville World's Fair in 1992, the newspaper offices for the *Financial Times* in the London Docklands, the *Daily News* in Plymouth and the offices at Heathrow Airport.

Sponsored by R.M.W. (Robinson Mills + Williams)

Monday October 2
Antoine Predock

Antoine Predock of Albuquerque, New Mexico, is noted for his regionally distinctive design, which draws from the spirit of the Southwest. Predock is best known for the Fine Arts Complex at Arizona State University, the Las Vegas Library and Children's Museum and the Mesa Public Library in Los Alamos, New Mexico. His recent projects include buildings at Stanford University, California State Polytechnic, Pomona and the University of California at Santa Cruz and Davis. Historian Charles Jencks states that Predock "is a minimalist who confines himself to one or two materials from which he constructs his virtual all-over world, his lunar landscape."

Sponsored by Gerson/Overstreet Architects

Monday October 16
Margaret Crawford

Margaret Crawford is a teacher and critic of architecture and public life currently living in Los Angeles. Ms. Crawford received her graduate diploma from the Architectural Association in London and earned her Ph.D. from the Graduate School of Architecture and Planning at UCLA. She is chair of the History and Theory Program at the Southern California Institute of Architecture and is also adjunct professor in the Public Art Studies Program at USC. Ms. Crawford has published essays on the American city in *Out of Site: A Social Criticism of Architecture* and *Variations on a Theme Park: Scenes from the New American City.* Her new book: *Constructing the Workingman's Paradise: The Architecture of the American Company Town*, is forthcoming.

Sponsored by Crosby Helmich Architects

Monday October 23
Rafael Moneo

Rafael Moneo's academic and professional career has been extensive and varied. He received his architectural degree from the Madrid University School of Architecture in 1961 and was awarded a fellowship at the Academy of Rome in 1963. He has been professor of architecture at the Madrid and Barcelona schools of architecture in Spain and has taught in the United States at the Institute for Architecture and Urban Studies in New York, the Cooper Union, Princeton and Harvard Universities. Rafael Moneo has completed buildings in Barcelona, Madrid, Florida, Seville and Wellesley College in Massachusetts. He is currently designing in Stockholm, Houston and Berlin. In 1992, Mr. Moneo was awarded [...] architecture by the Spanish government.

Sponsored by Stone Marraccini Patterson

Monday November 6
Craig Hodgetts & Ming [...]

Craig Hodgetts [...] based design firm Hodgetts & Fung Design Asso[...] the recent temporary Pow[...] buildings, they "raid [...] and exhibition desig[...] Charles and Ray Ea[...] & Associates, Arc[...] Agency [...] support of th[...]

17th Annual
AIA SF
SF[...]
L[...]

⊕AIA

1997 Architecture Lecture Series
constructions of [...]
AIA SFMOMA

Herzog & de Meuron

Mockbee — Sept 8
Muschamp — Oct 6
Van Berkel — Oct 13
Libeskind — Oct 20
Patkau — Nov 3
— Nov 24

1996
18th Annual SFMOMA
visio[n] revolution
Will Bruder Sept 16
Santiago Calatrava Oct 7
Enrique Norten Oct 21
Julie Eizenberg Nov 4
Norman Foster & Partners Nov 11
Tony Vidler Nov 18

PROJECT: AIA/SFMOMA LECTURE SERIES CARDS
DESIGN FIRM: TENAZAS DESIGN
CREATIVE DIRECTOR: LUCILLE TENAZAS
DESIGNER: KELLY TOKERUD
CLIENT: AMERICAN INSTITUTE OF ARCHITECTS, SAN FRANCISCO CHAPTER

For grunge or experimental typographers, words are graphic elements; their placement should work visually, but they don't necessarily need to be readable. For classicists, communication is paramount. Now that the dust from the "type wars" has settled a bit, it's become obvious that placing words unconventionally doesn't necessarily make them unreadable—it can actually help, as these mailing cards by Lucille Tenazas make clear.

Publicizing a yearly series of lectures arranged jointly by the American Institute of Architects and the San Francisco Museum of Modern Art, the cards have type going every which way. But the reader has absolutely no trouble figuring out what's what in these movement-filled, layered compositions. In fact, the cards, executed consistently in Franklin Gothic, Mrs. Eaves, and Bell Gothic, are models of concise design—seemingly free-form yet effective and rigorous.

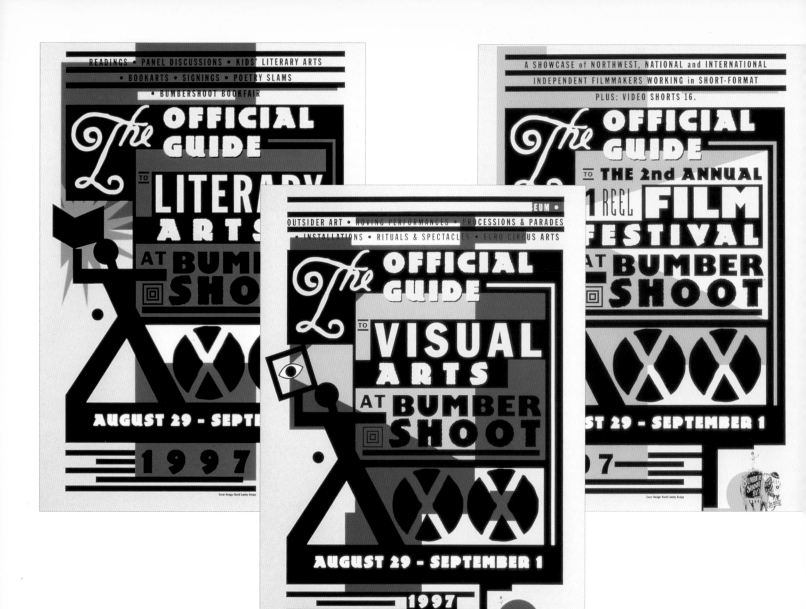

PROJECT: BUMBERSHOOT GUIDE COVERS
DESIGN FIRM: DAVID LEMLEY DESIGN
ART DIRECTOR: DAVID LEMLEY
DESIGNERS: TAWNYA LEMLEY, DAVID LEMLEY
ILLUSTRATOR: FRANK'S PLACE (BUMBERSHOOT ELEPHANT)
CLIENT: ONE REEL

Even as designers rush into the future, they mine the past with increasing aggressiveness; rarely do they do so with the flair shown in this project, however.

When Seattle's popular Bumbershoot arts festival published its first official guidebooks in 1997, cover designers Tawnya and David Lemley deliberately went retro in order to harmonize with the festival's 1997 publicity materials, which included the circus elephant in the lower right-hand corner of each guide. They drew a neo-constructivist figure, which held a different icon for each guide, and selected basic colors that would run well on the newspaper press they knew would be printing the covers. The type is deliberately imperfect; the designers chose Publicity Gothic for most of the words because they felt its rough edges gave it a uniquely American look.

PROJECT: HAWORTH INC. FURNITURE SHOWROOM
DESIGN FIRM: CONCRETE®, CHICAGO; BOOTH/HANSEN & ASSOCIATES
ART DIRECTORS: JILLY SIMONS (CONCRETE®, CHICAGO), THOMAS LEHN
(BOOTH/HANSEN & ASSOCIATES)
DESIGNERS: JILLY SIMONS, KELLY SIMPSON, MADELEINE KLEIN
PHOTOS OF SHOWROOM: BRUCE VAN INWEGEN
CLIENT: HAWORTH INC.

In three-dimensional environments as elsewhere, designers increasingly must help convey messages relating to cultural and business change. In this dramatic 1997 showroom for the furniture maker Haworth, Concrete® worked with a team that included architecture, interior design, photography, and lighting.

Jilly Simons and her co-designers floated a palette of words and food images on walls, screens, and freestanding clipboards that created a context for Haworth's new lines of office furniture: multilingual versions of the word "convergence" speak to the new global business imperative, food shows new combinations becoming commonplace, while scattered question marks imply an open, rapidly changing environment. While the type (in Trade Gothic and Triplex) suggests possibilities and driving forces, intensely colored light washes provide a stimulating backdrop—more reinforcement for the idea of flexible workspaces.

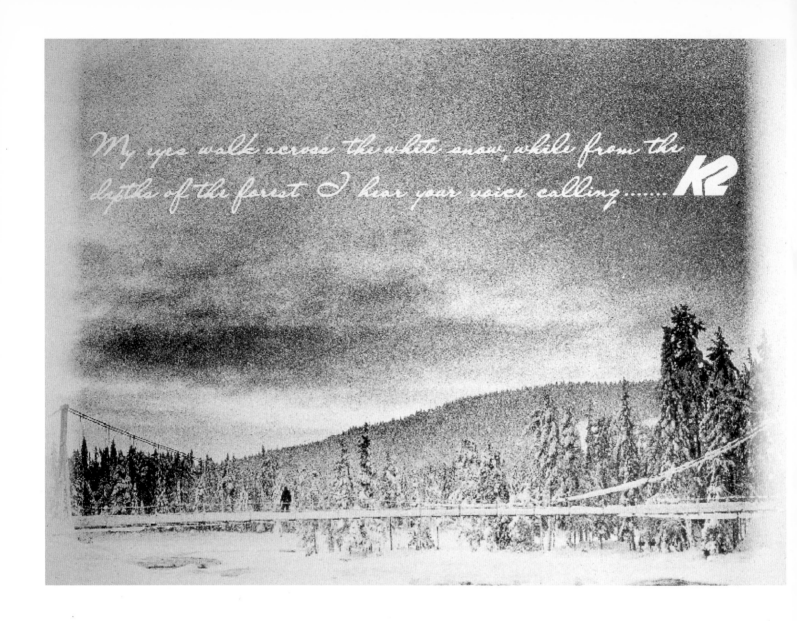

My eyes walk across the white snow, while from the depths of the forest I hear your voice calling........ **K2**

PROJECT: K2 IMAGE POSTER
DESIGN FIRM: MEDIA ARTISTS INC.
ART DIRECTOR/DESIGNER: MICHAEL CONNELL
PHOTOS: RENÉ RUSSO
CLIENT: K2 SKI SPORT GMBH

In an era of ever-intensifying speed, sometimes the most effective statement is one that slows things down, operates on a human scale, and triggers associations with feelings that aren't easily described.

K2 asked Media Artists Inc. to soften its image—previously associated with high-action, technical imagery—with a poster for the 1995 season, and this was the result: a duotone landscape that captures the oddly intimate feeling of being alone in nature, connected with something enormous and wordless. The copy also suggests a sense of connection, and the fact that it appears to be written by hand—the sentence is reversed out, as if written in snow—makes the thought seem even more personal, though we can't tell who is speaking or who or what the person is addressing.

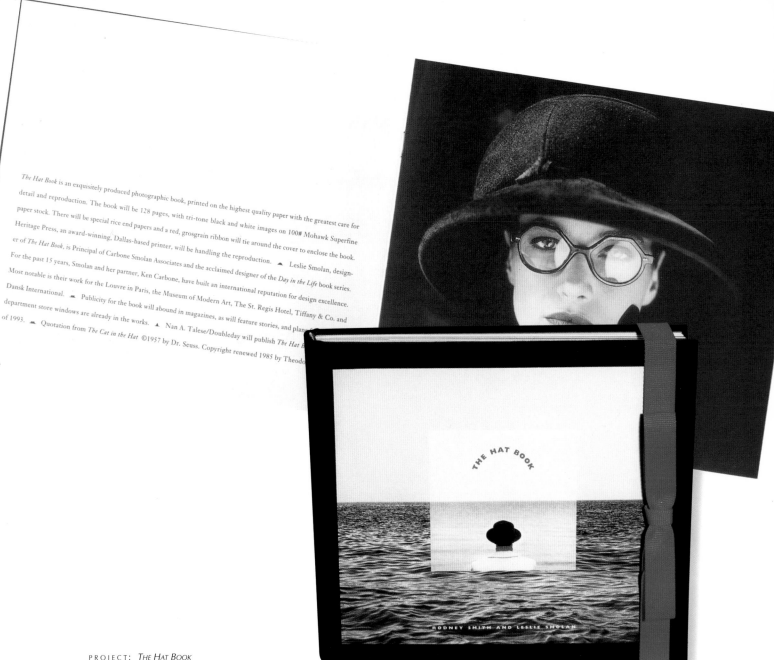

The Hat Book is an exquisitely produced photographic book, printed on the highest quality paper with the greatest care for detail and reproduction. The book will be 128 pages, with tri-tone black and white images on 100# Mohawk Superfine paper stock. There will be special rice end papers and a red, grosgrain ribbon will tie around the cover to enclose the book. Heritage Press, an award-winning, Dallas-based printer, will be handling the reproduction. ♠ Leslie Smolan, design-er of The Hat Book, is Principal of Carbone Smolan Associates and the acclaimed designer of the Day in the Life book series. For the past 15 years, Smolan and her partner, Ken Carbone, have built an international reputation for design excellence. Most notable is their work for the Louvre in Paris, the Museum of Modern Art, The St. Regis Hotel, Tiffany & Co. and Dansk International. ♠ Publicity for the book will abound in magazines, as will feature stories, and plan department store windows are already in the works. ♠ Nan A. Talese/Doubleday will publish The Hat of 1993. ♠ Quotation from The Cat in the Hat ©1957 by Dr. Seuss. Copyright renewed 1985 by Theodo

PROJECT: *THE HAT BOOK*
DESIGN FIRM: CARBONE SMOLAN ASSOCIATES
DESIGNERS: LESLIE SMOLAN, JENNIFER DOMER
PHOTOS: RODNEY SMITH
CLIENT: CARBONE SMOLAN ASSOCIATES

When desktop publishing made imaginative layouts easier to achieve, design seemed to lose its sense of how people read, and one of the most important skills a designer could master became how to display contemporary flair without driving the reader crazy.

In *The Hat Book* (and its publicity materials), Carbone Smolan Associates adopted the technique, still somewhat new at the time, of creating one column across an entire page; but, unlike many magazine designers, who are prone to do this in unhelpful typefaces, without adequate leading, or using pale, unreadable colors, the type here is classically oriented (Janson Text), airily leaded, and set in a warm black. Clever black hat-shaped dingbats denote paragraph divisions. Though published in 1993, the book remains a great example of how formal precision triumphs over trends.

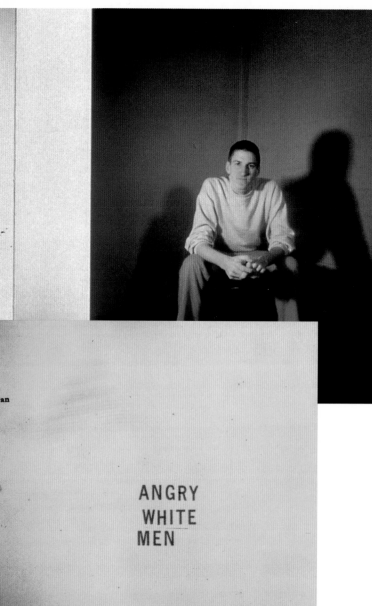

All day yesterday and most of today we watched TV coverage of the rescue crews inging the dead and injured out of the building. It is a heavy burden of responsibility for us to bear, since most of the victims of our bomb were only pawns who re no more committed to the sick philosophy or the racially destructive goals of e system. **But there is no way we can destroy the System without hurting nany thousands of innocent people – no way. It is a cancer too deeply ooted in our flesh.** And if we don't destroy the Syst before it destroys us – if we don't cut this cancer out of our living flesh – our wh race will die. We have gone over this before, and we are all completely convine that what we did is justified, but it is still very hard to see our own people suffer so intensely because of our acts. It is because Americans have for so many ye been unwilling to make unpleasant decisions that we are forced to make decisie now which are stern indeed." **from The Turner Diaries.**

TIMOTHY MCVEIGH

ANGRY
WHITE
MEN

PROJECT: *ANGRY WHITE MEN*
DESIGN FIRM: JOHNSON & WOLVERTON
CREATIVE DIRECTORS: HAL WOLVERTON, ALICIA JOHNSON
DESIGNERS: ROBIN MUIR, JEFF DOOLEY
PHOTOS: ROBBIE MCCLARAN
COPYWRITER: RENE DENFELD
CLIENT: ROBBIE MCCLARAN

This project won recognition in *I.D.* magazine's annual design review issue last year and presents a potentially incendiary subject in an extraordinarily subtle way. A collection of photographs by Robbie McClaran, the self-published book examines a range of white male subjects on the political far right, surrounding McClaran's images with text and captions.

The book's typographic choices are possibly the most important: cast entirely in Bodoni and Monotype News Gothic, the pages look like reprinted newspaper articles—but with tiny margins, constantly changing type sizes, and type quality that's even poorer than it is on real newsprint. Thus the design borrows the credibility and objectivity of mainstream newspaper journalism, but unravels them at the same time. Design's seemingly new ability to visually "deconstruct" such authoritative institutions gives it a far broader vocabulary.

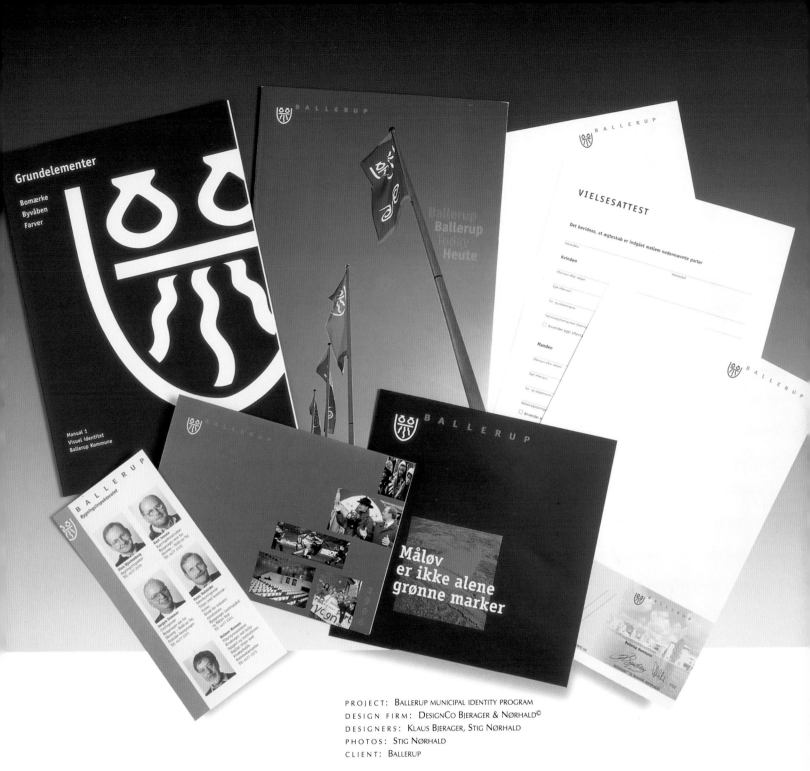

PROJECT: BALLERUP MUNICIPAL IDENTITY PROGRAM
DESIGN FIRM: DESIGNCO BJERAGER & NØRHALD©
DESIGNERS: KLAUS BJERAGER, STIG NØRHALD
PHOTOS: STIG NØRHALD
CLIENT: BALLERUP

Typographic solutions are often technical solutions as well, giving an edge to designers with mastery of, or access to, technological skills. In the early nineties, the Danish town of Ballerup had no unified identity program; in addition, an archaic computer network meant that Ballerup's employees faced special problems when they tried to create well-designed documents for production on their office printers—not the best situation for a town that is effectively the Silicon Valley of Denmark.

Designer Klaus Bjerager first devised a clean, contemporary update to the town's logo; he and partner Stig Nørhald went on to create an Officina-based visual identity as well as the extensive graphics standards for the program, and collaborated with a technology company to make it possible for city employees to create and print nice-looking documents smoothly.

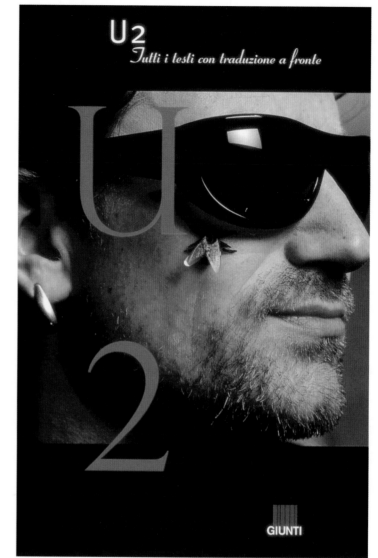

© GIUNTI GRUPPO EDITORIALE, 1995.

PROJECT: *U2* BOOK COVER
DESIGN FIRM: TANGRAM STRATEGIC DESIGN
CREATIVE DIRECTOR/ART DIRECTOR/
 DESIGNER: ENRICO SEMPI
PHOTOS: WOWE / AG. GRAZIA NERI
CLIENT: GIUNTI GRUPPO EDITORIALE

In certain design categories, success has become far more likely if the designer takes a new approach, as this book cover shows.

Produced for a series on rock groups for an Italian publisher, the cover has an arresting image with near-perfect close-up focus. Floating over it, the group's name is all the more striking for being set in an elegant, "classical" font (Meta Normal) in a welcoming blue that seems at odds with the subject matter. The solid black areas above and below the image recall museum art posters; in fact, creative director Enrico Sempi says he believes a book cover must be like a little poster, designed so that it can attract the reader from four or five meters (fifteen feet) away.

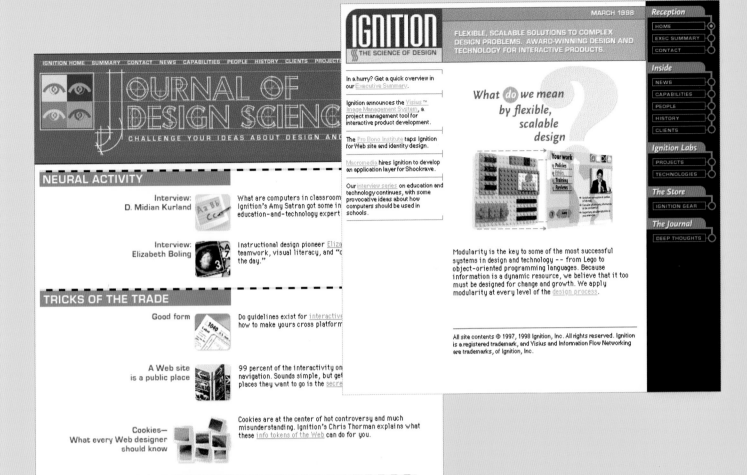

PROJECT: IGNITION WEB SITE
<WWW.IGNITIONDESIGN.COM>
DESIGN FIRM: IGNITION, INC.
CREATIVE DIRECTOR: RAY KRISTOF
TECHNICAL DIRECTOR: CHRIS THORMAN
WRITERS: AMY SATRAN, RAY KRISTOF, CHRIS THORMAN
CLIENT: IGNITION, INC.

So many Web designers' sites promise great strategic thinking, brilliant graphics, and fast downloads; making an effective statement is becoming very difficult. San Francisco-based Ignition did two things very well in its Web site, relaunched in 1997 when the company merged with a technology partner.

Ignition's strong suit of navigation signage emerges on the home page, which is thick with type but somehow uncluttered, in part because the designers chose sans serif faces with solid, consistent strokes (Eurostile, Scala Sans and—for the logotype only—Badloc). Second, the company chose to start an online journal as a way of marketing its ideas, and did it very well. This orientation toward type didn't keep them from creating 5-bit color graphics to ensure quick downloads, though.

PROJECT: New Reversal product launch system
DESIGN FIRM: Media Artists Inc.
ART DIRECTOR: Michael Connell
DESIGNER/ILLUSTRATOR: Joe Connell
COPYWRITER: Elias Jones
CLIENT: Imaging Services Group/New Reversal S.P.A.

A glut of technological images—along with an overuse of technical terms—have created a challenge to any designer seeking to brand a high-tech product or service over the last few years. Media Artists Inc. faced just such a challenge in 1996 when New Reversal asked the firm to help launch a new line of digital printing products.

Many images that combine the human face and digital technology have an alienating tone, but Media Artists left one of its model's eyes open; she looks slightly upward in quiet thought. The design has words associated with computers floating, each on a different layer, within the frame of her face; because of their placement, the illustration leaves an impression of knowledge contained within the human mind, rather than the mind uncomfortably racing to keep up.

When they call it "paradox," they're hiding the oxygen.

There's a special quality in a good translation that can never be captured in the original.

Travel light, stay alert, and eat what you kill.

Always look at the underside first.

When you find truth, pass it on, quick, before they bury it under money.

"The Revolution" devours its young.

To contact a human operator, press "zero."

WILLIAM GIBSON & BRUCE STERLING

PROJECT: 1994 MTV EUROPEAN MUSIC AWARDS PROGRAM PAGE
DESIGN FIRM: JOHN D. BERRY DESIGN
ART DIRECTOR/TYPOGRAPHER: JOHN D. BERRY
WRITERS: WILLIAM GIBSON, BRUCE STERLING
PHOTOS: PATRICIA QUINN
SCULPTOR: MICHAEL ACKER
CLIENT: MTV EUROPE

When MTV prepared for its first European Music Awards, writers, designers, and other cultural figures were invited to use pages in the program book as they saw fit. Asked by science fiction writer William Gibson to design his page, Seattle designer and writer John Berry collaborated with Gibson and fellow science fiction writer Bruce Sterling on an enigmatic assemblage with layered messages.

Ironic, paranoid, skeptical, and shrewd, the words seem to sum up the character of the nineties—as does the image's suggestion of material decay. Unlike much of the other material in the program, though, this page is completely readable. Berry made a Photo CD file from Quinn's photograph of a carefully colored foam slab into which a sign-maker had cut four words, and set the floating yellow text (in Meta) in an Adobe PageMaker file with an accompanying drop shadow.

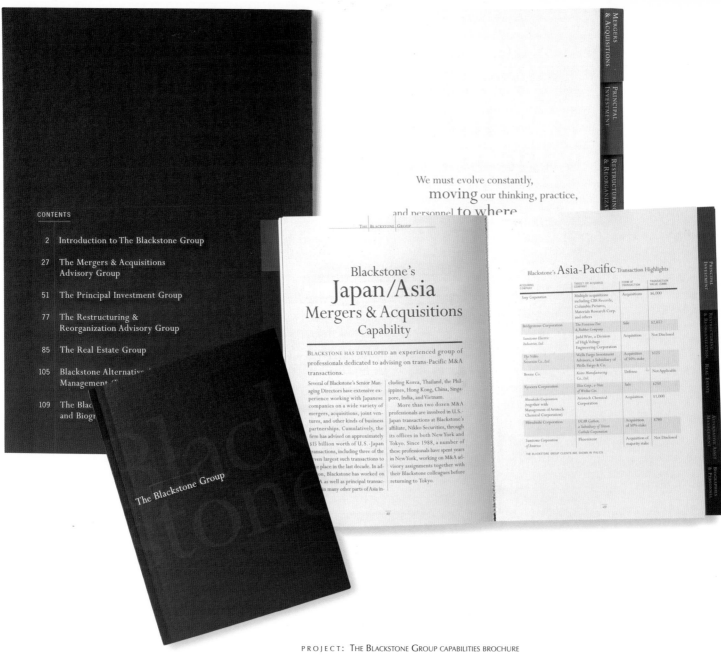

Blackstone's
Japan/Asia
Mergers & Acquisitions
Capability

BLACKSTONE HAS DEVELOPED an experienced group of professionals dedicated to advising on trans-Pacific M&A transactions.

Several of Blackstone's Senior Managing Directors have extensive experience working with Japanese companies on a wide variety of mergers, acquisitions, joint ventures, and other kinds of business partnerships. Cumulatively, the firm has advised on approximately $15 billion worth of U.S.-Japan transactions, including three of the seven largest such transactions to take place in the last decade. In addition, Blackstone has worked on M&A as well as principal transactions in many other parts of Asia including Korea, Thailand, the Philippines, Hong Kong, China, Singapore, India, and Vietnam.

More than two dozen M&A professionals are involved in U.S.-Japan transactions at Blackstone's affiliate, Nikko Securities, through its offices in both New York and Tokyo. Since 1988, a number of these professionals have spent years in New York, working on M&A advisory assignments together with their Blackstone colleagues before returning to Tokyo.

Blackstone's Asia-Pacific Transaction Highlights

ACQUIRING COMPANY	TARGET OF ACQUIRED COMPANY	FORM OF TRANSACTION	TRANSACTION VALUE ($MM)
Sony Corporation	Multiple acquisitions including CBS Records, Columbia Pictures, Materials Research Corp. and others	Acquisitions	$6,000
Bridgestone Corporation	The Firestone Tire & Rubber Company	Sale	$2,652
Sumitomo Electric Industries, Ltd.	Judd Wire, a Division of High Voltage Engineering Corporation	Acquisition	Not Disclosed
The Nikko Securities Co., Ltd.	Wells Fargo Investment Advisors, a Subsidiary of Wells Fargo & Co.	Acquisition of 50% stake	$125
Boone Co.	Kosei Manufacturing Co., Ltd.	Defense	Not Applicable
Kyocera Corporation	Elco Corp., a Unit of Wickes Cos.	Sale	$250
Mitsubishi Corporation (together with Management of Aristech Chemical Corporation)	Aristech Chemical Corporation	Acquisition	$1,000
Mitsubishi Corporation	UCAR Carbon, a Subsidiary of Union Carbide Corporation	Acquisition of 50% stake	$780
Sumitomo Corporation of America	Phoenixcor	Acquisition of majority stake	Not Disclosed

THE BLACKSTONE GROUP CLIENTS ARE SHOWN IN ITALICS

The Blackstone Group

We must evolve constantly, moving our thinking, practice, and personnel to where

CONTENTS

PROJECT: THE BLACKSTONE GROUP CAPABILITIES BROCHURE
DESIGN FIRM: CARBONE SMOLAN ASSOCIATES
PRINCIPAL: LESLIE SMOLAN
DESIGNERS: JOHN NISHIMOTO, KARLA HENRICK
CLIENT: THE BLACKSTONE GROUP

Much attention has been focused in recent years on designed pieces that carry a relatively small amount of text: Web sites, thin brochures, packaging, and so on. But there are many business opportunities for designers in industries that typically present many words and few pictures, and that require a reserved color palette to maintain the client's credibility.

Carbone Smolan Associates has mastered the art of visual communication when "visual" means words, as this 1995 capabilities piece for The Blackstone Group shows, and helped pioneer high-level design for financial services companies. Set entirely in Perpetua and News Gothic—the only images are black-and-white photos of the banking group's staff—the book uses an organized type system and subtle color gradations, in both ink and paper, to create a restful and extremely clear piece.

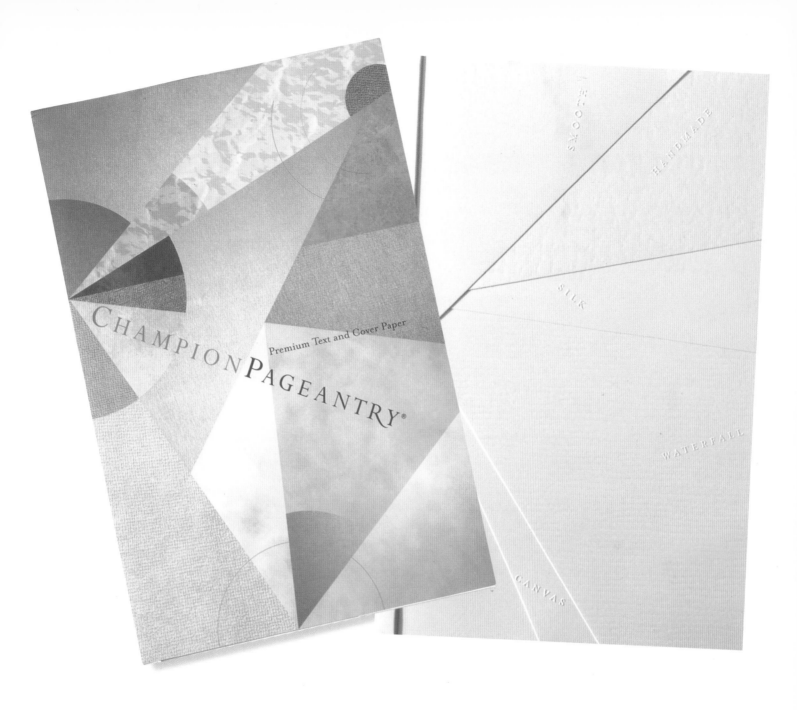

PROJECT: CHAMPION PAGEANTRY PAPER PROMOTION
DESIGN FIRM: TENAZAS DESIGN
CREATIVE DIRECTOR: LUCILLE TENAZAS
DESIGNER: KELLY TOKERUD
CLIENT: CHAMPION INTERNATIONAL CORPORATION

Being able to see new relationships among familiar elements has become, if anything, even more important in recent years despite the hectic pace of change and an ever-increasing volume of work. Lucille Tenazas showed that quality perfectly when she did a promotional piece for Champion Pageantry text and cover papers in 1997.

She picked up the peacock theme used by the designer of another Pageantry piece, recapitulating it abstractly on this promotion's cover. Inside, she decided to fan the different textures of the Pageantry line out—again, like a peacock's tail—and to allow designers' fingers to "read" the names of the different textures by having the names embossed in the eminently readable Mrs. Eaves. The result is an enhanced textile experience for the customer and a memorable design piece.

Garden Of Eden
Il giardino dell'Eden

It's a critical solution / La soluzione è pericolosa
And the east coast got the blues / La costa orientale ha il blues addosso
It's a mass of confusion / Solo confusione
Like the lies they sell to you / Come le menzogne che ti vendono

You got a glass jawed toothache / Hai la mandibola fragile
Of a mental disease / e un mal di denti
An they be runnin' round back / Da malattia mentale
See 'em line up on their knees / E loro ti correranno dietro come pazzi
'Cause the kiss ass sycophants / Guardali lì tutti in fila inginocchiati
Throwin' penance at your feet / Questi viscidi leccaculo
When they got nowhere to go / Che si prostrano pentiti
Watch 'em come in off the streets / Quando non sanno dove andare
While they're bangin' out front / Li vedi andare e venire per la strada
Inside they're slammin' to the crunch / Fuori tutto entusiasmo
Go on an throw me to the lions / Dentro rancore a stecca
And the whole damn screamin' bunch / Dai, datemi in pasto ai leoni
'Cause the pissed-off rip-offs / E al bastardo mucchio urlante
'R' everywhere you turn / Queste sanguisughe incazzate
Tell me how a generation's / Sono dappertutto
Ever s'posed to learn / Ditemi come fa una generazione
This fire is burnin' and it's out of control / A imparare
It's not a problem you can stop / Questo fuoco brucia senza controllo
It's rock'n'roll / È un problema senza risoluzione
È rock & roll

I read it on a wall / L'ho letto su un muro
It went straight to my head / Mi è andato dritto in testa
It said "Dance to the tension / Diceva: "Balla sul ritmo teso
Of a world on edge" / Di un mondo in tensione"
We got racial violence / Abbiamo la violenza razziale
And who'll cast the first stone / Chi lancerà la prima pietra?
And sex is used anyway it can be / E sesso usato in tutti i modi
Sometimes when I look out / A volte guardando fuori
It's hard to see the day / È difficile vedere il giorno
It's a feelin' you can have it / È un'emozione normale
It's not mine to take away / Non è tutta per me

66

Lost in the garden of Eden / Persi nel giardino dell'Eden
Said we're lost in the garden of Eden / Siamo persi nel giardino dell'Eden
And there's no one's gonna believe this / Nessuno lo crederà mai
But we're lost in the garden of Eden / Ma siamo persi nel giardino dell'Eden
This fire is burnin' and it's out of control / Questo fuoco brucia senza controllo
It's not a problem you can stop / È un problema senza risoluzione
It's rock'n'roll / È rock & roll
Suck on that / Succhiamelo

Lookin' through this point of view / Da questo punto di vista
There's no way I'm gonna fit in / Non mi va bene niente
Don't ya tell me what my eyes see / Non ditemi cosa vedono i miei occhi
Don't ya tell me who to believe in / Non ditemi in chi credere
I ain't superstitious / Non sono superstizioso
But I know when something's wrong / So quando qualcosa non va
I've been draggin' my heels / Mi trascino dietro
With a bitch called Hope / A una puttana di nome Speranza
Let the undercurrent / Lasciate che la corrente sotterranea mi
drag me along / porti con sé

Lost in the garden of Eden / Persi nel giardino dell'Eden
Said we're lost in the garden of Eden / Siamo persi nel giardino dell'Eden
And there's no one's gonna believe this / Nessuno lo crederà mai
But we're lost in the garden of Eden / Ma siamo persi nel giardino dell'Eden

Most organized religions make / Quasi tutte le religioni organizzate
A mockery of humanity / Si fanno beffe dell'umanità
Our governments are dangerous / I governi sono pericolosi
And out of control / E senza controllo
The garden of Eden is just another / Il giardino dell'Eden è un'altra
graveyard / tomba
Said if they had someone to buy it / Se qualcuno la comprasse
Said I'm sure they'd sell my soul / Venderebbero anche la mia anima

This fire is burnin' and it's out of control / Questo fuoco brucia senza controllo
It's not a problem you can stop / È un problema senza risoluzione
It's rock'n'roll / È rock & roll

Lost in the garden of Eden / Persi nel giardino dell'Eden
(An we ain't talkin' about no poison apple / (E non parlo di mele avvelenate
Or some missin' rib ya hear) / O di qualche costola in meno)

67

PROJECT: *Guns n' Roses* BOOK INTERIOR SPREAD
DESIGN FIRM: TANGRAM STRATEGIC DESIGN
CREATIVE DIRECTOR/ART DIRECTOR/DESIGNER: ENRICO SEMPI
PHOTOS: AG. GRAZIA NERI
CLIENT: GIUNTI GRUPPO EDITORIALE

In another book from Giunti Gruppo's series on rock artists, Tangram used a technique that looks deceptively like "grunge" typography.

In pages from 1996's *Guns n' Roses*, art director Enrico Sempi set English lyrics on the left in Perpetua, with the Italian translation on the right in Gill Sans. The two language sets are so close together they would almost touch were it not for the fact that the Italian lines are slightly lower. Despite the "alternative" appearance of this technique, the approach emerged from research showing what would make a low-stress reading experience—ample evidence that being thoughtful of the reader can produce great design work.

PROJECT: OVERLAKE PRESS 1996 CALENDAR
DESIGN FIRM: DAVID LEMLEY DESIGN
DESIGNER: DAVID LEMLEY
CLIENT: OVERLAKE PRESS

This cleverly designed calendar for a Seattle printer takes a respectful yet whimsical approach to type.

For its knowledgeable audience of art directors, designers, and production managers, designer David Lemley selected a different typeface for each month, then played around with it, as he does here with Kabel (May) and Times Roman (November). Lemley did extensive research and included quotes and other significant historical information relating to the faces, none of which was designed after 1960. Now in his mid-thirties, Lemley appears typical of designers his age, who got into computers early and use them extensively—but are tiring of the wild typography of the last few years. This piece is his homage to the typographers who inspired him most when he was a student.

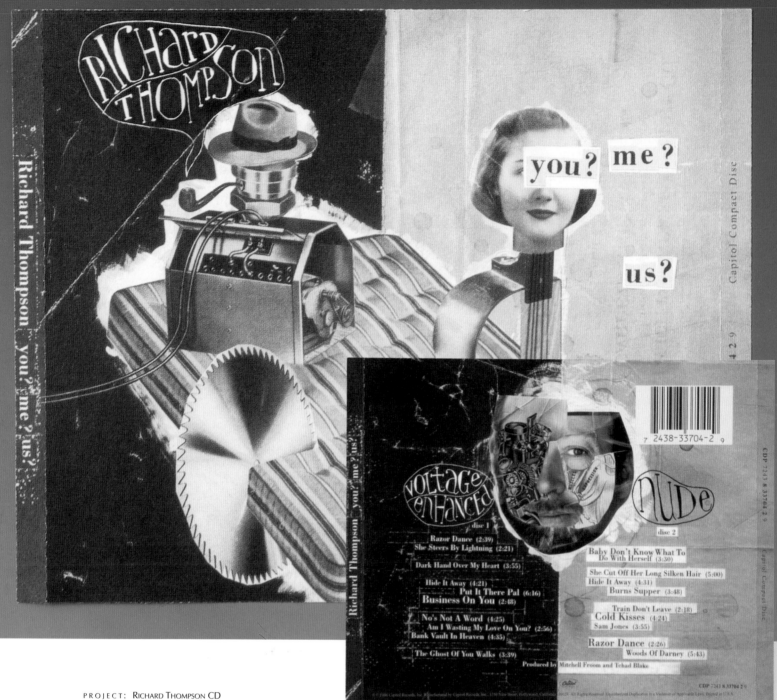

PROJECT: RICHARD THOMPSON CD
DESIGN FIRM: SPUR DESIGN
ART DIRECTORS: JEFF FEY, TOMMY STEELE, CAPITOL RECORDS
DESIGNER/ILLUSTRATOR (COVER): DAVID PLUNKERT, SPUR DESIGN
CLIENT: CAPITOL RECORDS

This 1996 CD cover shows the kinds of processes type can be put through in the era of computer-based design.

Contacted by Capitol Records to design and illustrate the front and back tray cards of a 2-CD set, Spur Design's David Plunkert created a front-cover illustration and a back-cover photo-illustration, and collaged them on the computer. He drew the lettering for front and back in pencil, scanned it, and reversed it; he set the CD title type and the type for the song titles in Adobe Illustrator, then printed the type and collaged it as mock mechanicals before rescanning it. This kind of softening treatment, which has become very popular, may in part be a reaction to the hard edges of computerized type.

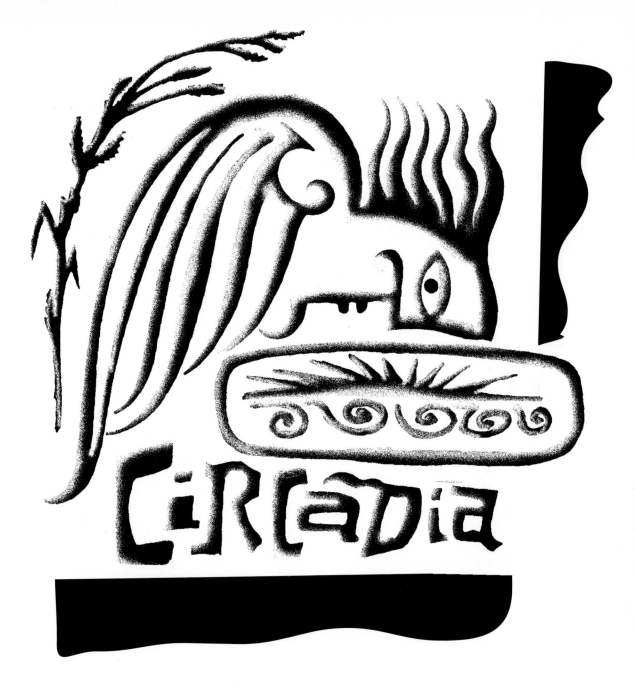

PROJECT: CIRCADIA LOGO
DESIGN FIRM: DAVID LEMLEY DESIGN
DESIGNER: DAVID LEMLEY
CLIENT: CIRCADIA

Though this logo for a Seattle flat-bread bakery and restaurant, done in 1996, was not used, it remains an interesting example of current design conditions.

Lemley's research revealed that bread was a universal food, found in all cultures, so he believed the lettering needed to speak to something primal. At the same time, it could not be literal, and it had to have a sound relationship with the elemental iconography with which Lemley surrounded the name. His approach was to hint at a Near Eastern look, with strong, somewhat angular shapes, and an unusual serif on the "D" that almost becomes its own character. This sensitivity to cultural nuance is important in an era when design is one of a new business's most important marketing tools.

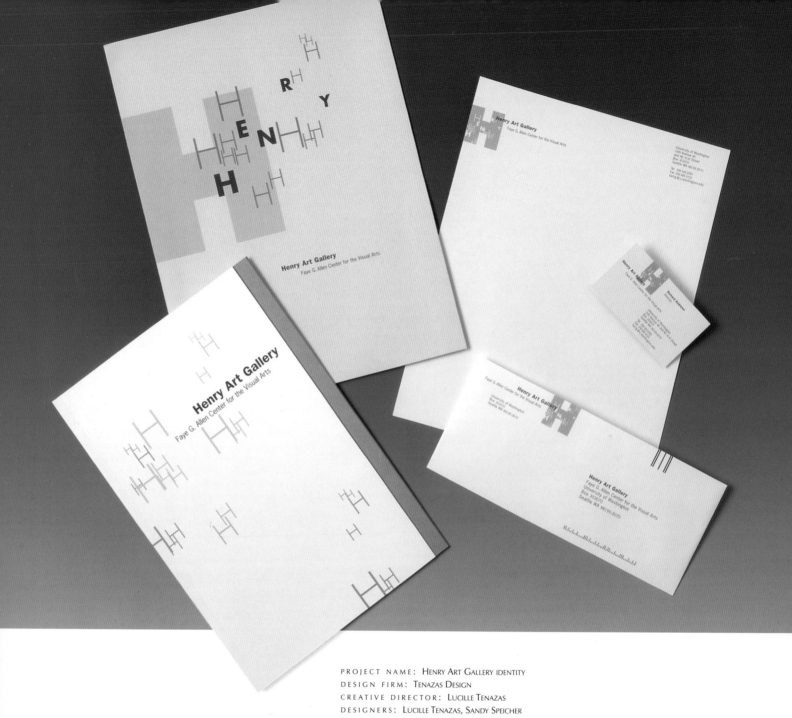

PROJECT NAME: HENRY ART GALLERY IDENTITY
DESIGN FIRM: TENAZAS DESIGN
CREATIVE DIRECTOR: LUCILLE TENAZAS
DESIGNERS: LUCILLE TENAZAS, SANDY SPEICHER
PHOTO: FREDERICK HOUSEL, JOHN STAMETZ
CLIENT: HENRY ART GALLERY, FAYE G. ALLEN CENTER FOR THE VISUAL ARTS, UNIVERSITY OF WASHINGTON

Because cultural institutions must think about marketing themselves and their ideas as much as commercial entities do, the most effective design speaks to what makes the institution what it is.

Lucille Tenazas says she wanted to make a "kinetic" design system when she created a new identity for a renovated and expanded gallery and arts center at the University of Washington. Appropriately for an institution focusing on the arts, the execution is almost three-dimensional; the name "Henry" and the capital letter "H" dance inside a giant "H," then wander again across stationery, folder panels, envelope backs, brochures, and invitation cards. A varied palette of autumn colors sets off the unexpected type executions in Franklin Gothic and News Gothic, making for a unique, easily manipulated kit of identity "parts."

PROJECT: CARTIERA DI CORDENONS PAPER BROCHURE
DESIGN FIRM: TANGRAM STRATEGIC DESIGN
CREATIVE DIRECTOR/ART DIRECTOR/DESIGNER: ENRICO SEMPI
PHOTOS: VARIOUS
CLIENT: CARTIERA DI CORDENONS

Deconstructing words to make them fit a visual approach is a hallmark of contemporary design, but the deconstruction can be carried out in a number of ways—including ways that appear more traditional than they really are.

Enrico Sempi created this 1995 brochure for a paper line that ultimately was not produced. His sensitive grid work called for some of the headline type to be set in vertical rectangles that were repeated on each page. As in much of the work done by experimental typographic designers, the headline words become graphic elements, but the look is classical, elegant, and light, substituting the structure of the grid for the traditional structure of line breaks and paragraphs.

PROJECT: "ALPHABET"
DESIGN FIRM: MARGO CHASE DESIGN
CONCEPT: DAVID SHIH, HAL RINEY & PARTNERS
CREATIVE DIRECTOR: MARGO CHASE
AUDIO: HUM
CLIENT: MARGO CHASE DESIGN

The experimental layouts of the early nineties created much more variety in how the reader's eye moves around a designed two-dimensional surface. So much movement is in those layouts, in fact, that graphic designers have begun taking up film and video as a natural extension of what they were already doing.

Kinetic type forms the basis of this 1996 self-promotion video by Margo Chase, one of the most visible of the American designers shifting to moving media. As an unseen little girl sings the traditional "A, B, C" nursery song, individual letters fly through a black space, giving the viewer a look at the custom letterforms that have made Chase's reputation. It's just one step beyond a graphic design approach in which the grid pushes outward rather than containing material within itself.

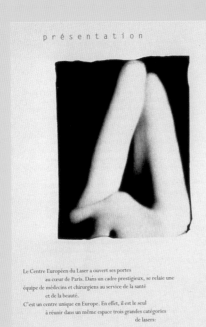

présentation

Le Centre Européen du Laser a ouvert ses portes
au cœur de Paris. Dans un cadre prestigieux, se relaie une
équipe de médecins et chirurgiens au service de la santé
et de la beauté.
C'est un centre unique en Europe. En effet, il est le seul
à réunir dans un même espace trois grandes catégories
de lasers:

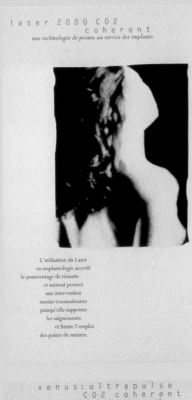

laser 2000 CO2
coherent
une technologie de pointe au service des implants

L'utilisation du Laser
en implantologie accroît
le pourcentage de réussite
et surtout permet
une intervention
moins traumatisante
puisqu'elle supprime
les saignements
et limite l'emploi
des points de sutures.

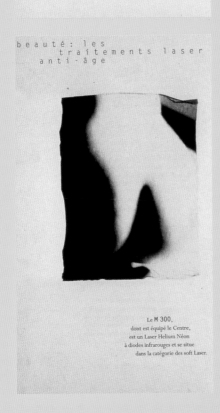

beauté: les
traitements laser
anti-âge

Le M 300,
dont est équipé le Centre,
est un Laser Helium Néon
à diodes infrarouges et se situe
dans la catégorie des soft Laser.

venus:ultrapulse
CO2 coherent
La révolution dans le traitement antirides

Issu de la haute technologie américaine, il s'impose
comme la "Rolls Royce" des lasers dans le domaine de
la chirurgie esthétique.
Son ordinateur intégré et son boîtier Silk-Touch lui
confèrent une précision jusqu'à aujourd'hui inégalée,
ce qui permet de traiter avec sécurité des zones
difficiles: nez, lèvres, visage …
sans cicatrices chirurgicales.

PROJECT: Centre Européen du Laser brochure
DESIGN FIRM: Tangram Strategic Design
CREATIVE DIRECTOR: Enrico Sempi
ART DIRECTORS: Enrico Sempi, Antonella Trevisan
DESIGNER: Antonella Trevisan
PHOTOS: Enea Bottaro
CLIENT: Centre Européen du Laser

Few changes in typography—and in reading—have been as marked in the last few years as the way designers set words irregularly. They vary grids, sizes, and typefaces as they feel it necessary in order to achieve a smooth reading flow. Often this approach shows up in "grunge" products, but it can also be done successfully for less aggressive pieces.

In this 1996 brochure for a French laser center, Tangram Design used two faces, each in two styles—Letter Gothic Regular and Bold and Perpetua Regular and Italic—and gently varied the placement of the words, softening the chilly medical vocabulary and including Polaroid-transfer, duotone-printed images to establish a fashion atmosphere.

PROJECT: K. J. HENDERSON WEB SITE
 <WWW.KENHENDERSON.COM>
DESIGN FIRM: ASYLUM
ART DIRECTOR: BILL CURRENT
DESIGNER/ ILLUSTRATOR: RON KLEIN
COPYWRITER/CLIENT: K. J. HENDERSON

Asylum captured the mix-it look of nineties typography in this 1997 Web site for K. J. Henderson, a Chicago writer and marketing consultant.

The home page overlays the title on an image of old-fashioned-looking typewriter keys; the words "from K J Henderson" appear one at a time after the page loads. Click on the home page, and you see a page of selections. There, the selections themselves are set in white, with a reminder of the site name in red; Henderson's specialties appear in green, matching the green of the type bars in the background. All three type elements are interspersed with one another, creating three reading levels on the page. On the "profile & philosophy" page, the section title is again set in white, with two other groups of words—each in a different size—set in gray and seemingly scattered behind the section title.

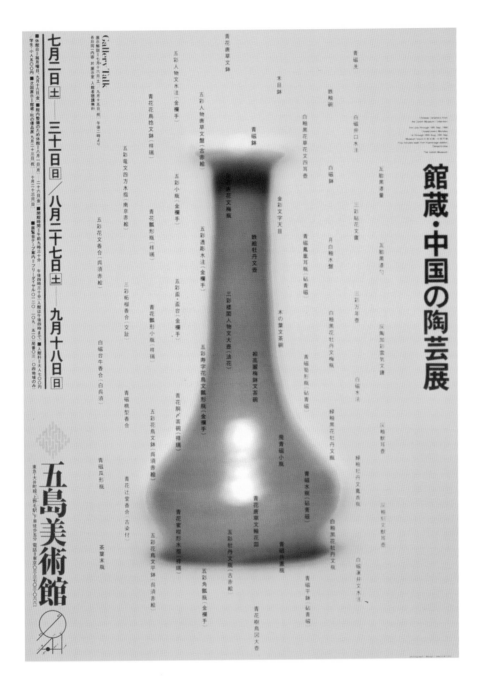

PROJECT: POSTER FOR CHINESE CERAMICS FROM THE
GOTOH MUSEUM COLLECTION exhibition
DESIGN FIRM: UNO, YASUYUKI DESIGN STUDIO INC.
DESIGNER: YASUYUKI UNO
PHOTO: YASUYUKI UNO
CLIENT: THE GOTOH MUSEUM

While many designers were spending the early nineties feuding over the purpose and future of typography, others were using digital tools to do new and beautiful things with the design of words.

This 1994 poster for a ceramics exhibition was intended to make the pottery appealing to a general audience. Uno took a photo of a celadon flower vase out of focus. Then, over the vase and its yellow background, he simply listed the works that were being shown in the exhibit. The list, done in computer-based Morisawa Futo-Gothic, is sprinkled over the paper almost like a series of soft, readable raindrops, reinforcing the nature associations of the flower vase.

5 Chaos and Classicism

Graphic design is like popular music; the grown-ups are always criticizing the younger generation for its lack of organization, skill, and taste. But, as with music, "what is new" and "what already exists" need each other, and gradually they become used to each other. Without the fresh influence of the new, existing design might ossify, while without experience and help from what (and who) is already there, new styles can simply disintegrate from lack of a center. Eventually, the two accommodate each other, although recalcitrant grumps usually remain on both sides.

In the last five to ten years, it is unquestionably the computer that has changed design from a relatively (these things are always relative) organized enterprise to one in which it seems that anything goes—or, at least, can if it wants to. Type design led the way, with its dissolving, morphing letter forms; the online world and the manipulation of digital images followed, creating a new aesthetic of high speed, discord, entropy, and—at times—ugliness. The dissolution of design's traditional organizing structures and truisms appears central to younger designers' approach. One need only think of how often muddy browns appear now in designed pieces, and think of the decay they so often signify, to realize how much things have changed. Balancing this have been the energy and inventiveness of a design generation

seemingly at one with the new digital tools, and the whimsical and occasionally luminous quality of their creations—product boxes adorned with charming little creatures not found in nature, imaginative new dimensions for business cards, or Web sites with beautiful colors wisping off into nothingness at the edges.

At the same time, designers already in practice quickly absorbed what the new tools could do, even though many of them complain about the need to keep up technically—and about the uninformed and occasionally unreadable work of their juniors. Virtually every designer working today uses a computer, or directs people who do, so it's clear that designers who consider their work more traditional in approach are nevertheless using computers with a high level of skill.

Moreover, it's not at all clear that designers in their twenties are always the ones leading the way. It is the experienced American designer Clement Mok who is often credited with creating the term "information design," after all, and other designers with real stature in the industry—Roger Black and Richard Saul Wurman come to mind—are forming multimedia companies, leading seminars, and publishing on the topic of computer-based design. In fact, what we are seeing now may be the classic cycle seen in Western countries, in which the market acts to subsume new trends, gradually shifting the mainstream, rather than rejecting one trend in favor of another.

And, of course, the market does make room for many approaches—which is why even traditional design seems to be doing well, in fact almost blossoming—at a time when its practitioners are faced with stiff competition from those who find organization constricting and dull. In the late nineties, grid-oriented pieces such as magazines, books, and some retail marketing materials seem infused with a new freshness, a clean look that makes them especially appealing and contemporary despite their deep roots in European and mainstream American design. It may be that this quality takes something from the energy that surrounds it.

In turn, traditional design seems to have given younger designers at least the important tools of white space and visible rule lines. Even some of the most aggressively electronic young designers are making ample use of white space, abandoning the crowded design canvases of the early to mid-nineties; and rules now show up routinely in brochures and Web sites created by younger designers, sometimes as indicators of spatial divisions, sometimes as leader lines to callout-style information, sometimes merely as balancing graphic elements.

It's too soon to tell where this dance will lead, but it does seem likely that, when there are no longer traditionally trained designers in practice, their experience—along with the elegance, clarity, simplicity, and organizational rigor of their work—will continue in those they have hired, managed, and taught.

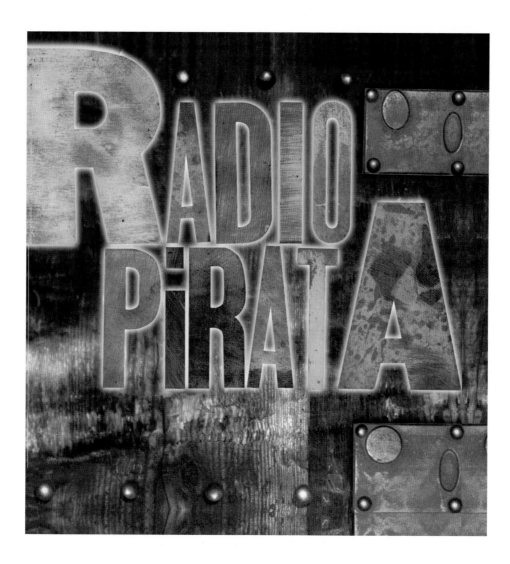

PROJECT: Radio Pirata CD package
DESIGN FIRM: Javier Romero Design Group
ART DIRECTOR: Javier Romero
DESIGNER: Dale Allarde
CLIENT: Fonovisa

This CD package shows an interesting combination of new technology and old objects. It was designed last year for a new pop/rock Latin band whose recording company wanted to introduce it to international markets. The band's manager was looking for an unusual design.

Because the band's name ("pirate radio station") was a powerful one, the designers made it the main element. But, rather than conveying its literal meaning, they focused on bringing character and mystery to the type treatment. Vintage woodblock type from various typefaces evoked the warmth and interest they wanted. A slight glow effect made the type a bit more active; a photo of an old wooden door shot by Romero in Italy served as the background image.

PROJECT: ROYAL MAIL STAMPS
DESIGNER: KRISTINE MATTHEWS
CLIENT: THE ROYAL MAIL

This 1997 project grew out of a design brief at London's Royal College of Art intended to test the capabilities of the Royal Mail's new nine-color press. Students chose a location of their choice anywhere in the world and designed a corresponding stamp sheet. This sheet was one of twelve designs selected for printing on the new press.

Elegantly simple, it shows a very contemporary attitude toward information. Although a number of locations were important enough to warrant having words included to show them, the words are layered over one another. Therefore all the characters aren't visible, and the viewer must read by implication in some instances; in a more "classical" piece, each word would most likely be separate.

EMPHASIZING DESIGN AS A VISIBLE LANGUAGE, THE DESIGN DEPARTMENT AT THE ART INSTITUTE OF BOSTON PREPARES STUDENTS TO PARTICIPATE IN THE WORLD AS GRAPHIC COMMUNICATORS IN AN INFORMATION-DRIVEN SOCIETY.

design

A STRONG FOCUS ON VISUAL FUNDAMENTALS—FORM, COLOR, IMAGERY, AND TYPOGRAPHY—CONTRIBUTES TO STUDENTS DEVELOPING A PROCESS-ORIENTED WAY OF THINKING, LOOKING, AND WORKING. THE PROGRAM COMBINES EXPOSURE TO, AND EXAMINATION OF, CONTEMPORARY AND HISTORIC DESIGN THEORY WITH THE REALITIES OF HANDS-ON STUDIO PROJECTS. OUR PROGRAM ENCOURAGES AN ACTIVIST, PARTICIPATORY APPROACH IN CREATING GRAPHIC COMMUNICATION—

The Art Institute of Boston

PROJECT: ART INSTITUTE OF BOSTON 1997 CATALOG AND IDENTITY
DESIGN FIRM: MINELLI DESIGN
DESIGNERS: MARK MINELLI, PETE MINNELLI, LESLEY KUNIKIS, BRAD RHODES
CLIENT: THE ART INSTITUTE OF BOSTON

This catalog draws on the extensive identity Minelli Design built for the Art Institute of Boston. In addition to catalogs, the identity included brochures, posters, fundraising materials, signage, and a CD-ROM.

The catalog in particular shows nicely how contemporary design often strikes a balance between contrasting tones. The cover image is somewhat dark and emotional, emblematic of the introspective aspects of the creative process. The image is referenced visually at the start of every section, where a small sepia frame encloses an artistic image of some sort. The curriculum information, on the other hand, is clear, bright, and ordered. The whole identity system allows the designers free play between these two poles.

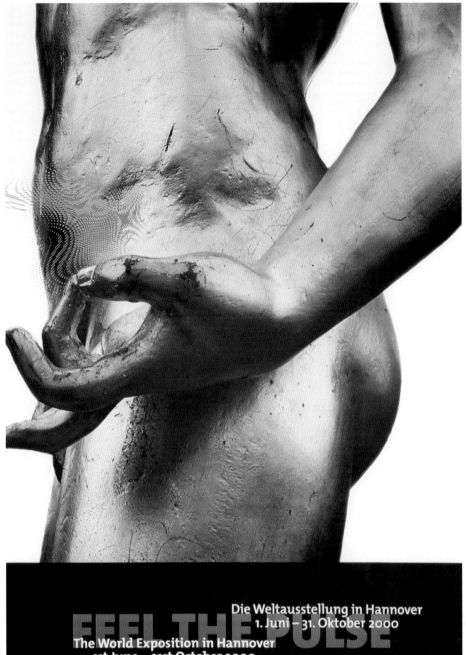

Die Weltausstellung in Hannover
1. Juni – 31. Oktober 2000
FEEL THE PULSE
The World Exposition in Hannover
1st June – 31st October 2000

Hannover

PROJECT: "FEEL THE PULSE" POSTER
DESIGN FIRM: MAVIYANE-PROJECT
DESIGNER/PHOTOS: CHAZ MAVIYANE-DAVIES
CLIENT: CITY OF HANNOVER

This simple, striking poster was done in 1997 as part of the promotion of the World Exposition that will be held in Hannover in 2000. Maviyane-Davies, in the city for a workshop, photographed a gilded statue in a garden.

Later he placed the logo for the exposition—a video-generated fractal—above the statue's delicate, classical hand gesture so that it looks as if the hand is presenting the image. The combination is the essence of the traditional (the static statue, symbol of a world that is gone) with the essence of the new (the technology-generated, "virtual" emblem). It is almost as if the statue was planned with the flamelike "pulse" logo in mind.

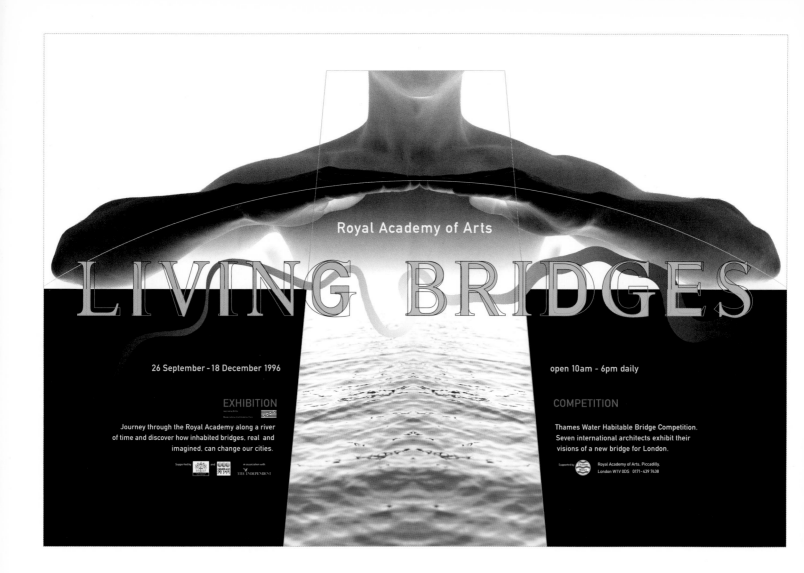

PROJECT: LIVING BRIDGES POSTER
DESIGN FIRM: WHY NOT ASSOCIATES
DESIGNERS: ANDY ALTMANN, DAVIS ELLIS, PATRICK MORRISSEY, IAIN CADBY
PHOTOS: ROCCO REDONDO
CLIENT: THE ROYAL ACADEMY OF ART

This 1997 poster for an architecture exhibition on habitable bridges seems simple, but it is composed of many parts.

The image of the quiet water is contained in a vertical, green-edged polygon that suggests a built structure. The water merges with a male torso holding its arms in a sheltering way. A yellow line curves along the line formed by the man's arms, bisecting the vertical "architectural" shape. Light seems to glow from the place where human and water meet, and a thick line snakes through the center. The words "Living Bridges" change color above and below the line that divides white background from black. The design has both a collected, classical quality and the cool feeling of contemporary work.

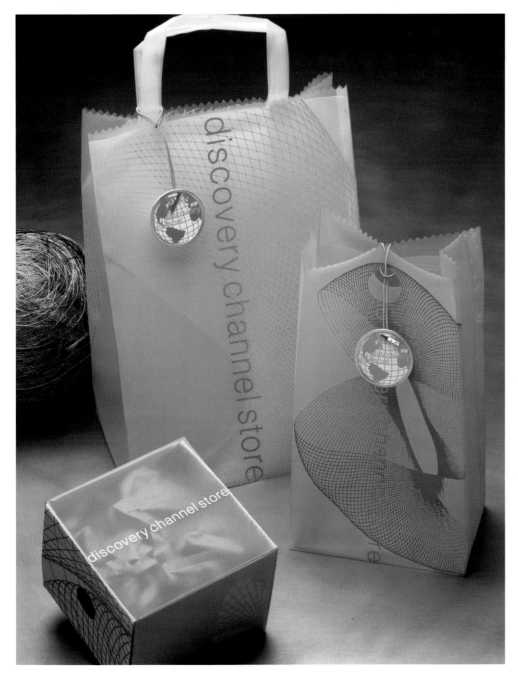

PROJECT: DISCOVERY CHANNEL STORE
SHOPPING BAGS
DESIGN FIRM: MORLA DESIGN
ART DIRECTOR: JENNIFER MORLA
DESIGNERS: JENNIFER MORLA,
ANGELA WILLIAMS,
YORAM WOLBERGER
CLIENT: THE DISCOVERY CHANNEL

At a time when many designers pack their work with visual information, these effortlessly simple shopping bags remind us that less often really is more. They stemmed from the creation of an overall identity for The Discovery Channel's retail stores in 1997.

Morla Design created the illustrations, reminiscent of Slinky® toys, mathematical models, or even astronomical orbit patterns, using Adobe Illustrator. The results allude to science—the foundation of The Discovery Channel's business—without being explicit. An equally light touch was applied to the material for the bags, a translucent plastic that plays gently with the idea of discovering what's inside. The typography is not only simple but classical: Helvetica Light, printed in a Pantone metallic silver.

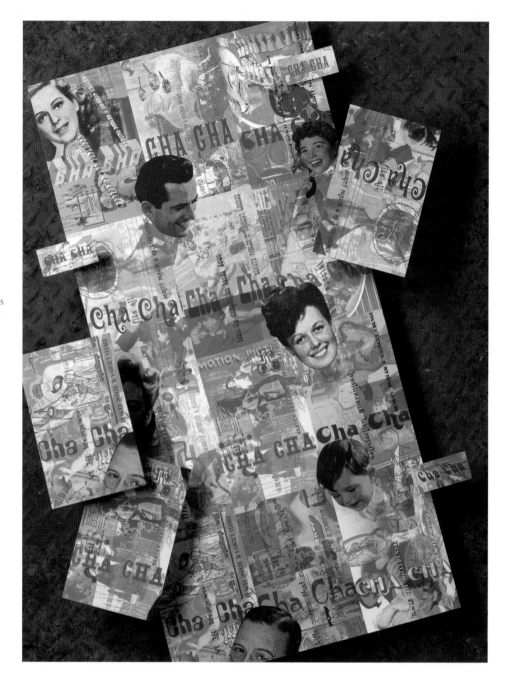

PROJECT: Cha Cha Beauty Parlor &
Haircut Lounge poster/mailers
DESIGN FIRM: Planet Design Company
DESIGNERS: Kevin Wade, Darci Bechen
COPYWRITER: John Besmer
CLIENT: Cha Cha Beauty Parlor &
Haircut Lounge

Judging from this poster, the Cha Cha Beauty Parlor & Haircut Lounge is a unique hair salon. Perhaps fittingly, the poster hails from the "more is more" school—and, in its own funky way, proves the assertion.

Eleven typefaces were used to put the poster together; they were combined with retro clip art in keeping with the shop's fifties-style name. Without losing its coherence as a whole, the 16 1/2" x 25 1/2" (42 cm x 65 cm) poster divides into twelve panels, each of which works as an individual mini-poster. To save money, the designers also printed the back with twelve direct-mail cards; when the poster was cut into its twelve component panels, the cards were ready to send.

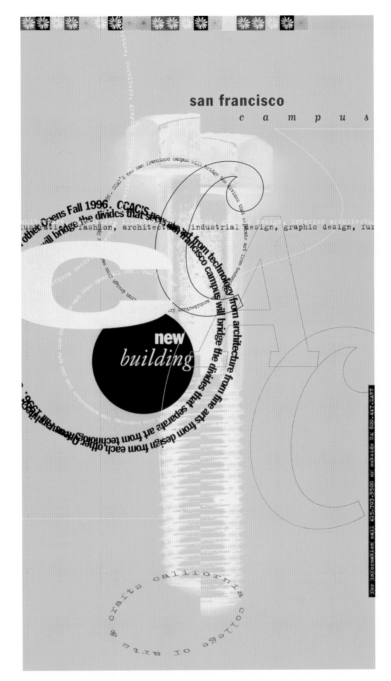

PROJECT: POSTER FOR CALIFORNIA COLLEGE OF
 ARTS & CRAFTS' NEW SAN FRANCISCO BUILDING
DESIGN FIRM: MORLA DESIGN
ART DIRECTOR: JENNIFER MORLA
DESIGNERS: JENNIFER MORLA, PETRA GEIGER
PHOTOS: MORLA DESIGN
CLIENT: CALIFORNIA COLLEGE OF ARTS & CRAFTS

In this recruitment/announcement poster for CCAC's new building, Morla Design used seven typefaces and seven circular shapes to arrange the words. Yet it is as spare and clear as a modern classicist could hope for.

The image of the bolt and the energetic type seem to symbolize the process of creating the building; the measuring rules and printer's registration bar act as a metaphor for the design disciplines. But these elements could have been used predictably. Instead, everything is artfully calculated. The black circle with the words "new building" catches the eye immediately, as do the words "san francisco campus." Other type is faded or runs into neighboring words, yet there is no difficulty in understanding any of the material.

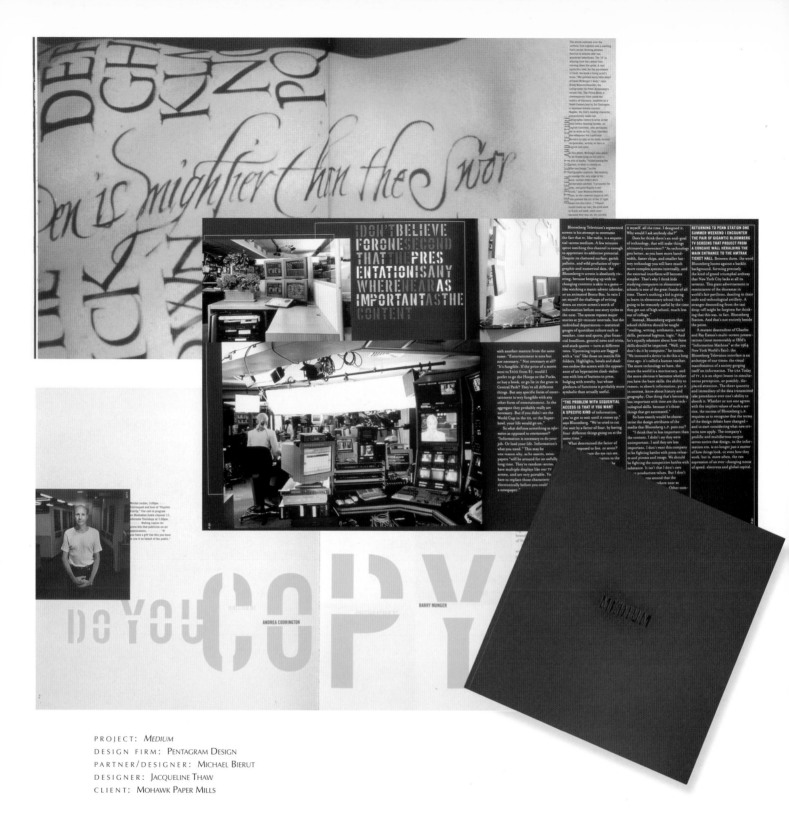

PROJECT: *MEDIUM*
DESIGN FIRM: PENTAGRAM DESIGN
PARTNER/DESIGNER: MICHAEL BIERUT
DESIGNER: JACQUELINE THAW
CLIENT: MOHAWK PAPER MILLS

This 1997 book is the fourth issue of *Rethinking Design*, a series of paper promotions published by Mohawk. In it, a variety of writers tackle the subject of shifts between one medium and another.

The subjects range from body calligraphy to photo booths, from cemeteries to photocopy-store culture. Along with a host of insights into creativity and contemporary society, the book captures a level of visual variety that's peculiar to our time. Although the production notes cite only three typefaces for the book's design, each essay looks like a major feature article from a wildly different magazine. Some are organic-looking, some tightly gridded, some text-oriented. To the nineties reader, none of this is surprising; we take it in stride.

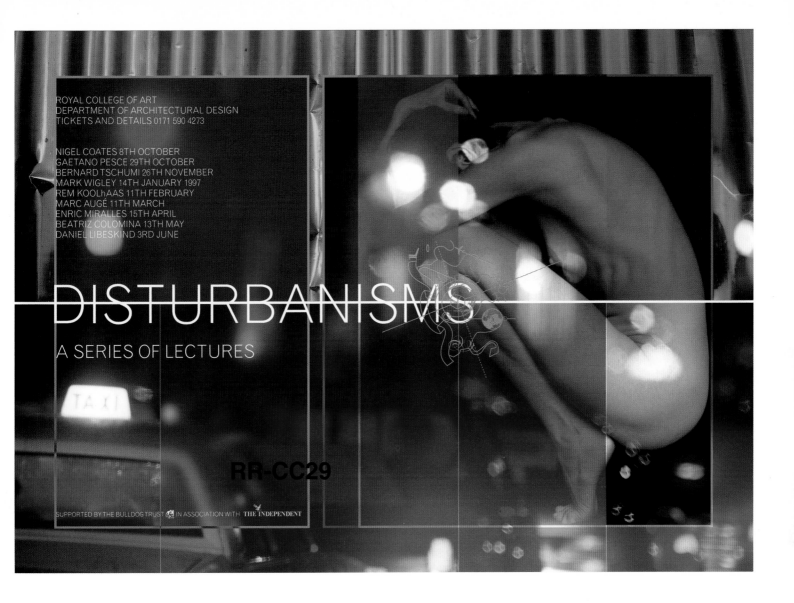

ROYAL COLLEGE OF ART
DEPARTMENT OF ARCHITECTURAL DESIGN
TICKETS AND DETAILS 0171 590 4273

NIGEL COATES 8TH OCTOBER
GAETANO PESCE 29TH OCTOBER
BERNARD TSCHUMI 26TH NOVEMBER
MARK WIGLEY 14TH JANUARY 1997
REM KOOLhAAS 11TH FEBRUARY
MARC AUGÉ 11TH MARCH
ENRIC MIRALLES 15TH APRIL
BEATRIZ COLOMINA 13TH MAY
DANIEL LIBESKIND 3RD JUNE

DISTURBANISMS

A SERIES OF LECTURES

RR-CC29

SUPPORTED BY THE BULLDOG TRUST IN ASSOCIATION WITH THE INDEPENDENT

PROJECT: DISTURBANISMS POSTER
DESIGN FIRM: WHY NOT ASSOCIATES
DESIGNERS: ANDY ALTMANN, DAVIS ELLIS, PATRICK MORRISSEY, IAIN CADBY
PHOTOS: ROCCO REDONDO, PHOTODISC
CLIENT: THE ROYAL COLLEGE OF ART

While it captures the anxiety implicit in its title, this 1997 poster for a series of architecture lectures also creates a sense of order. A set of boxes, some wide and some narrow, parse the area of the poster.

A white line also bisects it—and the title—horizontally. Fiery traffic lights make a red base in the lowest part of the space. A crumpled-looking metal surface peeks out from between the boxes in the upper half. The woman on the right, seemingly escaping an overstimulating environment, balances the type on the left. Enigmatic line art blurs the end of the title word. All these, and the complicated panels and image relationships, visually represent the stress inherent in the idea of the lectures, but contain the stress in a structured way.

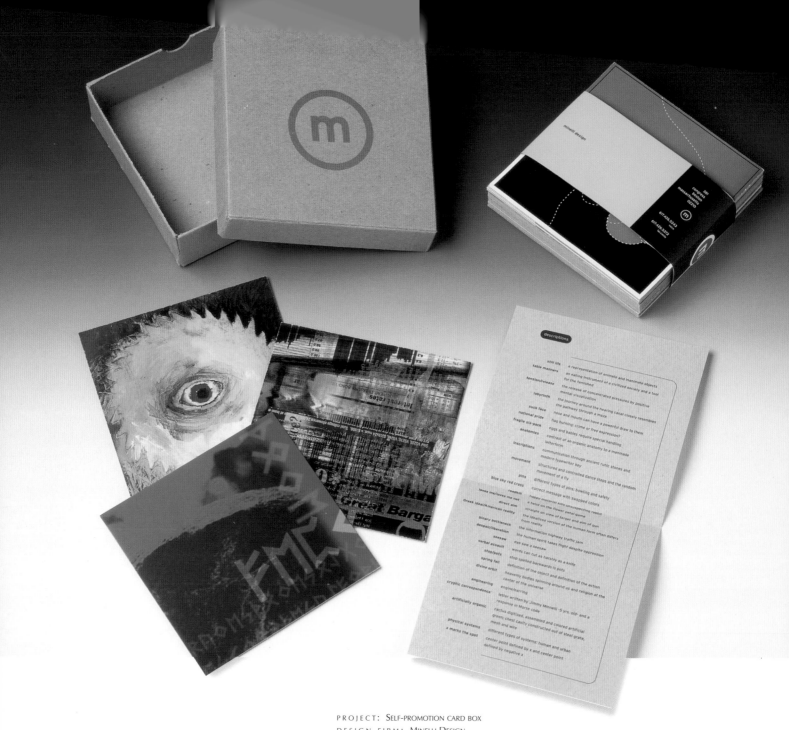

PROJECT: SELF-PROMOTION CARD BOX
DESIGN FIRM: MINELLI DESIGN
DESIGNERS/ILLUSTRATORS: MARK MINELLI, PETE MINNELLI, LESLEY KUNIKIS,
 BRAD RHODES
CLIENT: MINELLI DESIGN

Self-expression by designers in promotional materials has reached an all-time high in the nineties; self-promotions can be toys, display pieces, or almost anything else, giving the whole category a certain unpredictability. Some designers see themselves not only as business problem-solvers, but also as posers of questions, as this piece suggests.

A 1997 self-promotion for Minelli Design, the piece consists of a box of square cards, each carrying conceptually related artwork on both sides. The subjects are various and so are the styles of the pieces: some are realistic, some extremely digital-looking, others clearly constructed from clip art. A paper band holds the cards together within the box, and a paper label seals the box.

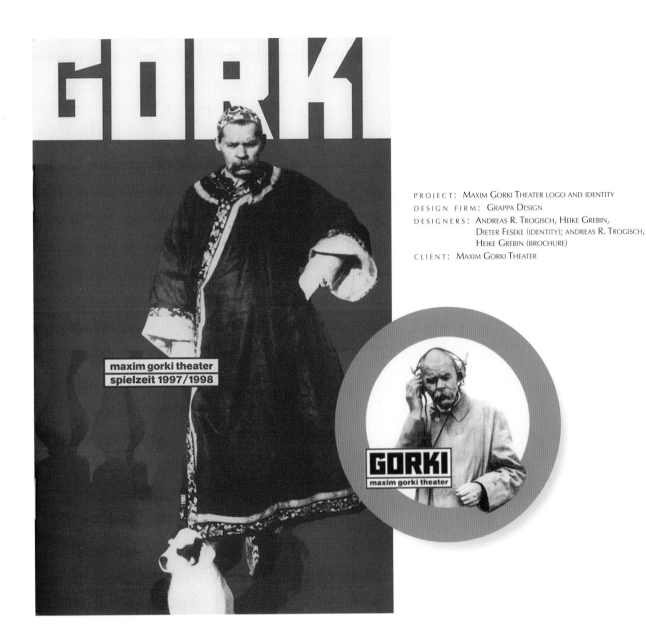

PROJECT: MAXIM GORKI THEATER LOGO AND IDENTITY
DESIGN FIRM: GRAPPA DESIGN
DESIGNERS: ANDREAS R. TROGISCH, HEIKE GREBIN,
 DIETER FESEKE (IDENTITY); ANDREAS R. TROGISCH,
 HEIKE GREBIN (BROCHURE)
CLIENT: MAXIM GORKI THEATER

In 1995, when Berlin's Maxim Gorki Theater needed a new identity, funding for cultural projects in Germany was being cut severely. Thus the identity needed to be a simple one that could nevertheless express both the Russian avante-garde style of the twenties, when some of Gorki's best work was published, and—because the head of the theater was a jazz fan—the influence of American jazz.

The image of Gorki wearing Walkman®-like headphones became the main icon. The script was developed from Cyrillic lettering from the twenties. Over three years, the identity has been applied to a wide variety of printed pieces. Although it is simple, it draws from a powerful design period, and the brooding presence of Gorki himself adds greatly to its strength.

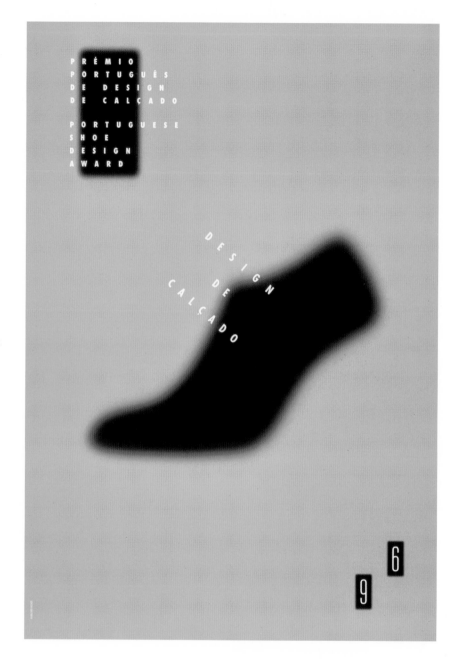

PROJECT: PORTUGUESE SHOE DESIGN AWARD POSTER
DESIGN FIRM: JOÃO MACHADO, DESIGN LDA
DESIGNER: JOÃO MACHADO
CLIENT: CENTRO DE ARTE DE S. JOÃO DA MADEIRA

In the nineties, Machado created several posters promoting Portugal's yearly prize for footwear design.

For the 1996 competition, he created a moody, textured look with a shadowy, almost insubstantial shoe afloat in the background at the center of the poster. The image is an oblique visual reference to all the cultural associations shoes have developed over the years; its simplicity almost asks the viewer to attach his or her own ideas. An equally shadowy rectangle in the upper left echoes the shoe and serves as a backdrop for the utterly simple Futura type. The contrast of an undefined, "empty" image and the modern-classical type treatment gives the poster an especially haunting and contemporary look.

The cover and interior of the attendee book. Text visible on the cover: THURSDAY JUNE 6 / FIDELITY INVESTMENTS 1996 / ANNUAL CLIENT CONFERENCE / FIDELITY INSTITUTIONAL RETIREMENT SERVICES COMPANY / FIDELITY AT FIFTY: 50 A Tradition of Partnership. The running side tab reads JUNE 6 THURSDAY.

Interior schedule page:

Registration and Buffet Breakfast *Essex Ballroom, 3rd Floor*	7:00 a.m. – 8:00 a.m.
General Session Welcome and Opening Remarks *America Center and South, 4th Floor*	8:00 a.m. – 8:15 a.m. *Peter J. Smail, President, FIRSCo*
General Session Outlook for Fidelity and the Investment Business *America Center and South, 4th Floor*	8:15 a.m. – 8:45 a.m. *Edward C. Johnson 3d, Chairman of the Board and Chief Executive Officer, Fidelity Investments*

As Fidelity celebrates its 50th anniversary, we will take a look at its history and development over the past five decades. Fidelity CEO Edward C. Johnson 3d will take us through critical milestones that shaped Fidelity as we know it today, and what we might expect for the future.

Break	8:45 a.m. – 9:15 a.m.
General Session Fidelity's Investment Process: Updates and Insights *America Center and South, 4th Floor*	9:15 a.m. – 10:45 a.m. *J. Gary Burkhead, President and Chief Executive Officer, Fidelity Management & Research Company* *William J. Hayes, Chief Operating Officer, Equity Research, Fidelity Investments* *Fred L. Henning, Jr., Managing Director, Director of Fixed Income and Money Market Investments, Fidelity Investments* *Robert L. Reynolds (Moderator), President, Fidelity Institutional Retirement Group*

Fidelity's investment process drives the management of our funds, shaping both current and future investing policies. Joined by key members of his management team, J. Gary Burkhead, President of Fidelity Management & Research Company, will share important insights into how Fidelity's investment process works and is managed. This session will cover issues such as organizational changes, as well as focused discussions on:

- portfolio management teams;
- research-driven investment decision-making;
- trading and execution of investment decisions; and
- control and compliance measures.

Break	10:45 a.m. – 11:15 a.m.

PROJECT: ATTENDEE BOOK FOR FIDELITY INSTITUTIONAL RETIREMENT SERVICES COMPANY 1996 NATIONAL CORPORATE CLIENT CONFERENCE

DESIGN FIRM: MINELLI DESIGN

DESIGNERS: MARK MINELLI, PETE MINNELLI, LESLEY KUNIKIS, BRAD RHODES

ILLUSTRATOR: MARK MINELLI

CLIENT: FIDELITY INSTITUTIONAL RETIREMENT SERVICES COMPANY

Financial institutions may once have been bound by pinstriped suits and the classicism they implied. But it is no longer true that materials for such companies need be boring.

For Fidelity Institutional Retirement Services Company's fiftieth-anniversary National Corporate Client Conference in 1996, Minelli Design used bright, high-contrast colors, a contemporary type treatment, and clean-looking Wire-O® binding to create a lively piece that would get participants' attention. The cover illustration shows an intense, broad-stroke adaptation of FIRSCo's logo. Every section divider page uses a unique mix of the red, blue, green, gold, umber, orange, and purple colors chosen for the overall color scheme. The typography is mainly hierarchical, but multiple axes appear on the section divider pages, and numerous gradations add depth.

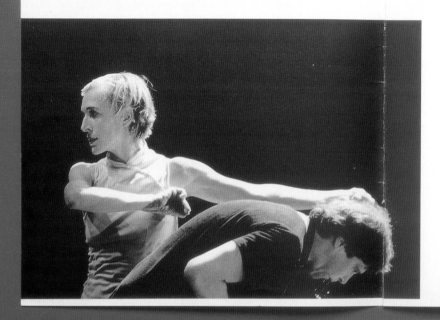

En arrivant à Montpellier en janvier 94, j'ai tout de suite voulu réfléchir à cette idée des Missions* d'un centre chorégraphique.
Non pour répondre à un moule préétabli mais pour définir mes propres missions et donc celles du centre, puisque ce lieu m'était confié.

Quels enjeux artistiques et quels rêves pour quelle équipe ?
Un centre chorégraphique est avant tout une maison qui se construit autour d'une aventure artistique qui répond autant à l'idée de création qu'à l'idée d'expérimentation (ces deux-là vont de pair).
L'élaboration des spectacles doit être liée de façon étroite à une pratique artistique et à un mode de fonctionnement d'une équipe autour d'un créateur.

Il est en tous les cas important de se pencher sur la question de la place d'un centre chorégraphique (vie, rythme, fonctionnement).
Le centre chorégraphique doit pouvoir alterner entre deux mouvements contradictoires :

- un mouvement de fermeture d'une part, répondant à un processus d'intériorisation et donc donnant une part importante à une recherche interne (ateliers, répétitions, expérimentation, élaboration des œuvres, recherche).

- un mouvement d'ouverture d'autre part, donnant à lire et à comprendre ce temps intérieur au public (spectacle, diffusion, enseignement, sensibilisation).
La notion de mission entraîne avec elle une réflexion sur la position de l'artiste face à la responsabilité de l'argent public.
Face à cette responsabilité, une partie des réponses se trouve dans la matière même du spectacle ; une autre partie des réponses se trouvera dans les rapports que le centre établira avec les autres professionnels de la région et de la ville.
Il n'existe de toute façon aucun clivage entre la création d'une part, et d'autre part, ce que l'on nomme la sensibilisation, ce que j'appellerai les missions...

* mission : "être en charge de" / envoyé par

P R O J E C T : Centre Chorégraphique National de Montpellier/Mathilde Monnier Dance Company visual identity
D E S I G N F I R M : L Design, Pippo Lionni
D E S I G N E R : Pippo Lionni
P H O T O S : Marc Coudrais
C L I E N T : Centre Chorégraphique National de Montpellier/Mathilde Monnier Dance Company

Constantly multiplying communication techniques can create visual clutter unless a designer is skilled and careful. This ongoing identity system for a dance troupe, begun in the early nineties, needed to be flexible because of the many pieces planned: posters, programs, cards, fliers, brochure…even a tabloid newspaper.

The designer achieved an elegant simplicity by making photos black-and-white except in the newspaper. Thus virtually every piece is two-color. A color bar with a "broken" look extends horizontally across each piece, with type reversed out. The sans serif type is in either black or white, with very rare exceptions, and there is always plenty of space around type blocks, giving both words and images room to breathe.

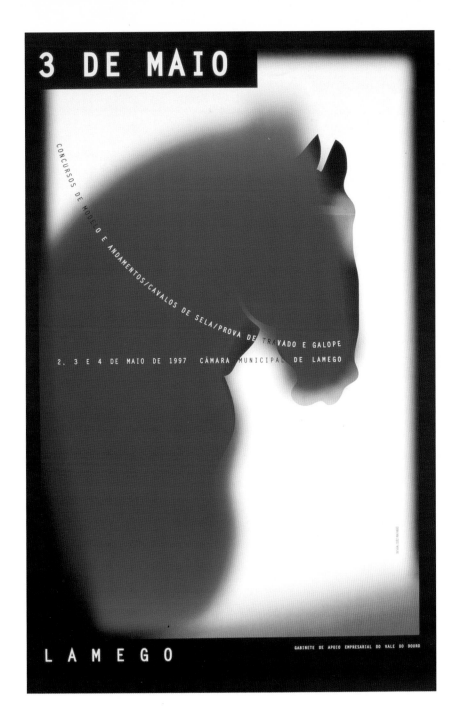

3 DE MAIO

CONCURSOS DE MODELO E ANDAMENTOS/CAVALOS DE SELA/PROVA DE TRAVADO E GALOPE

2, 3 E 4 DE MAIO DE 1997 CÂMARA MUNICIPAL DE LAMEGO

GABINETE DE APOIO EMPRESARIAL DO VALE DO DOURO

LAMEGO

PROJECT: 3 DE MAIO POSTER
DESIGN FIRM: JOÃO MACHADO, DESIGN LDA
DESIGNER: JOÃO MACHADO
CLIENT: GABINETE DE APOIO EMPRESARIAL DO
VALE DO DOURO

This 1997 poster, created for a horse show, illustrates with special clarity how computers have made new design work possible.

The shading around the edges of the blue "shadow" horse and the red area at the bottom of the illustration frame calls to mind the many modifications to images that can be made through software applications. The type is set so as to suggest reins. With all the elegant simplicity of the piece, it also has a brooding quality, as if the shadowy blue horse is meant to suggest some unknown force we don't normally see. This sense of something hidden is a chaotic potential within the understated composition.

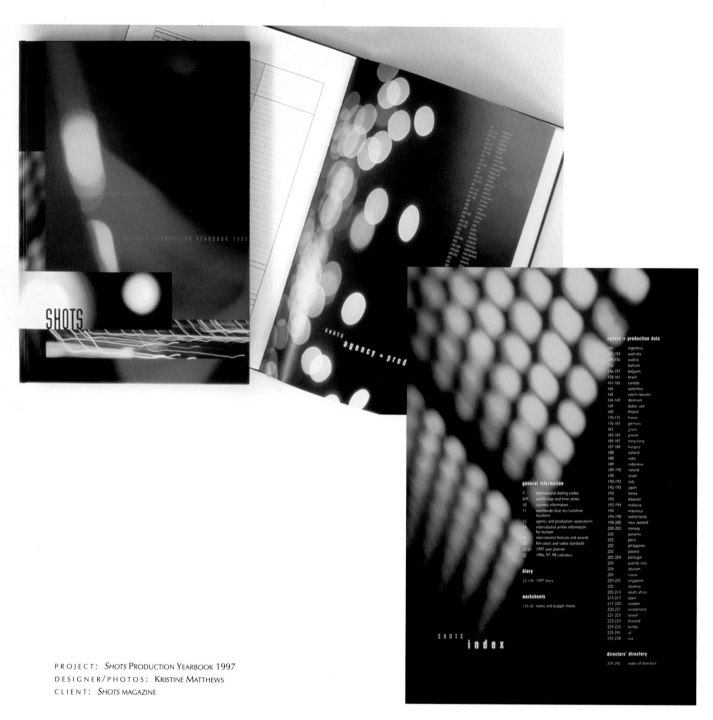

PROJECT: *SHOTS* PRODUCTION YEARBOOK 1997
DESIGNER/PHOTOS: KRISTINE MATTHEWS
CLIENT: *SHOTS* MAGAZINE

London-based *Shots*, an international magazine for film and advertising producers, needed a new look for its three-hundred-page 1997 diary/production annual. The annual had to look "filmic," yet not specific to any field, since the piece sells to a varied audience.

Matthews shot an original photo series, then used the images in designing the cover and subsequent divider pages. There's something extremely current, yet elegantly classical in the design. The images seem to come out of the urban nighttime landscape, but the confusion typical of urban-based design is stripped away, leaving soft bits of light behind. The sans serif type (Trade Gothic Condensed, DIN Schriften, and Gill Sans) floats over the images as if over dark water.

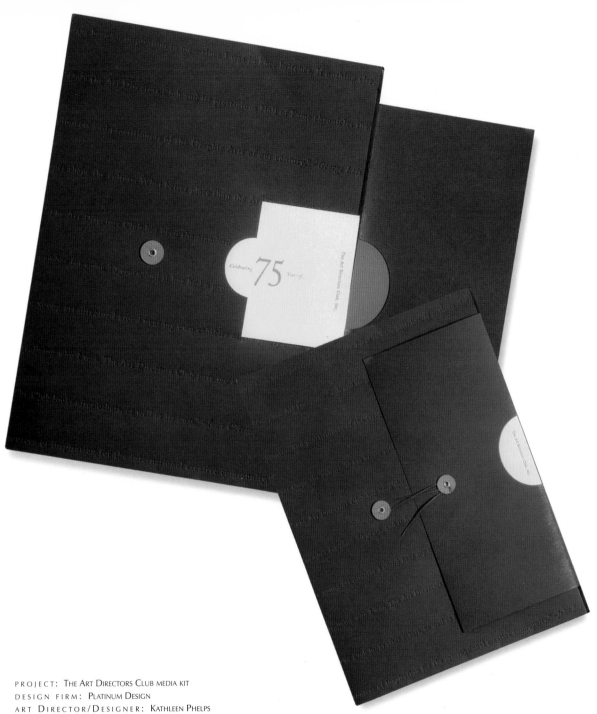

PROJECT: THE ART DIRECTORS CLUB MEDIA KIT
DESIGN FIRM: PLATINUM DESIGN
ART DIRECTOR/DESIGNER: KATHLEEN PHELPS
CLIENT: THE ART DIRECTORS CLUB, INC.

This 1996 project shows that dramatic color combinations need not seem loud, and that software can be indispensable even when a classic look is the goal.

The designers tried to create a package that was not overly designed but used paper and ink cleverly. Thus a front flap that exposes a small brochure tucked in a front-cover slot embellishes the traditional two-pocket design of the folder. The string fastener with two paper disks is an endearing reference to tradition. The deep blue, orangy-yellow, and red prove a sophisticated combination. And the debossing on the front cover—with die strike mechanicals created in Adobe Illustrator—allows running commentary from designers who have benefited from membership in the Art Directors Club.

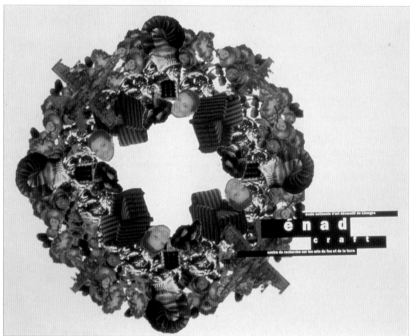

PROJECT: Ecole Nationale d'Art Décoratif de Limoges
 Identity
DESIGN FIRM: L Design, Pippo Lionni
DESIGNER: Pippo Lionni
CLIENT: Ecole Nationale d'Art Décoratif de Limoges

The ready availability of digital images, along with the proliferation of layout software, combine to create options that might not have occurred fifteen years ago—and that have invented a seemingly new vocabulary of design. This 1995 identity for a school of the decorative arts poses the question of what decoration actually is, in a time when images of objects become meaningful objects in their turn.

The designer created a soup of seemingly superfluous images. Couches, lightbulbs, faces, airplanes, and more objects from everyday life multiply in patterns reminiscent of Busby Berkeley choreography, yet completely of the present.

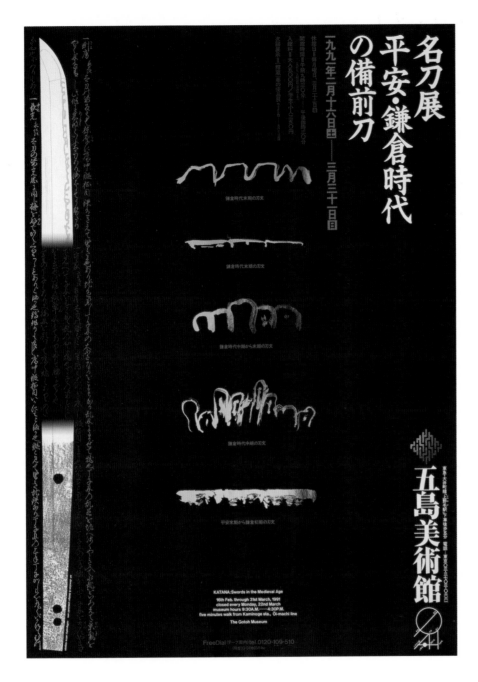

PROJECT: "KATANA: SWORDS IN THE MEDIEVAL AGE"
EXHIBITION POSTER
DESIGN FIRM: UNO, YASUYUKI DESIGN STUDIO INC.
DESIGNER: YASUYUKI UNO
CALLIGRAPHER: AKIRA NAGOYA
CLIENT: THE GOTOH MUSEUM

In the United States and to some degree in Western Europe, organic shapes have come to be associated with an agressively unstructured approach to design. Here, a poster from 1991 uses a loose line to harmonize with a tight structure. The piece promoted an exhibition of Japanese medieval swords.

Uno used calligraphy to represent the straightish or wavy patterns running the length of the tempered blades; information about the relevant sword appears below each example of calligraphy. More calligraphy appears at the left, some fitting within the blade's bandlike shape, other lines lining up with its left- and right-hand edges. With its clear verticals and horizontals, the poster has a strong structure that helps the silvery calligraphy stand out.

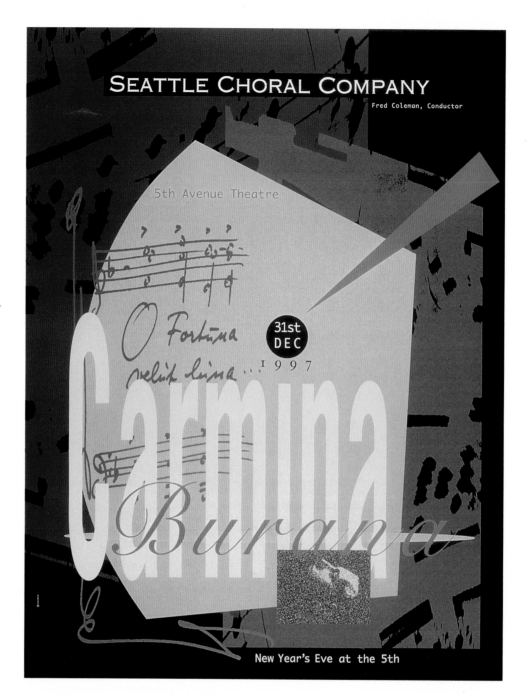

SEATTLE CHORAL COMPANY

Fred Coleman, Conductor

5th Avenue Theatre

O Fortuna
velut luna...

31st DEC
1997

Carmina
Burana

New Year's Eve at the 5th

PROJECT: SEATTLE CHORAL COMPANY
CARMINA BURANA POSTER
DESIGN FIRM: STUDIO OZUBKO
DESIGNER: CHRISTOPHER OZUBKO
CLIENT: SEATTLE CHORAL COMPANY

Sometimes design portrays a subject that itself is an unusual blend of elements. *Carmina Burana*, the musical work whose performance this 1997 poster advertises, combines medieval and old German rhythms with bursts of vitality and surprising percussion and harmonies.

The unexpected color mix in the poster—a dark, somber palette with highlight colors of yellow, red, and light blue—evokes the music's complexity and exuberance. The typefaces (Janson, Copperplate, Shelley Andante, Monaco, and digitally manipulated News Gothic) suggest the voices in the performance: soprano, tenor, baritone, girls' choir, and mixed chorus. The poster's details are especially pleasing: the red exclamation mark, the pale blue musical notation, and the clarity of the chorus name.

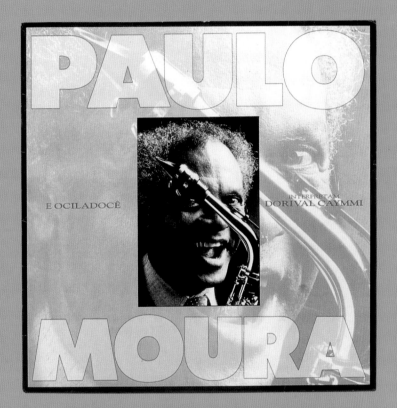

PROJECT: PAULO MOURA RECORD COVER
DESIGN FIRM: INTERFACE DESIGNERS
ART DIRECTOR: SERGIO LIUZZI
DESIGNER: ANDRÉ BONBONATTI DE CASTRO
PHOTO: LUIZ GARRIDO
CLIENT: CHORUS ESTUDIO LTDA.

A portrait from a successful photo shoot provided the central image for the cover of this 1996 LP by Brazilian saxophonist Paulo Moura.

The designers ghosted the same image at a larger scale in the background and overlaid the musician's name in Futura Bold, in a slightly different gray. It's the image that makes this design more than a well-mannered classical piece. Moura looks directly at the viewer, and the neck of his instrument slants upward between his eyes at an odd angle. A small piece of the saxophone looks unnervingly as if it is about to enter his left eye. The faint suggestion of imminent harm combines with the composition's elegance and strong lines to jolt the viewer's attention.

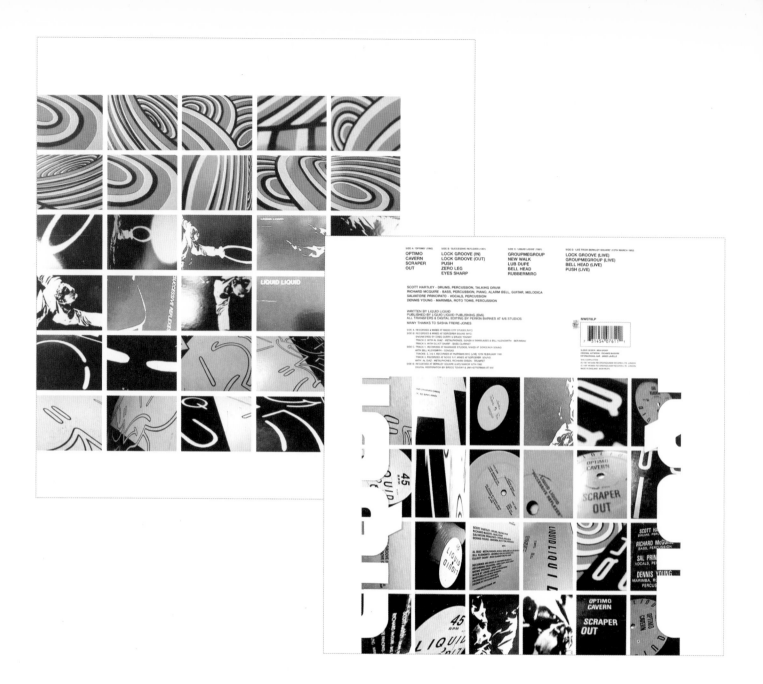

PROJECT: LIQUID LIQUID DOUBLE LP AND CD PACKAGING
DESIGNER/PHOTOS: BEN DRURY
ORIGINAL ARTWORK: RICHARD MCGUIRE
CLIENT: MOWAX RECORDINGS

Ben Drury developed this piece for a 1997 rock album released on vinyl and CD. One of the band members had created the artwork for the previous albums that yielded the music for the collection.

The designer photographed the albums and composed them in grids on the front and back sides. On the front, rubylith-cut swirls create odd associations with toys and funhouses. A bluish-purple-and-white image, printed on silver paper, pairs with a found image of an acrobat. Black-and-white ink artwork completes the grid. Images of labels from the previous records help make up the grid on the back, under die-cut flaps spelling out the band's name. Oddly balanced, with strange echoes of work from the twenties, this is a uniquely unpredictable design.

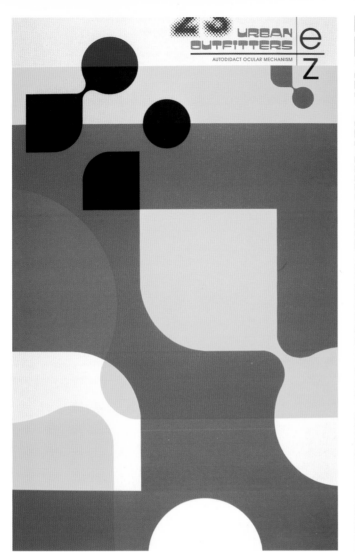
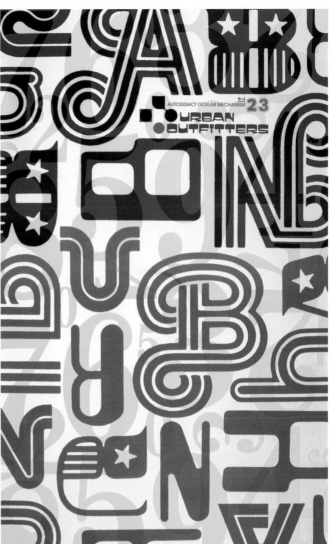

PROJECT: URBAN OUTFITTERS FALL 1996 POSTERS
DESIGN FIRM: URBAN OUTFITTERS
ART DIRECTOR/DESIGNER/COPYWRITER: HOWARD BROWN
CLIENT: URBAN OUTFITTERS, INC.

These posters for Urban Outfitters, the popular U.S. clothing and home merchandise retailer for the youth market, served as seasonal signage in the company's stores.

The designer intentionally evoked the style of the seventies so that the posters would complement the clothing being sold that season, which was inspired by the same period. Like many designs that reach into the past, the posters have an intensity and vividness that pieces original to that decade may not have had. Printing was in process color, which was overprinted in certain areas to create additional colors. The fluid, balanced feeling about the posters isn't surprising; the company's marketing pieces are done in various retro styles, but with great care and attention to detail.

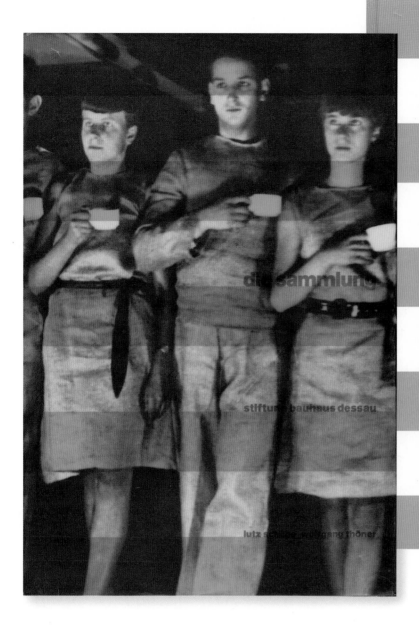

PROJECT: *DIE SAMMLUNG, STIFTUNG BAUHAUS DESSAU*
DESIGN FIRM: GRAPPA DESIGN
DESIGNERS: DIETER FESEKE, UTE ZSCHARNT
CLIENT: STIFTUNG BAUHAUS DESSAU

This 1996 book comprises a catalog of the archives of the Bauhaus, published to mark an exhibition and make the archives publicly available; the accompanying poster is also seen here. Both have been honored in important German design competitions.

In keeping with Bauhaus principles, the designers developed an economical grid, using a sans serif typeface (Akzidenz Grotesk). Weaving patterns and wall murals inspired the strip motif. The book cover was printed in orange-red stripes, white stripes, and black type, while a vellum dust jacket carried the image of three young people (students from the twenties) in black and white. The combination of the stripes and the period image of the students creates a mysterious impression that softens the bold typography and design grid.

SOHO
601

DIGI BETA

SOHO 601 71 DEAN STREET LONDON W1V 5HB TEL +44 171

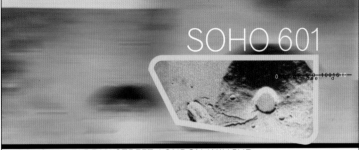

SOHO 601 71 DEAN STREET LONDON W1V 5HB
TEL +44 171 439 2730 FAX +44 171 734 3331 WEB www.sohogroup.com

[KEITH WILLIAMS MANAGING DIRECTOR]

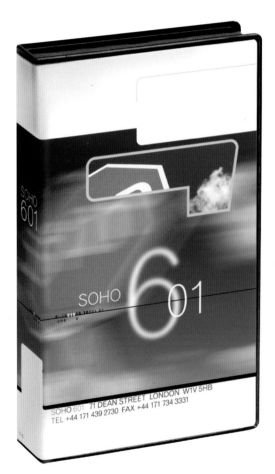

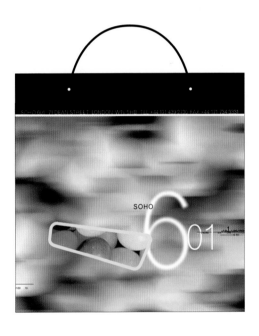

PROJECT NAME: SOHO 601 IDENTITY
DESIGN FIRM: WHY NOT ASSOCIATES
DESIGNERS: ANDY ALTMANN, DAVIS ELLIS, PATRICK MORRISSEY, IAIN CADBY
PHOTOS: PHOTODISC
CLIENT: SOHO 601

This corporate identity for a digital post-production facility dates from 1996. Its unpredictability comes, in part, from the fact that a different image is used for each of the items shown here (a video-cassette cover and label, a business card, and a carrier bag).

In every case, the color image is blurred except for an irregular area defined by a thick border of pink or yellow. Into each image comes a fine black line with ones and zeros above and below it. The company's name appears in yellow or pink, the address in black or white. In the larger items, the three digits of "601" are different sizes and focused differently. The style is undefinable, but completely fresh.

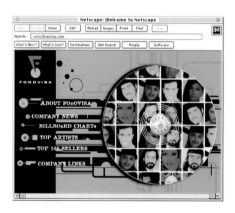
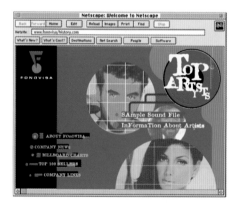

PROJECT: FONOVISA WEB SITE
DESIGN FIRM: JAVIER ROMERO DESIGN GROUP
ART DIRECTOR: JAVIER ROMERO
DESIGNER: ENRIQUE GONZALO
CLIENT: FONOVISA

Javier Romero Design Group created this Web site in 1998 for a rapidly growing recording company. Fonovisa was known for its dominance of the "Mexican regional" music market. But the company signed major artists in other categories, so the site needed to be neither too edgy nor too conservative, and the designers also wanted to avoid anything that would limit the company's reach by presenting it as ethnic.

The solution was to use a CD shape as a holding device for headers and pictures, along with strong, vibrant colors and organic, rough typography (in Times Roman and Attic) that conveys the company's vitality. As the design suggests, using a successful retro approach can help designers needing to avoid stylistic extremes.

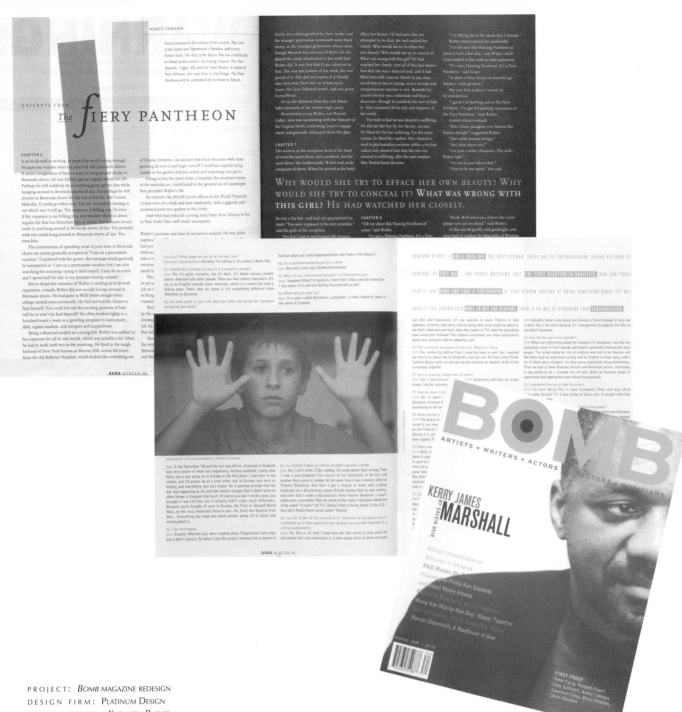

PROJECT: *BOMB* MAGAZINE REDESIGN
DESIGN FIRM: PLATINUM DESIGN
ART DIRECTOR: KATHLEEN PHELPS
DESIGNERS: MIKE JOYCE, KELLY HOGG
CLIENT: *BOMB* MAGAZINE

Magazines—ever-evolving and mostly contemporary—are in some ways the cutting edge of design. Although publications like *Ray Gun* and *Wired* receive attention for pushing the boundaries of readability, this 1997 redesign illustrates how designers can meld the unpredictable and the refined—without using more than two colors at a time except on the cover.

Bomb, a fourteen-year-old nonprofit arts and literary publication, asked the designers to make the magazine smaller, unify the publication visually while providing more flexibility, and air out the pages with more white space. The task was made far quicker because of the computer, the designers say. In the final design, type strikes out in unexpected directions, yet the overall impression is graceful, clear, and elegant.

PROJECT: BOOK DESIGN IN SWITZERLAND +
 LARS MÜLLER PUBLISHERS EXHIBITION POSTER
DESIGN FIRM: STUDIO OZUBKO
DESIGNER: CHRISTOPHER OZUBKO
CLIENT: UNIVERSITY OF WASHINGTON

This 1997 poster, which advertised an exhibition on contemporary book design, is a reminder of the Swiss style's vitality. The exhibition combined a traveling exhibit organized by the Art Council of Switzerland with books by Lars Müller, the noted designer and publisher.

The poster uses the cross in two ways: reversed out of a field of red, it symbolizes Switzerland, and as a plus sign, it calls attention to the fact that Müller's work was added to the exhibition. The design is asymmetrical but still balanced. Its crisp lines inevitably recall the clean compositions the Swiss style made famous. Today, even in designs with wild backgrounds or other misleading elements, you can still see type organized along strong, invisible lines.

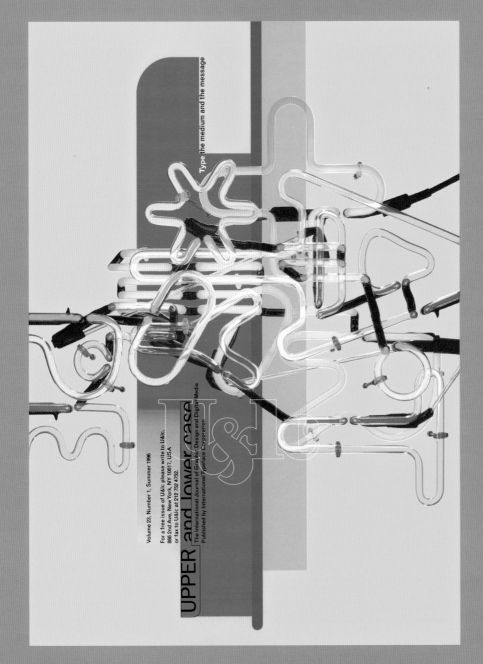

PROJECT: PRINT ADVERTISEMENT FOR *U&lc* MAGAZINE
DESIGN FIRM: WHY NOT ASSOCIATES
DESIGNERS: ANDY ALTMANN, DAVIS ELLIS,
PATRICK MORRISSEY, IAIN CADBY
PHOTOS: ROCCO REDONDO
CLIENT: *U&lc* MAGAZINE

This print ad from 1996 probably makes type more fun than it ought to be.

The image shows a mass of tubes, each twisted into the outline of a letter shape or other typographic symbol. The type—that is, the type that's meant to be read—is massed near the bottom in black, and is turned ninety degrees so that it reads up from the bottom. The white-outlined logo of the magazine, and the solid word *Type* provide splashes of white amid the bright colors. One of the cleverest things about the piece is how the free-form shapes of the tubular letters make one think of grunge type, when they're actually carefully composed.

Multiculturalism, Internationalism, & Environmentalism

In a climate of near-constant change, designers have had to keep pace with their clients; one of the biggest changes those clients have experienced is the demographic shift toward a more diverse workforce. This change has accelerated in the last ten years. In the United States, regardless of how politically charged the issue of affirmative action has become, businesses face a population in which whites are soon to be less than the majority. Changing populations are also becoming more of a reality in Europe, and despite the problems of the Pacific Rim

nations in the mid to late nineties, the increased economic power of those countries means more visibility for Asian businesses and business-people worldwide.

In addition, the environmental movement that began during the sixties accelerated in the succeeding thirty years; what started by focusing on pollution has come to embrace the concepts of biodiversity and habitat conser–vation. This movement, which began on the grassroots level in the U.S. and Europe, has

become an ongoing worldwide discussion, however difficult, that involves governments from every continent.

Finally, the international nature of telecommunications, and thus business, in the nineties gives new importance to understanding cultural and national differences, even as (or perhaps because) nations have become more interdependent in their financial and trade relationships. At the same time, culture itself—especially youth culture—has become more global. In the United States, for example, music and advertising are especially strong forces, and carry with them the ability to change perceptions as the country changes. In particular, American television's role in marketing to younger viewers has meant incorporating images from black and other minority cultures, images that are less threatening to a more blended young population. These images, and echoes of them, inevitably make their way into designed communications in other countries, following T-shirts, blue jeans, and consumerism as they make their way around the world.

In giving an outward face to business endeavors, designers have had to take all these new elements into account. For instance, in the United States, it has become a given that the audience for any corporate communications piece—whether a general marketing brochure or a campaign aimed at the client's own employees—be portrayed as broadly as possible to convey a commitment to diversity in hiring. Thus American marketing brochures and annual reports are particularly likely to incorporate images of diverse races, usually through photography.

Likewise, because people in developed countries are understood to support environmentalist goals, it is also understood that corporations must let audiences know they also support those goals. So it is that marketing campaigns are built around this mutually understood agenda, through images of nature (sometimes photographic, sometimes not) and words and phrases that convey a concern for the environment.

The vocabulary of design has adapted to all these changes. And designers have begun to understand their own role as major decision-makers where the consumption of paper and the use of polluting technologies is concerned. In 1996, for example, the American Institute of Graphic Arts published a "handbook of environmental responsibility in graphic design." While underwritten by a major paper manufacturer, the handbook, *The Ecology of Design,* offered American designers guidelines to reduce corporate impact on the environment, updates on digitally based lower-impact printing technologies, and alarming statistics on how much the printing and publishing industry contributes to the "waste stream."

Of all these broad elements, it is probably designers' own environmentally related choices that will take the longest to assess—and perhaps the longest to change. After all, more inclusive images of people, cultures, and nature have already become a reality in design. But design organizations may need to be increasingly proactive to convince graphic designers to be more sensitive in their choices. As printing itself continues to evolve, digital technology will also provide new options—especially higher-quality direct imaging and waterless printing—that will lessen design's pressure on the environment.

PROJECT: THE RADIOLOGICAL SOCIETY OF NORTH AMERICA
 RESEARCH AND EDUCATION FUND TENTH-ANNIVERSARY BROCHURE
DESIGN FIRM: ASYLUM
ART DIRECTOR: BILL CURRENT
DESIGNER: JEN BAKER
ILLUSTRATOR: PASCAL MILELLI
CLIENT: THE RADIOLOGICAL SOCIETY OF NORTH AMERICA RESEARCH AND EDUCATION FUND

This 1996 brochure for a medical group illustrates how effectively earth-related images communicate a "soft" image.

The oil-on-paper illustrations have a handmade look, and each image shows an aspect of garden cultivation that the gardener carries out personally: pruning, planting seeds, watering, and so on. The unmistakable impression is that the fund has been nurtured by individual effort and needs more of that effort in order to continue. Even the papers, recycled sheets for body and cover called Celebration Fiesta and Confetti, contribute to the effect because of their flecked, uncoated surfaces. The classic typography, in Garamond and Berkeley, reinforces the gentle feeling of the piece.

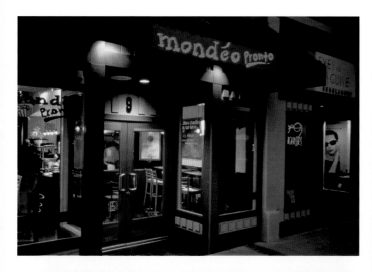

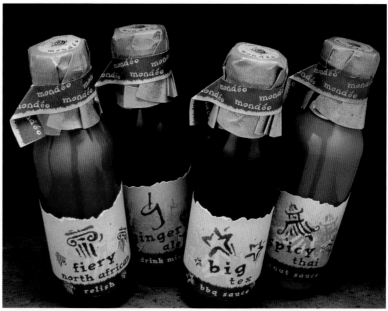

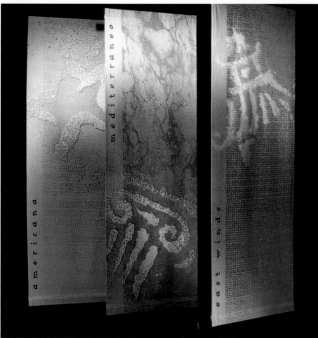

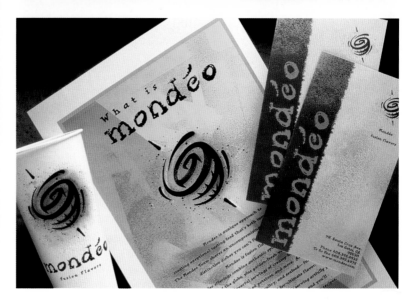

PROJECT: MONDÉO RESTAURANT IDENTITY
DESIGN FIRM: HORNALL ANDERSON DESIGN WORKS INC.
ART DIRECTOR: JACK ANDERSON
DESIGNERS: JACK ANDERSON, DAVID BATES, SONJA MAX
ILLUSTRATOR: DAVID BATES
CLIENT: CW GOURMET/MONDÉO

The identity system for this American restaurant, launched in 1997, draws on several important design concepts. The client wanted a logo reflecting the restaurant's "alternative" cuisine—a fusion of fast but healthy foods from around the world served in bowls or wraps—so the restaurant's mark blends a globe, a bowl, and a wrap in motion.

The earthy feel and soft colors of the identity touch the contemporary desire for less stressful, more natural surroundings. Various icons, such as the Corinthian capital and the unspecific Asian building used in the restaurant banners, convey a hip globalism on the part of both restaurant and clientele; even the name (the sign outside says "Mondéo pronto") conveys a certain Euro-familiarity without being ethnic *per se*.

PROJECT: THE MEXICAN MUSEUM
 TWENTIETH-ANNIVERSARY POSTER
DESIGN FIRM: MORLA DESIGN
ART DIRECTOR: JENNIFER MORLA
DESIGNERS: JENNIFER MORLA, CRAIG BAILEY
PHOTOS: COURTESY INTERNATIONAL MUSEUM OF
 PHOTOGRAPHY AT GEORGE EASTMAN HOUSE
CLIENT: BACCHUS PRESS

Representations of non-majority cultures have become increasingly imaginative and enjoyable in recent years.

This sophisticated 1996 poster for San Francisco's Mexican Museum uses early-twentieth-century Mexican woodblock type, imagery from the old Mexican card game *lotteria*, an image of Our Lady of Guadalupe, and a benday portrait of artist Frida Khalo that is owned by the museum. The woodblock lettering (some of the characters are printed twice, in two different typefaces) seems to dance across the surface, but this is all from its arrangement. The color palette, though bright, is somewhat limited. Khalo's gaze is knowing but ambiguous, contrasting with the playful letters and the polka dots and palm tree that cover the bottom portion of the piece.

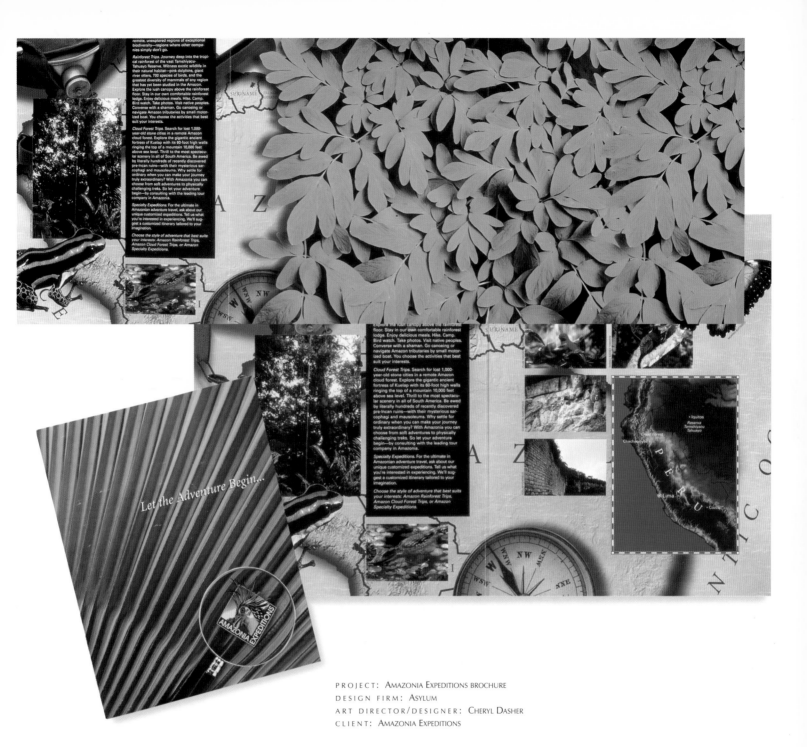

PROJECT: Amazonia Expeditions brochure
DESIGN FIRM: Asylum
ART DIRECTOR/DESIGNER: Cheryl Dasher
CLIENT: Amazonia Expeditions

With this 1997 combination brochure/folder for a United States-based tour company operating in Peru, Asylum gave the client a more high-profile look, allowing it to compete more effectively with other companies offering tour services.

To create the "environmental" look of the piece, art director Cheryl Dasher juxtaposed two maps with images of specific animals and places, alongside two emblems of Western treks, familiar to Americans from lifestyle catalogs: an old-fashioned compass and a canvas-covered water canteen. This kind of material requires careful attention because of the information-hungry audience; for example, wildlife in pictures must be named, not just shown. Close-up images of plant foliage convey the look of the jungle. Interestingly, this piece was done on a glossy paper with all-over varnish rather than on recycled stock.

PROJECT: SEALASKA 1997 ANNUAL REPORT AND SHAREHOLDER HANDBOOK
DESIGN FIRM: HORNALL ANDERSON DESIGN WORKS, INC.
ART DIRECTOR: JACK ANDERSON
DESIGNERS: JACK ANDERSON, KATHA DALTON, HEIDI FAVOUR, NICOLE BLOSS, MICHAEL BRUGMAN
ILLUSTRATORS: VARIOUS, FROM SEALASKA ARCHIVE
PHOTOS: VARIOUS FROM SEALASKA ARCHIVE, DAVID PERRY, MARK KELLEY, CLARK MISHLER,
 IMAGE BANK, ALASKA HISTORIC MUSEUM, UNIVERSITY OF WASHINGTON
CLIENT: SEALASKA CORPORATION

This project illustrates how well designers now incorporate images that are more inclusive and that accurately reflect a changing cultural and demographic landscape. This annual report served as a twenty-fifth anniversary commemoration for the Alaska Native products and investment company. Income from the corporation's timber harvesting, mining, and investments goes to its shareholders.

Since the corporation's mission includes preserving Native American land and culture, the annual report includes archival photographs from Alaska's past and full-bleed examples of Native American artwork on the section tab pages. Papers with an organic style and a double-page, full-bleed image of a sunset-washed scene of Alaskan water and mountains contribute to an environmentally conscious look, in keeping with the client's philosophy.

PROJECT: YesterData/DataToday poster
DESIGN FIRM: Kan & Lau Design Consultants
ART DIRECTOR/DESIGNER: Kan Tai-keung
COMPUTER ILLUSTRATOR: Benson Kwun
PHOTOS: C. K. Wong
CLIENT: DDD Gallery

This 1997 poster marked the sixth anniversary of an Osaka, Japan art gallery. It eloquently captures a shift in the handling of information that cultures are experiencing worldwide.

On the left, an antique book forms the vertical stroke of a capital "D." On the right, a compact disc forms the round portion of the letter. The materials of the two "information storage and retrieval devices" stand in stark contrast, and it becomes evident after a moment that the book and the disc are out of scale with one another. In real life, the disc would be much smaller. Yet it holds so much more, and its technology looms so large in our lives, that the disproportionate sizes are perhaps fitting.

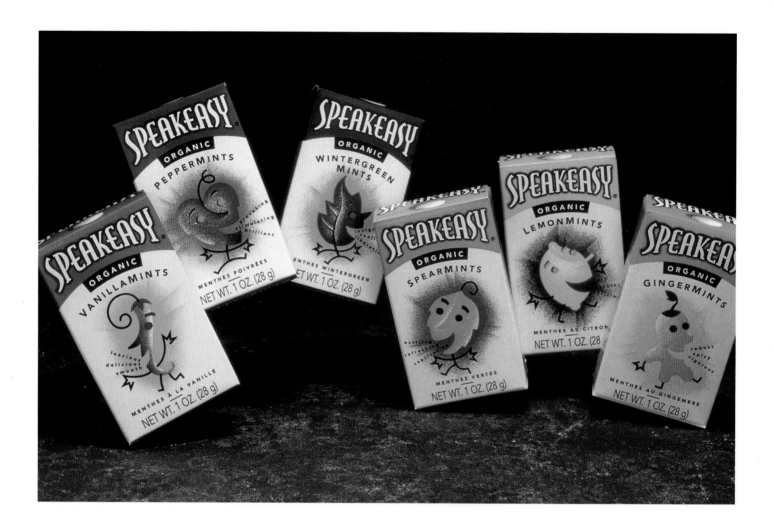

PROJECT: SPEAKEASY MINTS PACKAGING
DESIGN FIRM: HORNALL ANDERSON DESIGN WORKS, INC.
ART DIRECTOR: JACK ANDERSON
DESIGNERS: JACK ANDERSON, JANA NISHI, HEIDI FAVOUR, DAVID BATES, MARY HERMES
ILLUSTRATORS: JULIA LAPINE, DAVID JULIAN, JANA NISHI
CLIENT: CLOUD NINE

This 1997 packaging project aims at helping the client, which already was selling its products in specialty stores, break into grocery store chains.

The name was established; the designers developed the "talking heads" concept and the overall identity for the mints. The various characters reflect the plants whose flavors they represent, and the fact that the mints' attributes come out of the characters' mouths makes a direct contact with the customer. The illustration style, color scheme, and low-gloss packaging put the product in the environmentally friendly category. Equally important, the word "organic" appears very large, knocked out from black; this term is a significant adjective in the American marketplace, where anxiety over the food system has risen in recent years.

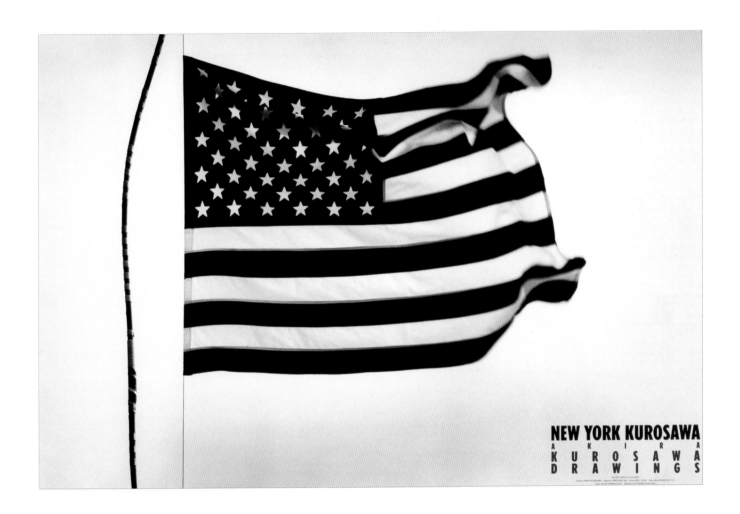

PROJECT: NEW YORK KUROSAWA
DESIGN FIRM: TODA OFFICE
DESIGNER: SEIJU TODA
CLIENT: ISE CULTURAL FOUNDATION

This 1995 poster promoted an exhibition of drawings by the acclaimed Japanese filmmaker Akira Kurosawa in New York. The idea for the piece is simple; as Toda explains it, the Japanese bow, represented by what looks like a carefully wrapped piece of wood, joins with the American flag, symbolizing the fusion between the two countries.

The thin line between the flag and the Japanese "zone" at the left looks a little like the line between two pages of a book. In a decade when trade tensions between the United States and Japan remain sensitive, it's a bold concept for a graphic piece. Indeed, as the design and its title suggest, international relationships, whether cultural or economic, are a part of life for everyone.

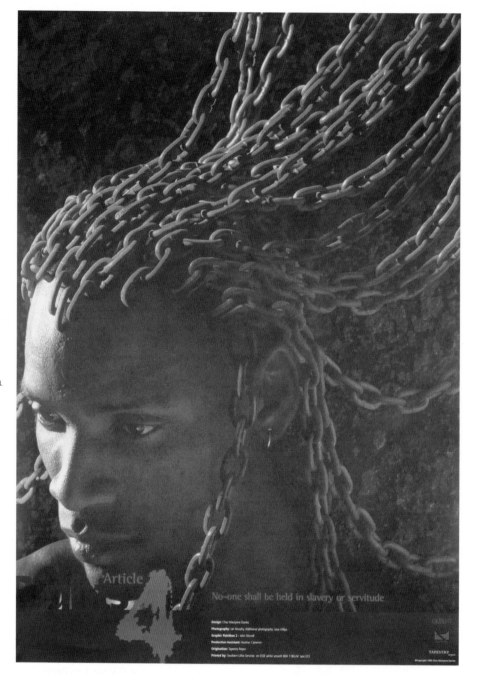

PROJECT: United Nations Declaration
of Human Rights poster
DESIGN FIRM: Maviyane-Project
DESIGNER: Chaz Maviyane-Davies
PRODUCTION ASSISTANT: Heather Cameron
DIGITAL IMAGE MANIPULATOR: John Murrell
PHOTOS: Ian Murphy, Jane Killips
CLIENT: Chaz Maviyane-Davies

This poster is one in a series. A private project that took form between 1995 and 1997, the posters highlight various articles of the United Nations Declaration of Human Rights. Maviyane-Davies is particularly skilled at visually interpreting important cultural ideas. The results can be striking, as this example shows.

Chains are a universal symbol for servitude, but here, arranged as strands of the model's hair, they become a metaphor for what Maviyane-Davies calls "colonization of the mind." Arranged so they flow back and up, the chains become almost clawlike, more interesting than they would be if they hung straight down.

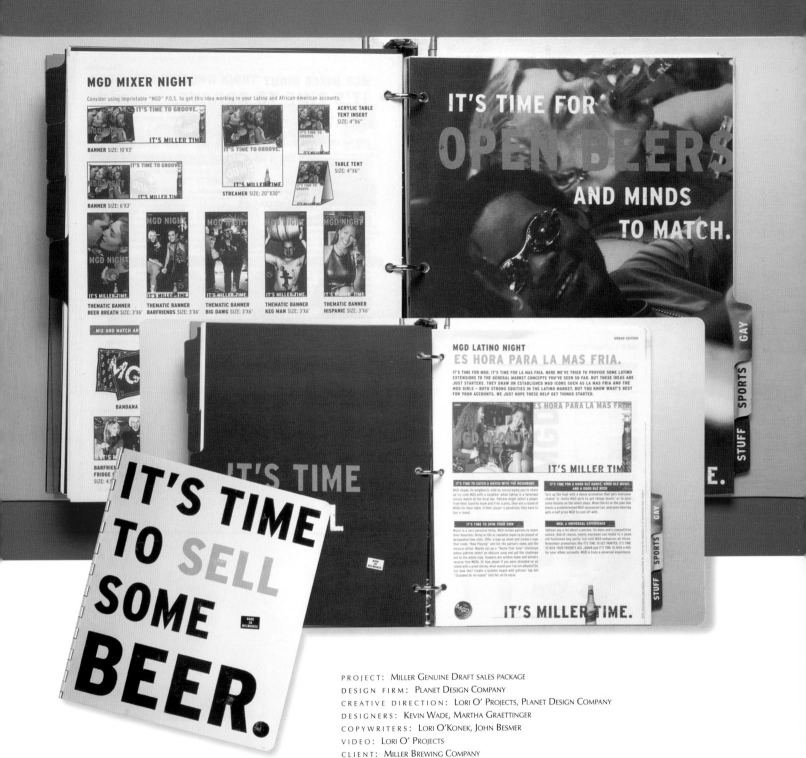

PROJECT: MILLER GENUINE DRAFT SALES PACKAGE
DESIGN FIRM: PLANET DESIGN COMPANY
CREATIVE DIRECTION: LORI O' PROJECTS, PLANET DESIGN COMPANY
DESIGNERS: KEVIN WADE, MARTHA GRAETTINGER
COPYWRITERS: LORI O'KONEK, JOHN BESMER
VIDEO: LORI O' PROJECTS
CLIENT: MILLER BREWING COMPANY

This 1997 sales package builds on the edgy consumer campaign for Miller Genuine Draft, a mass-market beer that helped dampen the boutique beer craze. The designers' challenge was to tap into the gritty style of MGD's television advertising while clearly conveying the information needed by the sales force.

The complex package includes an aluminum binder, gatefolded introductory pages, tabbed section pages, sales sheets, an attached sleeve holder and labels for a sales video that goes with the package, and ancillary folders. Interestingly, one of the beer's strategic positioning points is that its market is inclusive and multicultural. The sales package thus includes materials to support sales to new markets such as gays and Latinos.

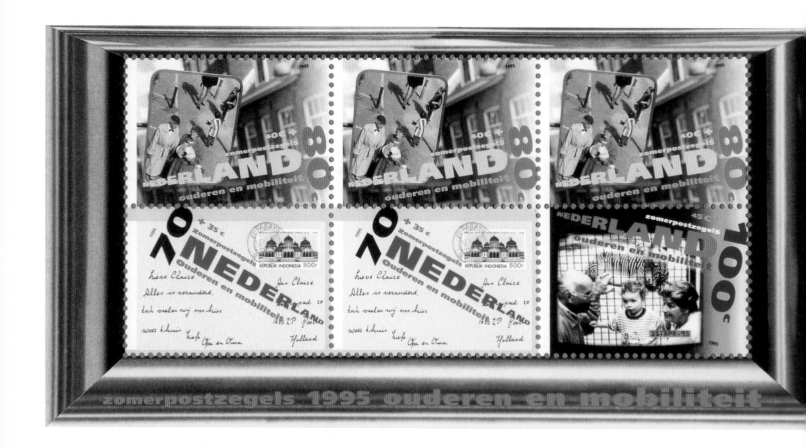

PROJECT: "OUDEREN EN MOBILITEIT" STAMPS
DESIGN FIRM: WILD PLAKKEN
DESIGNERS: LIES ROS, ROB SCHRÖDER
CLIENT: DUTCH PTT

In the nineties, perceptions of a variety of groups have begun to change, in part as a result of designers' work. This 1995 set of Dutch stamps focused on elderly people and mobility. However, there were to be no wheelchairs in the images.

The designers imagined three different trips that an elderly person might make, and created images to represent them. A postcard from Indonesia to a granddaughter represents the longest. The second-longest, a day trip to a local zoo, is shown in the imaginary video of grandparents and grandchild together. The top three stamps show a visit to neighbors, reflected in the "spy" mirror attached to the outside wall of every Amsterdam household.

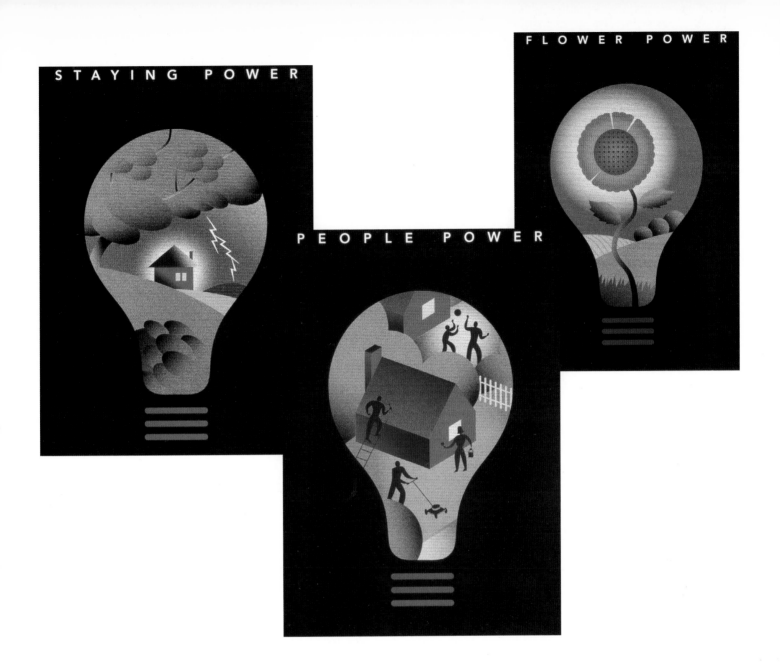

STAYING POWER

FLOWER POWER

PEOPLE POWER

PROJECT: TU ELECTRIC LOYALTY INITIATIVE MAILERS
DESIGN FIRM: SULLIVANPERKINS
DESIGNER/ILLUSTRATOR: KELLY ALLEN
COPYWRITERS: LARRY TALLEY, LINDA OSGOOD
CLIENT: TU ELECTRIC

As deregulation of ultility companies approached in the American market in 1997, TU Electric asked SullivanPerkins to design a set of mailers that would help establish and build loyalty among its customers.

The covers of the resulting pieces show several touchstones for American business in the nineties. One piece, "Staying Power," conveys the sense that the company is in business for the long haul and is closely focused on the needs of its customers. Another, "People Power," is about involvement in the community. And a third, "Flower Power," recalls a slogan from the sixties to suggest the company's commitment to the environment. The illustrations, all set within lightbulbs, are executed in a "soft" style that suggests painting on cloth.

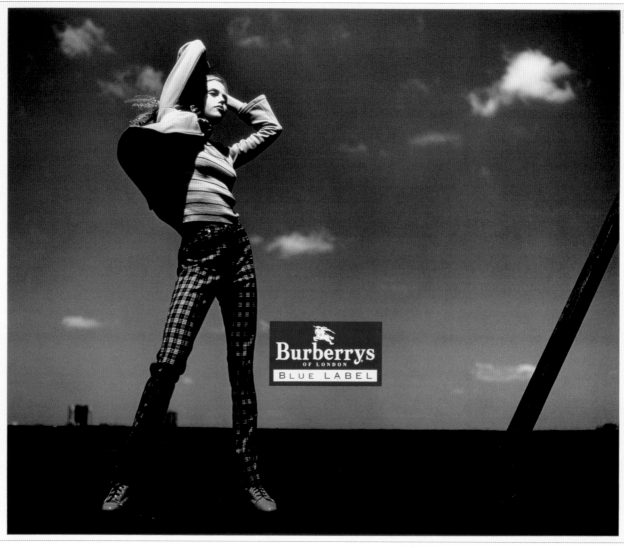

踊れるバーバリー。

PROJECT: Burberry's Blue Label poster
DESIGN FIRM: Toda Office
DESIGNER: Seiju Toda
CLIENT: Sanyo Shokai Co.

Television, movies, advertising, and youth-oriented products have created a global youth culture. For that culture, it is sometimes less important for designers to use local models, as this 1996 poster illustrates.

The elements seen here are familiar from fashion-oriented graphic design pieces done on virtually every continent: a very young model, a sense of motion, an absorbed expression, and an urban backdrop. The fact that the model appears Caucasian seems incidental; local information is provided by the Japanese characters to the left. More critical is the issue of branding; the poster repositions a very established clothing line, associated with older British customers, as a maker of international fashion for the young.

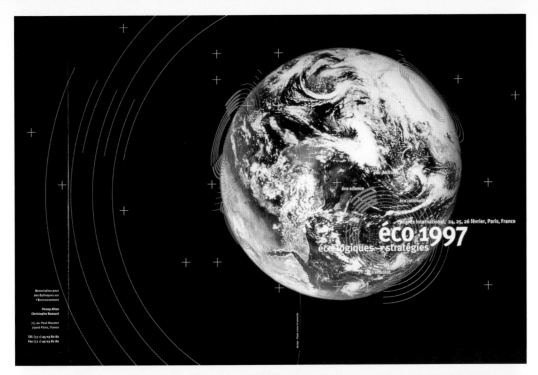

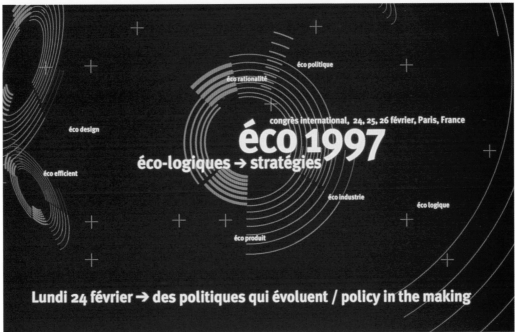

PROJECT: Eco-logiques/Stratégies international congress visual identity
DESIGN FIRM: L Design, Pippo Lionni
DESIGNER: Pippo Lionni
CLIENT: Association pour les Congrès d'Environnement

Environmental issues have created a new arena for designers, especially as computer technology developed since the mid-eighties has made it possible to express environmental ideas in new ways. Pippo Lionni developed this visual identity for an international environmental congress held in Paris in 1997.

The image of the Earth, floating in space, would be conventional were it not for the concentric rings that seem to radiate from it. The rings are reminiscent of CD-ROMs and audio CDs; they seem both technological and hopeful. There's another reference to technology in the small plus signs that take the place of stars in both posters; they're a little like printer's registration marks, but the allusion could also be to architecture or mathematics.

FORSCHER GEIST
in den IBM Laboratorien

Innovation ist der Antriebsmotor für den Fortschritt. Diese Erkenntnis gilt für kaum eine andere Branche so ausgeprägt wie für die Informatikindustrie.

Die IBM nimmt in der Forschung und Entwicklung mit jährlichen Investitionen von mehreren Milliarden Dollar eine Spitzenstellung ein. Das hat uns bis heute ein Portfolio von weit über 30'000 Patenten eingetragen; jedes Jahr kommen hunderte neuer hinzu. IBM Forscher haben für ihre herausragenden Leistungen zahlreiche Forschungs- und Wissenschaftspreise erhalten. Fünf IBM Forscher sind bisher mit dem Physik-Nobelpreis ausgezeichnet worden.

Die Ziele der Forschungsanstrengungen sind über die Zeit gleich geblieben, und sie haben auch in Zukunft mehr denn je Gültigkeit: wir wollen unsere Position als führendes Technologieunternehmen behalten. Wir wollen mit herausragenden Leistungen in Schlüsselbereichen - zum Beispiel Mikroprozessorentwicklung, Halbleiterfertigung, Speichertechnologie, Netzwerke, Software ... sis für erstklassige Produkte und Infor... ! auch neue Trend...

Für **Sie.**

Die IBM Schweiz

IBM

PROJECT: "FOR YOU" DIE IBM SCHWEIZ BROCHURE
DESIGN FIRM: KOMMUNIKATIONS-DESIGN BBV
CREATIVE DIRECTOR: MICHAEL BAVIERA
ART DIRECTORS/DESIGNERS: SIEGRUN NUBER, ROGER STECK
ILLUSTRATOR: JÜRG FURRER
CLIENT: DIE IBM SCHWEIZ

IBM Switzerland commissioned this brochure from Kommunikations-Design BBV in 1993, printed it in a small edition of one thousand, and sent it to its best business partners. The piece presented the company's business vision and showed IBM as an innovative and service-oriented company. The first part discusses IBM as a global company, the second IBM's Swiss operations.

Although the piece was set in the client's usual Bodoni along with Memphis Bold, it also used images of nature to conjure up specific associations, such as the spiderweb on a page devoted to how well IBM's services are organized. Such visual references have become increasingly common in marketing materials for business, even when the industry is far removed from the natural environment.

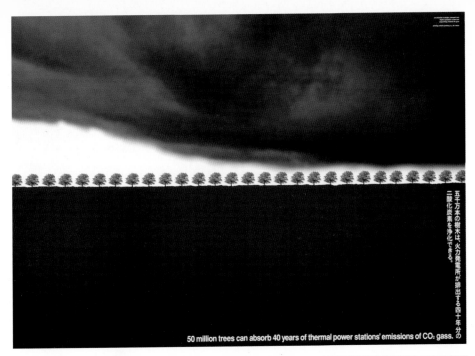

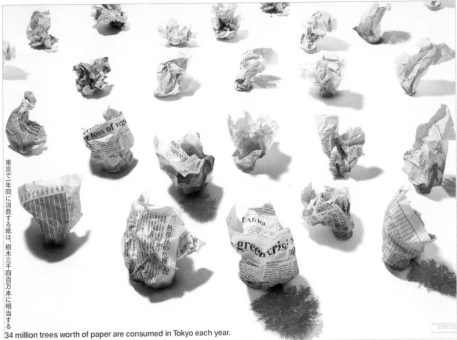

PROJECT: ENVIRONMENTAL POSTERS
DESIGN FIRM: UNO, YASUYUKI DESIGN STUDIO INC.
ART DIRECTOR/DESIGNER: YASUYUKI UNO
PRODUCTION ASSISTANT: RYUMA ARAI
COPYWRITER: THOMAS DEGRAW
CLIENT: YASUYUKI UNO

As the millennium approaches, not only design organizations but also some individual designers have become reflective about the environment. Both of these posters were done last year.

In one, focusing on the amount of paper used in Tokyo each year (expressed in millions of trees), Uno photographed crumbled pieces of paper; images of trees were then digitally inserted behind the shadows cast by the crumples. In the other, the computer was used to multiply a line of trees, then the resulting image was combined with a black cloud to dramatize trees' ability to absorb power-station emissions. Commentary in both Japanese and English is included in each poster.

PROJECT: BORNFREE RECYCLED PAPER SERIES PROMOTION
DESIGN FIRM: KAN & LAU DESIGN CONSULTANTS
CONCEPT/INK ILLUSTRATOR: KAN TAI-KEUNG
ART DIRECTORS: KAN TAI-KEUNG, EDDY YU
DESIGNERS: KAN TAI-KEUNG, EDDY YU, BENSON KWUN, LEUNG WAI YIN
COMPUTER ILLUSTRATORS: BENSON KWUN, JOHN TAM, LEUNG WAI YIN
CALLIGRAPHERS: YIP MAN-YAM, CHUI TZE-HUNG, YUNG HO-YIN
SEAL ENGRAVER: YIP MAN-YAM
PHOTOS: C. K. WONG
CLIENT: TOKUSHU PAPER MANUFACTURING CO. LTD.

This promotion is a showpiece of printing techniques and design. It is also built around the concept of a "free and easy" lifestyle in harmony with nature.

Perhaps the product of an Asian affluence newly attuned to Western leisure concepts, the piece devotes one page of each Bornfree paper color to a different part of a carefree life: walking free, sitting free, sleeping free, eating free, playing free, and feeling free. The background of each page contains a piece of award-winning calligraphy, enlarged and printed with a special technique such as embossing or the use of metallic ink. The surface of the paper, as the promotion points out, suggests the "bamboo-grained surface and tear-off edges of traditional Chinese hand-made paper."

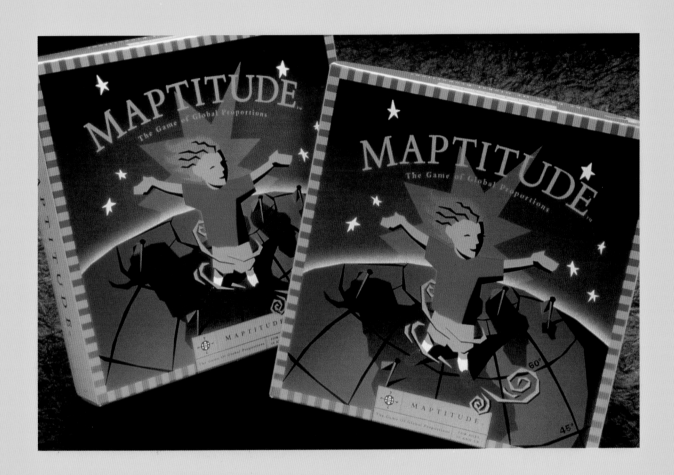

PROJECT: MAPTITUDE GAME PACKAGING
DESIGN FIRM: HORNALL ANDERSON DESIGN WORKS, INC.
ART DIRECTOR: JACK ANDERSON
DESIGNERS: JACK ANDERSON, JANA NISHI, HEIDI FAVOUR, DAVID BATES, SONJA MAX
ILLUSTRATOR: DENISE WEIR
CLIENT: RESOURCE GAMES

This geographical card game helps children learn about the world and its cultures. It was originally called "Atlas in a Box," but the client wanted a more marketable name for the game, and the clever "Maptitude" was the result.

The bright packaging design makes the game seem fun, and although the child on the cover stands astride the globe from the point of view of the North American continent, the style of the cover illustration and the bright, friendly color scheme take away any hint of colonialist superiority, reflecting a softer stance than might have been the case in prior decades.

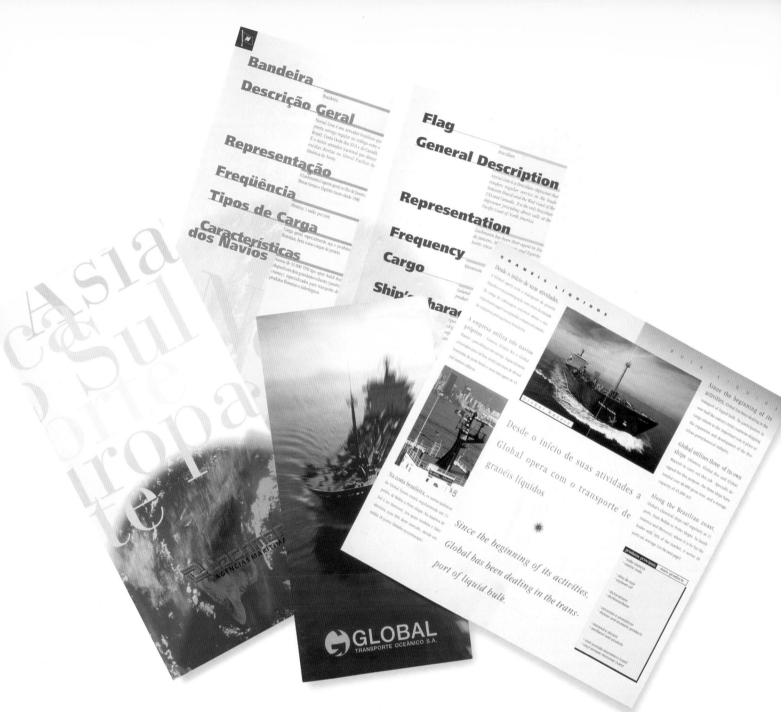

PROJECT: MARKETING PACKAGES FOR GLOBAL
TRANSPORTE OCEÂNICO S.A. AND LACHMANN AGÊNCIAS MARÍTIMAS S.A.
DESIGN FIRM: INTERFACE DESIGNERS
ART DIRECTOR/DESIGNER: ANDRÉ BOMBONATTI DE CASTRO
CLIENTS: GLOBAL TRANSPORTE OCEÂNICO S.A. AND LACHMANN AGÊNCIAS MARÍTIMAS S.A.

These two companies had the same owner, but the marketing packages were done separately to help differentiate their products and services, all of which involve international shipping.

If it's true that English has become the international language of business, these pieces help make the point. Both have English translations along with the Portuguese original. The major piece for each package is an outer brochure-style folder, which has several pages of information about the company's essential services in addition to a pocket for inserts. The Global folder cover photo, of an approaching ship, is intentionally blurred to suggest the urgency of international cargo, while the Lachmann package includes numerous computer-manipulated satellite images of various parts of the globe.

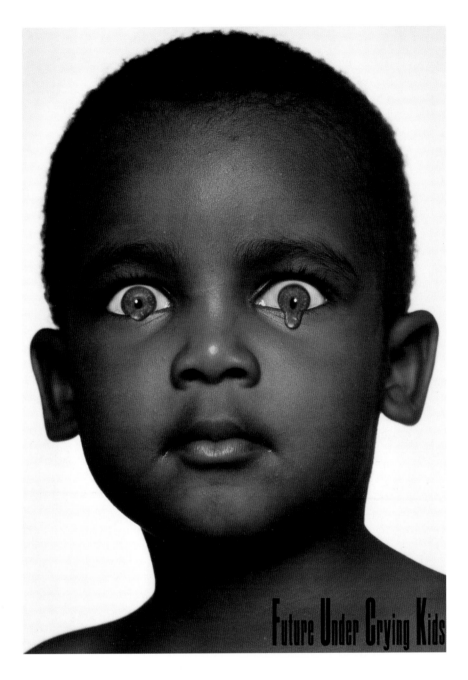

Future Under Crying Kids

PROJECT: FUTURE UNDER CRYING KIDS POSTER
DESIGN FIRM: TODA OFFICE
DESIGNER: SEIJU TODA
CLIENT: TOKYO ADC

For a Tokyo exhibition in 1995, the designer manipulated a photograph of a crying child to dramatize children's anxiety over the future.

The focus of the child's fear is not made explicit; it could be continued nuclear proliferation, starvation, or a host of other ills. The poster invites adult viewers to imagine the possibilities. At the same time, Toda gave the piece a global, as well as multicultural, perspective by giving the dark-skinned child bright blue eyes; this could be any child, anywhere, he seems to be saying. The imagery is even more arresting because the "tears" appear to be produced by the melting of the irises.

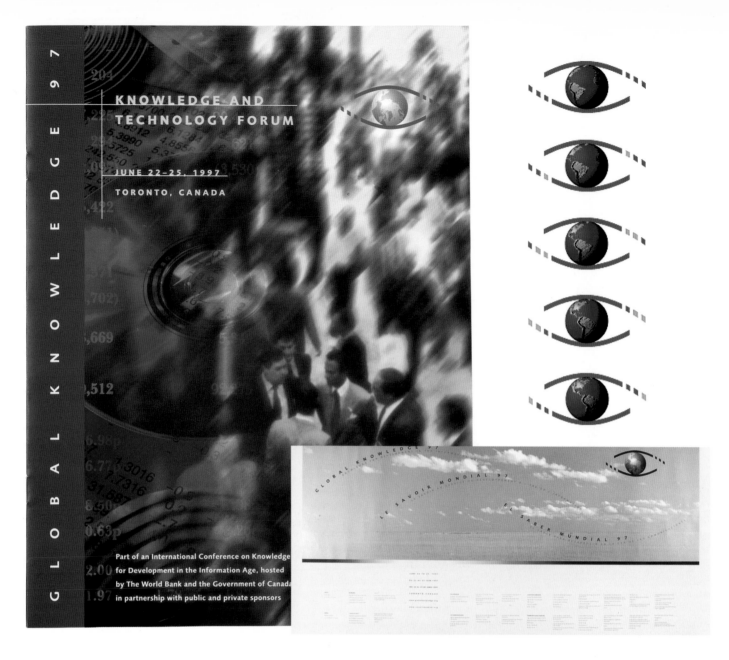

PROJECT: GLOBAL KNOWLEDGE 97 IDENTITY AND PUBLICATIONS
DESIGN FIRM: MEADOWS DESIGN OFFICE
ART DIRECTOR: MARC ALAIN MEADOWS
DESIGNERS: MARC ALAIN MEADOWS, KAREN SIATRAS, STACI DADDONA
CLIENTS: THE WORLD BANK, ECONOMIC DEVELOPMENT INSTITUTE; GOVERNMENT OF CANADA

Meadows Design Office created this project for a 1997 international conference on how information-age knowledge can be applied to development problems.

The designers created the logo (including an animated version for the conference's temporary Web site) and identity and applied them to brochures, a press kit, a poster, banners, and other materials. Most of the pieces were done in French and English; some included Spanish translations as well. The project's international flavor is typical for Meadows Design Office; the company, which designs publications and other editorial materials for corporations, museums, national associations, and publishers, has clients on four continents. The firm invested in software that allows correct hyphenation in foreign languages, an important nicety often overlooked in multi-language design pieces.

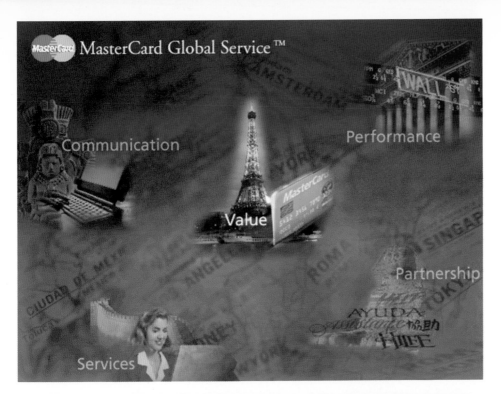

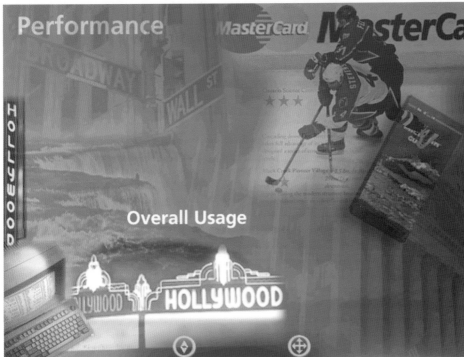

PROJECT: MASTERCARD GLOBAL SERVICES™
PRESENTATION AND AUTHORING SYSTEM
DESIGN FIRM: UNIFIED FIELD
ART DIRECTOR: URSULA DREES
SENIOR DESIGNER: CHRISTINE HSIAO
DIRECTOR OF PROGRAMMING: JEFF MILLER
CLIENT: MASTERCARD INTERNATIONAL

This 1997 project allowed MasterCard's Global Services™—the aggregated member benefits program—to be marketed all over the world.

The designers created a multimedia presentation that could be given before individual member banks, groups of member banks, and other large groups. Most importantly, the presentation was also an authoring tool. It was built on a 32-bit Windows platform that allowed non-Western characters to be displayed. Thus MasterCard staff could enter text in local languages, charts and graphs that showed local figures, or local video and sound files. Yet the presentation retained a simple visual consistency that made it recognizably the same everywhere. In a global business environment, the need for such communications tools represents an important new market for designers.

7. The Future

As design looks to its future, two words resonate: branding, that watchword of advertising and marketing, and convergence, the description of how technology blends previously separate industries.

Branding makes design possibly the most important partner business currently has, and it gives designers a seat at the same table with advertising agencies and heads of marketing. Behind this change is a set of other changes. Some of these, in turn, were made possible by technology, such as more sophisticated, data-based marketing research. But others are the result of a maturing consumer marketplace, in which products are more alike and thus need to be distinguished by their personalities rather than their inherent properties. In any case, it has become less clear why designers cannot create advertisements, and many of them report that they are now doing just that.

Convergence—perhaps an even more-discussed term—means that designers in San Francisco and Hong Kong, animators in Hollywood and Australia, videographers in New York and London, and Web site developers in Seattle and Spain are all essentially using different flavors of the same technology, drinking from the same digital fountain and using similar keyboard commands and mouse-clicks. In the next five to ten years, this phenomenon will make it even less clear what a designer actually is than it is today—and that definition is already fuzzier than it was. Is a designer someone who creates logos and lays out brochures? Not necessarily, when 3-D animation is practiced

by designers who work for product development companies, when videos are created by designers already steering major marketing campaigns, or when database-driven Web sites are choreographed by designers who themselves know no programming.

Early in the next century, improvements in bandwidth and application interfaces will likely level the technical playing field further, putting a premium on creativity and the quality of designers' visual thinking . . . which, ironically, is what was prized in the pre-digital era.

In the meantime, though, it's clear that designers who shun interactive work are gradually working their way into niches, and that while non-electronic (that is, print-only) projects will never go away, that segment of available work will continue to shrink somewhat, as businesses seek designers able to handle both print and interactive assignments.

The nature of interactive design itself promises to change, as well. To begin with, the Web is likely to give designers many more options for exercising their skills than it does now, as the installed base of computers becomes somewhat more uniform, browsers draw on the same standards for display of type and other graphic elements, and the software for creating online material becomes friendlier. Second, as bandwidth increases, video and sound files streaming into the home or business computer in real time will become a reality for more people, making a facility with moving images and audio an even more important skill for designers than it is now. Finally, it's likely that 3-D technology will develop dramatically in the next few years, making three-dimensional interfaces something designers can experiment with much more easily than they can now; since such interfaces haven't been terribly successful as yet, it may be that designers can help solve the problems with them, as they have dealt with so many other communications problems before.

As is the case now, though, designers with a good feel for technology will probably have a leg up on the competition. So far there appears to be a cultural divide between technologists and designers, a state of affairs that designers who love technology bemoan. That divide is likely to narrow, though, as the younger designers now making a mark in the field become old hands. The critical thing not to be lost in the change of generations is design judgment . . . the one thing technologists will never have.

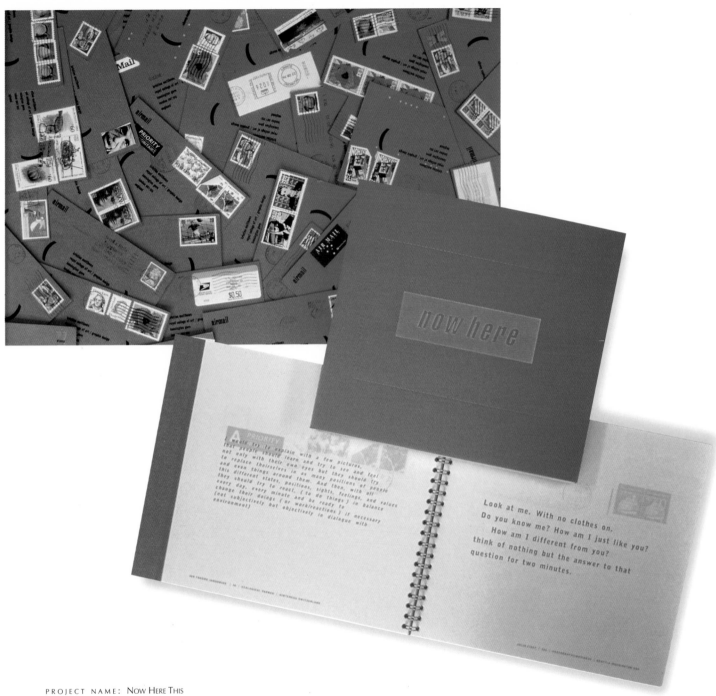

PROJECT NAME: NOW HERE THIS
DESIGNER: KRISTINE MATTHEWS
CLIENT: KRISTINE MATTHEWS

Performance artists get a lot of attention for public or semi-public projects that involve design, yet design itself is capable of being both personal and shared, as well as thought-provoking, as this 1997 project illustrates.

Designer Kristine Matthews sent postcards to a hundred individuals all over the world, ranging from three to eighty-nine years of age. Each was asked, "If you had the attention of the world for a moment or two, what would you do?" When the postcards were returned, Matthews compiled the answers in a book, one copy of which was sent to each respondent. The project created, in a sense, a virtual community—those who thought about the designer's question and sent an answer back.

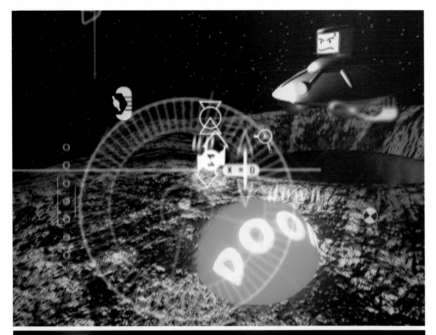

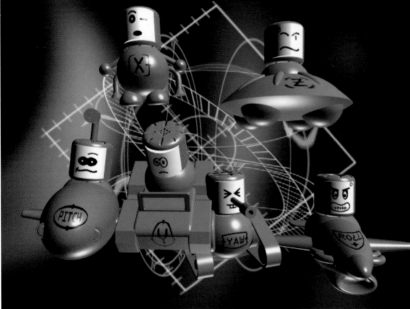

PROJECT: LOGITECH "CYBERMAN 2" VIDEOS
DESIGN FIRM: FORK, A DIVISION OF IDEO
PRODUCT DEVELOPMENT
DESIGNERS: PETER SPREENBERG, SAMUEL LISING, DENNIS POON
CLIENT: LOGITECH

Although many print-only designers are still at work, increasingly there are opportunities—and pressures—to work in other media, as these images suggest.

The "screen grabs" are from a 1997 series created to help Logitech, a maker of game control devices and other computer "senseware" peripherals, introduce CyberMan 2, a new type of game input device, at trade shows. Logitech showed the videos to both end-users and software developers; for both groups, the product's major feature is the fact that CyberMan 2 allows movement along six axes. This kind of video involves very little live-action shooting. Most of the work is conceptual, imaginative, and technical, with heavy emphasis on 3-D computer graphics, animation, and special-effects editing.

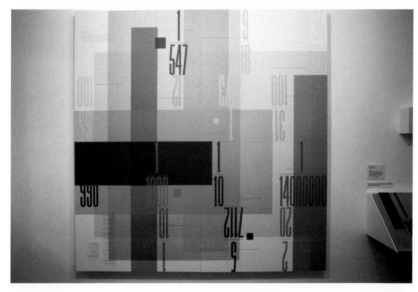

PROJECT: BY CHANCE
DESIGNER: KRISTINE MATTHEWS
PHOGRAPHERS: VARIOUS
CLIENT: KRISTINE MATTHEWS

Technology creates new tools that imaginative designers can make use of. In this 1997 project—a piece of design? an artwork?—Matthews captured fourteen probabilities in the form of a fifteen-color silkscreened poster that folded into a book.

A color field represents each statistic; the larger the field, the greater the probability it applies to the book's reader. In each case, the imagery was created in some random method, produced in the form of an Iris® print, and slipped into a pocket on the page for that statistic. To illustrate Americans' chance of seeing at least one UFO (one in ten), for example, Matthews sent disposable cameras to ten Americans, and included the images they returned to her.

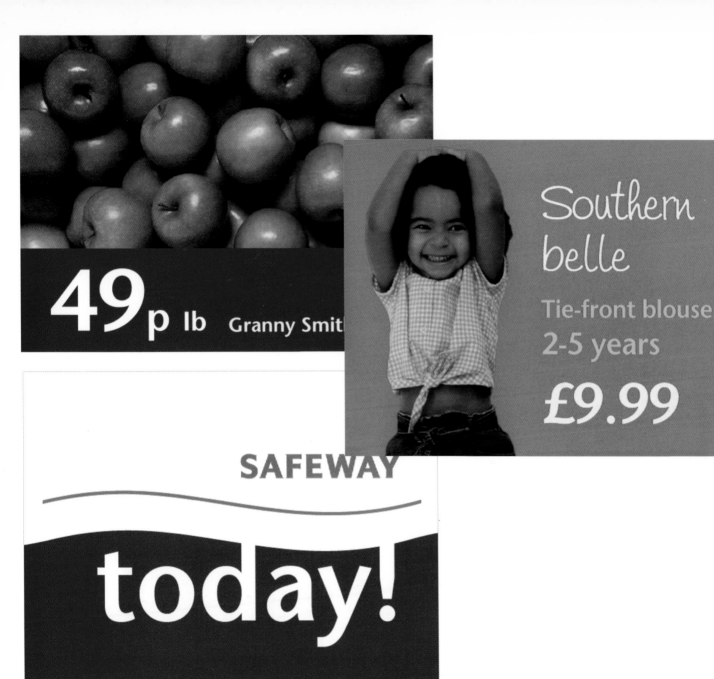

49p lb Granny Smit[h]

Southern belle
Tie-front blouse
2-5 years
£9.99

SAFEWAY
today!

PROJECT: SAFEWAY TODAY MARKETING SYSTEM
DESIGN FIRM: SAMPSON TURRELL ENTERPRISE
ART DIRECTOR: TERRY MOORE
DESIGNERS: BEN TOMLINSON, FIONA FRY
CONSULTANTS: DAVE ALLEN, ANNE MCCROSSAN
CLIENT: SAFEWAY STORES PLC

New technologies will continue to bedevil designers, but they will create significant new business opportunities for them as well. This 1997 project grew out of a remarkable new technology for the supermarket.

Safeway Today, which was installed in stores in the United Kingdom, used flat-screen plasma technology to create mobile "electronic posters" linked via ISDN lines to the company's communications headquarters. The screens can be moved from aisle to aisle within a store, allowing point-of-sale messages to be communicated from a variety of locations. Each screen displays a rolling program of promotional messages, computer graphics and traditional video imagery—a new medium that combines characteristics from television and print and that, unlike print, can be updated within minutes.

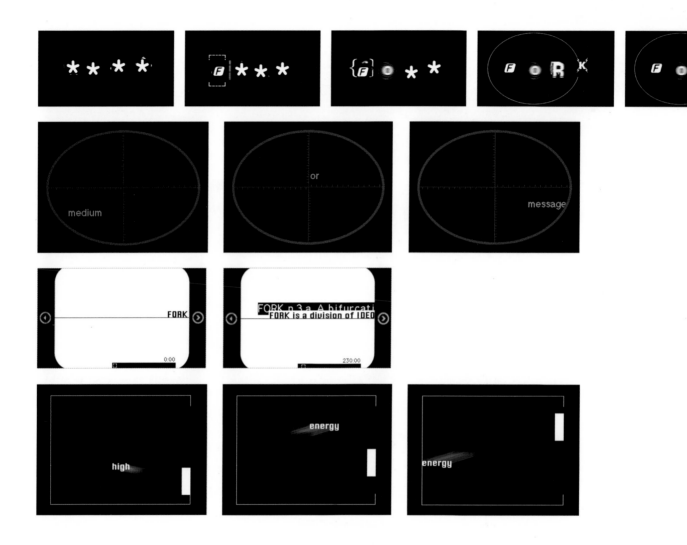

PROJECT: "INTERACTABLES" FROM FORK WEB SITE
 <WWW.PRONG.COM>
DESIGN FIRM: FORK, A DIVISION OF IDEO PRODUCT DEVELOPMENT
DESIGNERS: PETER SPREENBERG, DENNIS POON
CLIENT: FORK, A DIVISION OF IDEO PRODUCT DEVELOPMENT

These charming little pieces were programmed in Macromedia Director and compressed in Shockwave. Located at the Web site for Fork, the communications design division of IDEO Product Development, these "interactables" are messages that the reader must interact with in order to get the full experience.

In one, little asterisks scrub the screen; each one touched by the reader's mouse becomes a letter in "Fork." Another lets the mouse zoom a question through an oscilloscope. A third scrolls Fork marketing messages when the reader clicks on right-left arrows, while the fourth is a ping-pong game with unexpected consequences. As interface design and traditional graphic design become less separate, this kind of technical design experiment may appear with more frequency.

PROJECT: "SYNAPSE" AUDIO-VISUAL INSTALLATION
DESIGN FIRM: WHY NOT ASSOCIATES
DESIGNERS: ANDY ALTMANN, DAVIS ELLIS, PATRICK MORRISSEY, IAIN CADBY
PHOTOS: ROCCO REDONDO, RICHARD WOOLF, HULTON DEUTSCH, PHOTODISC
CLIENT: KOBE FASHION MUSEUM

As traditional art audiences age, museums turn to technology to reach out to younger viewers. Designers who can express ideas and interpret images have an important role to play in museums and other public spaces.

This installation is an example. Built around the idea of influences on fashion, it was done in 1996 at a Japanese museum. More than five thousand images—grouped around concepts like culture, materials, and technology—were projected onto four walls and the floor. The wash of words and images, and the associations they make, go well beyond traditional graphic design. Much as paintings and sculpture do, they change viewers' preconceived notions, and suggest new ways to see life. Could any designer ask for more?

Index of Designers

ASYLUM
4811 Main Street
Suite 100
Skokie, Illinois 60077
U.S.A.
Telephone 847-982-1200
Facsimile 847-982-1221
E-mail bcurrent@refuge.com
(pp. 120, 156, 159)

BAU WOW DESIGN GROUP
1008 Homer Street
Suite 402
Vancouver, B.C. V6B 2X1
Canada
Telephone 604-669-6345
Facsimile 604-669-6362
E-mail dogs@bauwow.com
Web <www.bauwow.com>
(p. 18)

BOELTS BROS. ASSOCIATES
345 East University Boulevard
Tucson, Arizona 85705-7848
U.S.A.
Telephone 520-792-1026
Facsimile 520-792-9720
E-mail bba@boelts-bros.com
Web <www.boelts-bros.com>
(p. 70)

BURSON-MARSTELLER
Stanhope House, 14th Floor
738 King's Road, North Point
Hong Kong, China
Telephone 852-2963-6760
Facsimile 852-2817-8037
(p. 24)

CAHAN & ASSOCIATES
818 Brannan Street
Suite 300
San Francisco, California 94103
U.S.A.
Telephone 415-621-0915
Facsimile 415-621-7642
E-mail info@cahanassociates.com
Web <www.cahanassociates.com>
(pp. 16, 97)

CARBONE SMOLAN ASSOCIATES
22 West 19th Street
10th Floor
New York, New York 10011
U.S.A.
Telephone 212-807-0011
Facsimile 212-807-0870
E-mail mail@carbonesmolan.com
Web <www.carbonesmolan.com>
(pp. 79, 103, 110)

CONCRETE©, CHICAGO
633 SOUTH PLYMOUTH COURT
SUITE 208
CHICAGO, ILLINOIS 60605
U.S.A.
TELEPHONE 312-427-3733
FACSIMILE 312-427-9053
E-MAIL CONCRETEUS@AOL.COM
(PP. 69, 101)

CRONAN DESIGN
42 Decatur Street
San Francisco, California 94103-4517
U.S.A.
Telephone 415-522-5800
Facsimile 415-522-5801
E-mail dsgn@cronan.com
Web <www.cronan.com>
(p. 73)

DESGRIPPES GOBÉ & ASSOCIATES
411 Lafayette Street
New York, New York 10003
U.S.A.
Telephone 212-979-8900
Facsimile 212-979-1401
E-mail lsherr@dga.com
Web <www.dga.com>
(p. 14)

DESIGNCO BJERAGER & NØRHALD©
Jægersborg Allé 131, Box 31
2820 Gentofte
Denmark
Telephone 45-3965-7136
Facsimile 45-3965-7159
E-mail designco@post4.tele.dk
(p. 105)

DIETZ DESIGN CO.
80 South Jackson
Suite 308
Seattle, Washington 98104
U.S.A.
Telephone 206-621-1855
Facsimile 206-621-7146
E-mail robert@dietzdesign.com
Web <www.dietzdesign.com>
(pp. 17, 23, 75, 98)

BEN DRURY
142D Tachbrook Street, Pimlico
London SW1V 2NE
England
Telephone
0171-834-6218, 0171-736-8031
Facsimile
0171-834-6218, 0171-736-8041
E-mail drury@easynet.co.uk
(p. 146)

FITCH INC.
10350 Olentangy River Road
Worthington, Ohio 43085
U.S.A.
Telephone 614-885-3453
Facsimile 614-885-4289
E-mail shirley_rogers@fitch.com
Web <www.fitch.com>
(pp. 44, 58, 61, 89)

FORK, A DIVISION OF
IDEO PRODUCT DEVELOPMENT
Pier 28 Annex
San Francisco, California 94105
U.S.A.
Telephone 415-778-4777
Facsimile 415-778-4701
E-mail spreenberg@ideo.com
Web <www.prong.com>
(pp. 28, 181, 184)

FROETER DESIGN COMPANY INC.
954 West Washington
Chicago, Illinois 60607
U.S.A.
Telephone 312-733-8895
Facsimile 312-733-8894
E-mail cfroeter@xsite.net
(pp. 48, 54, 64, 87)

GR8
2400 Boston Street
3rd Floor
Baltimore, Maryland 21224
U.S.A.
Telephone 410-837-0070
Facsimile 410-685-2616
E-mail info@gr8.com
Web <www.gr8.com>
(pp. 40, 56, 91)

Formerly:
Grappa Design
(pp. 135, 148)
Now:
GRAPPA BLOTTO DESIGN
Brunnenstraße 24, Loft 4
10119 Berlin
Germany
Telephone 030-44342971
Facsimile 030-4410715
E-mail grapp@snafu.de
 blotto@grappa.net
Web <www.grappa.net>

and

GRAPPA.DOR
Brunnenstraße 24, Loft 2
10119 Berlin
Germany
Telephone 030-443584-00
Facsimile 030-443584-01
E-mail grappa@aol.com
 dor@grappa.net
Web <www.grappa.net>

GYRO INTERACTIVE
502 Albert Street
East Melbourne, Victoria 3002
Australia
Telephone 61 3 9662-1027
Facsimile 61 3 9663-8805
E-mail wayne@rba.com.au
Web <www.gyro.com.au>
(p. 77)

HARTFORD DESIGN, INC.
954 West Washington
4th Floor
Chicago, Illinois 60607
U.S.A.
Telephone 312-563-5600
Facsimile 312-563-5603
tim1@hartforddesign.com
Web <www.hartforddesign.com>
(pp. 34)

HORNALL ANDERSON DESIGN WORKS, INC.
1008 Western Avenue
Suite 600
Seattle, Washington 98104
U.S.A.
Telephone 206-467-5800
Facsimile 206-467-6411
E-mail info@hadw.com
Web <www.hadw.com>
(pp. 20, 25, 42, 157, 160, 162, 173)

IGNITION, INC.
870 Market Street
San Francisco, California 94102
Telephone 415-392-6244
Facsimile 415-392-6245
E-mail info@ignitiondesign.com
Web <www.ignitiondesign.com>
(pp. 15, 107)

INTERFACE DESIGNERS
Rua do Russell 300/702 /
Glória 22210-010
Rio de Janeiro
Rio, Brazil
Telephone 55 021 2055161 /
55 021 5565422
Facsimile 55 021 557 1900
E-mail sflower@ism.com.br
(pp. 145, 174)

INTERNET.BROADCASTING.SYSTEM™
7711 Computer Avenue
Edina, Minnesota 55435
U.S.A.
Telephone 612-896-9898
Facsimile 612-896-9899
E-mail graphics@ibsys.com
Web <www.ibsys.com>
(pp. 27, 43)

JAGER DI PAOLA KEMP DESIGN
47 Maple Street
Burlington, Vermont 05401-4784
U.S.A.
Telephone 802-864-5884
Facsimile 802-864-8803
E-mail michael_jager@jdk.com
Web <www.jdk.com>
(pp. 46, 63)

JAVIER ROMERO DESIGN GROUP, INC.
24 East 23rd Street
3rd Floor
New York, New York 10010
U.S.A.
Telephone 212-420-0656
Facsimile 212-420-1168
E-mail zahavat@jrdg.com
Web <www.jrdg.com>
(pp. 124, 150)

JOÃO MACHADO, DESIGN LDA
Rua Padre Xavier Coutinho, 125
4150 Portugal
Telephone 610 37 72, 610 37 78
Facsimile 610 37 73
E-mail jmachado.design@mail.telepac.pt
(pp. 136, 139)

JOHN D. BERRY DESIGN
c/o *U&lc*
International Typeface Corporation
228 East 45th Street
New York, New York 10017
U.S.A.
Telephone 212-949-8072, ext. 147
Facsimile 212-949-8485
E-mail jberry@itcfonts.com
(p. 109)

JOHNSON & WOLVERTON
510 N.W. 19th Avenue
Portland, Oregon 97209
U.S.A.
Telephone 503-241-6145
Facsimile 503-241-2407
E-mail kirk@j-w.com
(p. 104)

KAN & LAU DESIGN CONSULTANTS
28/F, Great Smart Tower
230 Wanchai Road
Hong Kong, China
Telephone 852-2574-8399
Facsimile 852-2572-0199
(pp. 93, 161, 172)

KOMMUNIKATIONS-DESIGN BBV
Rheingasse 5
78462 Konstanz
Germany
Telephone 07531 1 80 47
Facsimile 07531 1 80 45
(pp. 55, 62, 170)

L DESIGN, PIPPO LIONNI
5 bis, rue des Haudriettes
75003 Paris
France
Telephone 33(0)1 44 78 61 61
Facsimile 33(0)1 44 78 00 46
E-mail ldesign@club-internet.fr
(pp. 51, 138, 142, 169)

LAUGHING DOG CREATIVE, INC.
1925 North Clybourn
No. 202
Chicago, Illinois 60614
U.S.A.
Telephone 773-529-4989
Facsimile 773-529-4887
E-mail frank@laughingk9.com
Web <www.laughingk9.com>
(p. 29)

DAVID LEMLEY DESIGN
1904 Third Avenue
Suite 920
Seattle, Washington 98101
U.S.A.
Telephone 206-682-9480
Facsimile 206-682-9495
E-mail lemley1@aol.com
(pp. 12, 74, 88, 100, 113, 115)

MARGO CHASE DESIGN
2255 Bancroft Avenue
Los Angeles, California 90039
U.S.A.
Telephone 213-668-1055
Facsimile 213-668-2470
E-mail info@margochase.com
Web <www.margochase.com>
(pp. 80, 118)

KRISTINE MATTHEWS
Royal College of Art
Graphic Design Department
Kensington Gore
London SW7 2EU
England
Telephone 0171-590-4306
Facsimile 0171-590-4300
E-mail k.matthews@rca.ac.uk
(pp. 125, 140, 180, 182)

MAVIYANE-PROJECT
P.O. Box 4974
Harare, Zimbabwe
Telephone (263-4) 496468
Facsimile (263-4) 496468
E-mail maviyane@hotmail.com
(pp. 127, 164)

RICHARD MCGUIRE
45 Carmine Street
New York, New York 10014
Telephone 212-627-9464
Facsimile 212-691-5719
E-mail rmcguire@thing.net
(p. 59)

MEADOWS DESIGN OFFICE
4201 Connecticut Avenue, N.W.
Washington, D.C. 20008
U.S.A.
Telephone 202-966-6007
Facsimile 202-966-6733
E-mail mdo@mdomedia.com
Web <www.mdomedia.com>
(p. 176)

MEDIA ARTISTS INC. S.R.L.
Via Marconi 10/A
Albino (BG)
Italy
Telephone 39 35 774115
Facsimile 39 35 773968
E-mail maimail@cyberg.it
(pp. 72, 76, 82, 102, 108)

MINELLI DESIGN
381 Congress Street
Boston, Massachusetts 02210
U.S.A.
Telephone 617-426-5343
Facsimile 617-426-5372
E-mail info@minelli.com
Web <www.minelli.com>
(pp. 86, 126, 134, 137)

MORLA DESIGN
463 Bryant Street
San Francisco, California 94107
U.S.A.
Telephone 415-543-6548
Facsimile 415-543-7214
E-mail jennifer@morladesign.com
(pp. 30, 49, 129, 131, 158)

PENTAGRAM DESIGN
204 Fifth Avenue
New York, New York 10010
Telephone 212-683-7000
Facsimile 212-532-0181
E-mail info@pentagram.com
Web <www.pentagram.com>
(pp. 47, 53, 132)

PLANET DESIGN COMPANY
605 Williamson Street
Madison, Wisconsin 53703
U.S.A.
Telephone 608-256-0000
Facsimile 608-256-1975
E-mail info@planetdesign.com
Web <www.planetdesign.com>
(pp. 65, 130, 165)

PLATINUM DESIGN
14 West 23rd Street
New York, New York 10010
U.S.A.
Telephone 212-366-4000
Facsimile 212-366-4046
E-mail platinum@interport.net
Web <www.platinum-design.com>
(pp. 33, 141, 151)

PRIMO ANGELI INC.
101 15th Street
San Francisco, California 94103
U.S.A.
Telephone 415-551-1900
Facsimile 415-551-1919
E-mail pai@primo.com
Web <www.primo.com>
(p. 22)

RANKINBEVERS ASSOCIATES
502 Albert Street
East Melbourne, Victoria 3002
Australia
Telephone 61 3 9662 1233
Facsimile 61 3 9663 8805
E-mail wayne@rba.com.au
Web <www.rba.com.au>
(p. 78)

RAZORFISH
107 Grand Street
3rd Floor
New York, New York 10013
U.S.A.
Telephone 212-966-5960
Facsimile 212-966-6915
E-mail info@razorfish.com
Web <www.razorfish.com>
(p. 60)

SAMPSON TYRRELL ENTERPRISE
6, Mercer Street
London WC2H 9QA
England
Telephone 0171 574-4000
Facsimile 0171 574-4100
(p. 13, 183)

SAYLES GRAPHIC DESIGN
308 Eighth Street
Des Moines, Iowa 50309
U.S.A.
Telephone 515-243-2922
Facsimile 515-243-0212
(p. 90)

SEGURA INC.
1110 North Milwaukee Avenue
Chicago, Illinois 60622-4017
U.S.A.
Telephone 773-862-5667
Facsimile 773-862-1214
E-mail segurainc@aol.com
Web <www.segura_inc.com>
(p. 71, 96)

SPINPOINT INC.
954 West Washington
4th Floor
Chicago, Illinois 60607
U.S.A.
Telephone 312-563-5608
Facsimile 312-563-5603
info@spinpoint.com
Web <www.spinpoint.com>
(p. 32)

SPUR DESIGN LLC
3647 Falls Road
Baltimore, Maryland 21211
U.S.A.
Telephone 410-235-7803
Facsimile 410-235-4674
E-mail info@spurdesign.com
Web <www.spurdesign.com>
(pp. 21, 68, 83, 114)

STUDIO ARCHETYPE
600 Townsend Street, Penthouse
San Francisco, California 94103
U.S.A.
Telephone 415-703-9900
Facsimile 415-703-9901
btempleton@studioarchetype.com
Web <www.studioarchetype.com>
(p. 35)

STUDIO OZUBKO
3044 38th Avenue West
Seattle, Washington 98199
U.S.A.
Telephone 206-284-8122
Facsimile 206-284-8252
E-mail ozubko@u.washington.edu
(p. 144, 152)

SULLIVANPERKINS
2811 McKinney
Suite 320
Dallas, Texas 75204
U.S.A.
Telephone 214-922-9080
Facsimile 214-922-0044
sullperk@earthlink.net
(pp. 45, 52, 167)

TANGRAM STRATEGIC DESIGN
Via Negroni 2
28100 Novara
Italy
Telephone 321 35662
Facsimile 321 392232
E-mail tangram@msoft.it
(pp. 81, 85, 106, 112, 117, 119)

TENAZAS DESIGN
605 Third Street
Suite 208
San Francisco, California 94107
U.S.A.
Telephone 415-957-1311
Facsimile 415-957-0707
E-mail tenazas@earthlink.net
(pp. 84, 99, 111, 116)

TODA OFFICE
#505 Azabu-Toriizaka Building
5-10-33 Roppongi
Minato-ku, Tokyo 106
Japan
Telephone 03-5770-1533
Facsimile 03-5770-1531
E-mail 47221103@people.or.jp
(pp. 41, 50, 57, 163, 168, 175)

UNIFIED FIELD
226 Fifth Avenue
New York, New York 10001
U.S.A.
Telephone 212-532-9595
Facsimile 212-532-9667
E-mail unified@interport.net
Web <www.unifiedfield.com>
(p. 177)

UNO, YASUYUKI DESIGN STUDIO INC.
710 Casa Grande Miwa Building
7-5-11 Roppongi
Minato-ku, Tokyo 106-0032
Japan
Telephone 81 3 3401 5451
Facsimile 81 3 3401 5379
E-mail uno-d@sb3.so-net.or.jp
(pp. 31, 121, 143, 171)

URBAN OUTFITTERS
1809 Walnut Street
Philadelphia, Pennsylvania 19103
U.S.A.
Telephone 215-557-4759
Facsimile 215-568-1691
E-mail urbanout@voicenet.com
(p. 147)

WHY NOT ASSOCIATES
Studio 17
10-U Archer Street
London W1V 7HG
England
Telephone 0171 494-0762
Facsimile 0171 494-0764
ISDN 494 0242
E-mail whynot@easynet.co.uk
(pp. 128, 133, 149, 153, 185)

WILD PLAKKEN
Elandsstraat 149'
1016 RZ Amsterdam
The Netherlands
Telephone 020 / 6252897
Facsimile 020 / 6265735
E-mail wldplkkn@xs4all.nl
(p. 19, 26, 36, 166)

WIZARDS OF THE COAST®
1801 Lind Avenue S.W.
Renton, Washington 98055
U.S.A.
Telephone 425-204-7710
Facsimile 425-204-5869
E-mail carian@wizards.com
Web <www.wizards.com>
(pp. 37, 92)

Index of Clients

About the Author

©Rosanne Olson

Karen D. Fishler is a writer who lives in Seattle, Washington. She holds a B.A. from Wellesley College and an M.A. from Cambridge University. A former newspaper reporter and the former editor of *Garden Design* magazine, she also served as the creative and publishing director of The Nature Conservancy and launched *adobe.mag*, an online magazine, for Adobe Systems Incorporated.